One of the most recognisable names and silhouettes in fashion journalism, André Leon Talley was the indomitable creative director at *Vogue* during the magazine's rising dominance as the world's fashion bible. Over the past five decades, his byline has also appeared in *Vanity Fair*, *HG*, *Interview* and *Women's Wear Daily*. He has published several illustrated works, including *Little Black Dress*, *A.L.T.: 365+* and *Oscar de la Renta: His Legendary World of Style*. Talley is also the subject of the documentary *The Gospel According to André*. He received his MA in French studies from Brown and was on the board of trustees for the Savannah College of Art and Design for twenty years.

Twitter: @OfficialALT
Instagram: @andreltalley

A *Sunday Times* bestseller

'Honestly and candidly captures fifty sublime years of fashion. Talley's unrivalled knowledge, extraordinary eye for spotting raw talent and "ahead of the curve" ability to clearly define what makes a good dress, draws you in from page one. An insightful and intelligent read, conveyed in a way only he could' MANOLO BLAHNIK

'Such stories about the fashion greats make for perfect lockdown gossip … the lid has been lifted' *Sunday Times*

'What he gives us, ultimately, is a circus the likes of which, given present circumstances, we may never see again. My advice is to do as I did: apply a good squirt of Fracas to your wrists, and sit back and enjoy the lunatic ride' *Observer*, Book of the Week

'Ideal reading material for anyone who found *The Devil Wears Prada* addictive but now needs a stronger hit. It is brimful of toxic behaviour and noxious values, which makes it perfect consolation, too, for lockdown' *Daily Telegraph*

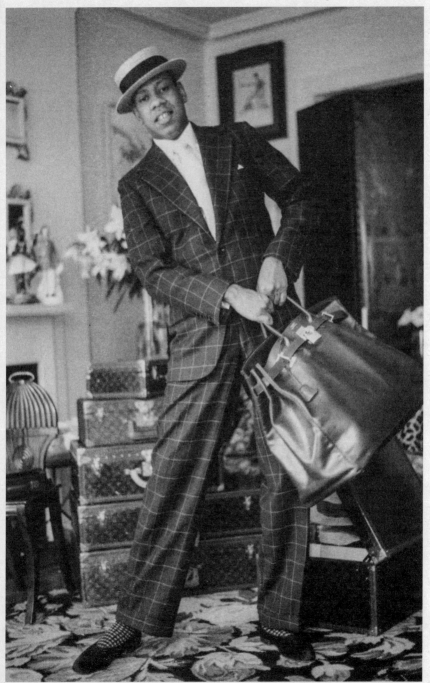

PHOTOGRAPH BY ARTHUR ELGORT

BY ANDRÉ LEON TALLEY

A.L.T.

THE CHIFFON TRENCHES

A MEMOIR

ANDRÉ LEON TALLEY

4th ESTATE · London

4th Estate
An imprint of HarperCollins*Publishers*
1 London Bridge Street
London SE1 9GF

www.4thEstate.co.uk

HarperCollins*Publishers*
1st Floor, Watermarque Building, Ringsend Road
Dublin 4, Ireland

First published in Great Britain in 2020 by 4th Estate
First published in the United States by Ballantine Books, an imprint of
Random House, a division of Penguin Random House LLC, New York, in 2020
This 4th Estate paperback edition published in 2021

1

A catalogue record for this book is
available from the British Library

ISBN 978-0-00-834237-1

Printed and bound in Great Britain by
CPI Group (UK) Ltd, Croydon

MIX
Paper from
responsible sources
FSC™ C007454

This book is produced from independently certified FSC™ paper
to ensure responsible forest management.

For more information visit: www.harpercollins.co.uk/gree

For Reverend Doctor Calvin O. Butts III,
minister of the Abyssinian Baptist Church, New York City

In loving memory of Lee Bouvier Radziwill

How I got over, how I got over
My soul looks back and wonders how I got over

—CLARA WARD

INTRODUCTION

For more than four decades, I went through a series of voyages with *Vogue* magazine and its editor in chief, Anna Wintour, the most powerful person in fashion. I was a fixture, a force, and a fierce advocate of fashion and style.

When I was an adolescent, *Vogue* was my inspiration. When other kids were tacking up baseball cards to their bedroom walls, mine were filled with the pages of the world's most influential fashion magazine. To my twelve-year-old self, raised in the segregated South, the idea of a black man playing any kind of role in this world seemed an impossibility. To think of where I've come from, where *we've* come from, in my lifetime, and where we are today, is amazing.

And yet, of course, we still have so far to go.

As I write this, I have just seen Beyoncé Knowles-Carter's September 2018 *Vogue* cover. It is, in some ways, another in a long line of fantastic images that made it through the meticulous process of becoming the cover of *Vogue*.

And then, in other ways, it stands alone.

This picture, and what it represents, is hugely important and significant. When you look at this cover and you know that Anna Win-

tour, whose exquisite taste has defined *Vogue* for decades, gave Beyoncé creative control of her cover and cover story, then you start to understand its importance. And it was the *September* issue, the biggest issue in the yearly lineup! Beyoncé is an incredible tsunami of talent and power. She cannot be defined through the cultural standards that define *Vogue;* Beyoncé defines herself.

When I first saw this cover, I knew it was history in the making. Chosen at Beyoncé's suggestion, photographer Tyler Mitchell, at only twenty-three years old, became the first black man to shoot a cover image in the 125-year history of one of the most prestigious magazines to ever exist.

Beyoncé stands out on a lawn somewhere outdoors, no big expensive studio. There's a flowing white sheet on a line, like laundry, as a backdrop.

Besides the rococo fresh flower arrangement on her head, Beyoncé's dressed simply, in a long Gucci dress. Her makeup, natural. Her skin moisturized and her knees exposed, and firmly together. No apologies or nuance or overt sexuality.

That image conjures for me laundry drying in the fresh open air. Mitchell's photograph suggests the laundress, that bygone station, delivering white linens to the white master's big white house. Crisp, immaculate whiteness. Cicely Tyson in the film *Sounder,* making money to feed her sharecropping family; my great-grandmother and grandmother, doing the weekly laundry, backs bent and weary in fatigue, just another duty in line with their responsibility for the "cleanliness is next to godliness" creed that is part of humble living.

In all its elegance, the sheet symbolizes so many black women, in their own confident beauty, who did laundry to survive, to provide for their families, to put food on the table. I find it subtly very black. Basic and black. Black with style.

As Mitchell so aptly pointed out in a *Vogue* interview about the shoot: "For so long, black people have been considered things."

I see the influence of Kara Walker, Alice Walker, and Zora Neale Hurston, along with the unnamed armies of black mothers and

maids working for whites to keep food on their own tables. That's amazing to me. The scene is fresh, unprecedented, and without parallel in the history of *Vogue* fashion covers.

Knowledge is power.

Fittingly, in the corresponding pages of *Vogue,* Beyoncé writes of exploring her roots and learning she's the descendant of slaves. That is evolution. That is revolution. She describes how she fought to get her body back after her first child, and how with the twins she embraced her FUPA, her little baby stomach, and how her arms are bigger and she's embraced that, too. As a black woman, she is going to inspire people.

The only other time Beyoncé was on the cover of *Vogue,* there was no story inside. She wanted to interview herself, and that was not allowed. And now *this* time, in 2018, she had full control of her story, suggesting the first black American photographer for the cover and writing her own narrative inside the issue. Beyoncé can do that because she's the most popular woman in the world. And she chooses to do that because . . . why? I suspect because she knows what all black people know: It's difficult to be a black woman or black man in this country.

We struggle to endure and overcome the centuries of ingrained white supremacy, the institutions of injustice and inequality, in every aspect of life in this, the great America.

I proudly wrote an op-ed for the Sunday edition of *The Washington Post* about the cultural significance of Beyoncé's cover. Upon its publication, I sent a link to Susan Plagemann, the publisher of *Vogue.* She was thrilled with the piece and sent it off to every major editor in the Condé Nast lineup, including Anna Wintour.

Not one of those editors wrote me about the piece. Not one quick e-mail from Anna Wintour.

Editors I've worked with for decades didn't understand the immense importance of this occasion simply because they are not capable of understanding. None of my contemporaries have seen the world through black eyes.

For so long I was the only person of color in the upper echelons of fashion journalism, but I was too busy pushing forward, making it to the next day, to really think about the responsibility that came with this role. Memories linger in the mind. Now I realize it is my duty to tell the story of how a black man survived and thrived in the chiffon trenches.

Although great strides have been made, I'm still very aware of my being black in this country. I'm aware that a black man still has to work one thousand times harder to live the American dream. I'm aware that every day when a black man wakes up in this country, no matter how successful or unsuccessful he is, his race will determine what he does and how far he goes in his life. No matter what you do, who you are, what career you choose, as a black man, you realize every day that our country was founded on the misguided rules and conceits of racism and slavery. A black man goes through life realizing, *There but for the grace of God go I.*

Racism moves under the epidermis as a constant, constant reality. It's part of the fabric of our existence.

"We are a blues culture," according to Cornel West. We invent the blues every day when we wake up. *Good morning, heartache, I rise, yes I rise, thank God.* Hope lives. You must wake up and create your own miracles every day. I went through my life on the strength of hope, and the memory of my ancestors, and the people who showed me unconditional love. There's no sunny day, yet there is sunshine in my life. You have to hope. It's a dangerous and perilous tightrope walk, and yet you must rise to meet the day.

We rejoice in Beyoncé and her blackness, in Tyler Mitchell and his blackness, and in all the generations behind them. I feel unspeakable joy for their landmark in history and for the future of fashion.

The power in knowledge cannot be understated. Whenever people ask me for advice, I tell them two things: Never give up on your dreams, and do your homework. "Homework" can mean a lot of things, but do your homework in life. Style will get you up the steps into the revolving door; substance and knowledge will allow you

access to create new horizons. My great depth of knowledge is the number one skill I possess and has carried me throughout my career to this day. Rivers deep, mountains high. All the people who mattered in my life have approached me because of my knowledge. Throughout my career, designers liked spending time with me because I studied, and I studied, and I resolved to learn as much as I could.

The waters I sailed through were oftentimes tumultuous. But I also found kindness, and people who were similar to me, and it opened a range of possibilities for being.

I hope you find my glorious and, somehow, triumphant crawls through the chiffon trenches to be fierce and fearless. I am now in my seventies, but mentally I feel like I am twenty-nine. Physically, I am a huge galleon slowly sailing into harbor, broken from so many battles. But still, I rise, and continue to express myself with articulation, eloquence, and respect. I bow down to no one and find my way through the memory of what has been good in this life, which is not yet finished. My past gives me strength.

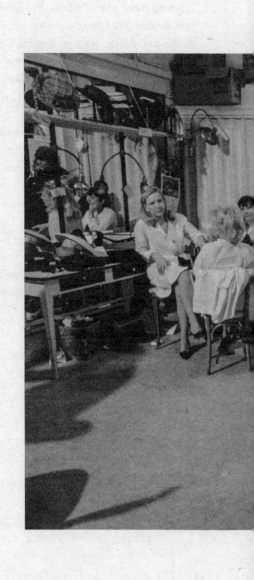

I was born in a now-torn-down hospital on the edge of tony, afflu-
ent Georgetown in Washington, D.C. Two months after my ar-
rival, my parents, Alma and William Carroll Talley, took me to my
grandmother's house in Durham, North Carolina, the center of the
tobacco industry. My parents were young, and as was typical in
Southern black households, it was decided I would live with my
grandmother, Bennie Frances Davis, as my parents sought careers in
the nation's capital. I called my grandmother Mama.

Mama and I lived with my great-grandmother China. Both wid-
ows, they coupled pension checks and my grandmother's salary from
being a domestic maid at the men's campus of Duke University, as
well as supplemental income from my parents, to make a house that
operated on organization, faith, God, and maintenance. As a young
child I was given duties: dusting, collecting coal for the stoves, and
gathering kindling from the woodshed, as well as washing dishes
after meals.

There was churchgoing, and there was churchgoing: Sunday
school; vacation Bible school; homecoming celebrations; baptisms
in the rain-filled concrete pool constructed just beyond the church-
yard cemetery.

I went to Lyon Park elementary school, which was just down the street from our home. I had close family bonds and my favorite cousins were my best friends. Most of the time, I managed to avoid the cruel bullies at school and in the neighborhood. I do, however, remember vividly staying home from school on a rare snow day and proudly building a three-tiered snowman in our front yard, complete with coal eyes, a carrot nose, and coal lips. I went into the kitchen at lunchtime, where my great-grandmother China was heating up a can of Campbell's chicken noodle soup for me. By the time I put on my coat and returned outside, the neighborhood kids had destroyed my freshly constructed snowman. I turned around, went back inside, and sulked. What could I do? My grandmother's mother couldn't come out and take up my defense, and I had no desire to chase down and confront the vandals.

Young people can be very mean. When I would get upset, my uncle Lewis used to say to me, "Just keep on getting up. Get up every day and just keep going." It was some of the best advice I've ever been given.

At an early age, I found my fantasy world in books and records, classical music, Nina Simone, Laura Nyro, Aretha Franklin, Diana Ross. In my aunt Myra's country house, I found a book on the disaster of the *Titanic,* the luxury ocean liner that was never supposed to sink. The wealthy and the middle-class went to their deaths in the cold seas. Every time I went to visit Aunt Myra, I picked up this book; it resonated as something in my mind's eye that was outside the norm of my everyday existence.

My favorite retreat was the city library in downtown Durham, North Carolina. By the age of twelve, I had read every magazine and book I had come across. My world became the glossy pages of *Vogue,* where I could read about Truman Capote's legendary ball, given at the Plaza, in honor of Katharine Graham. And Gloria Vanderbilt, in her patchwork antique quilts with Elizabethan ruffs, created by Adolfo. I loved seeing her photographed in her simple Mainbocher suits or the exotic Fortuny pleated gowns she kept folded in special

coils, like snakes, to keep the silk vibrant. I dreamed of meeting Naomi Sims and Pat Cleveland, and living a life like the ones I saw in the pages of *Vogue,* where bad things never happened. Blue spring skies lent my grandmother's rosebushes a glorious color in our front yard. Summers were spent picking wild blackberries, watching cardinals zoom around our house, and having wonderful, delicious dinners, cooked all day and eaten at five-thirty. Food was our luxury—simple, good, home-cooked food. Every day, there were fresh-cooked homemade meals. Sometimes we ate leftovers, but I remember Sundays, when hot, fresh beaten buttermilk biscuits; rows of crisp bacon; scrambled eggs; and preserves made our breakfast. Cake, pie, and a myriad of home-cooked desserts were my favorites.

Autumn brought with it crisp, crinkly golden leaves from the maple tree, a massive one in our front yard, its leaves awful to rake. In the winter, if it snowed, I had to gather extra buckets of glossy chunks of coal in the scuttle and store them on the back porch.

Great-Grandmother China died in January 1961, and I felt alone for the first time. For a budding young man, this was overwhelming, the death scene of my great-grandmother, a lady who was the matriarch of a God-fearing and God-loving family.

The family gathered at Aunt Pete's, and she made enough food to feed everyone, including her seven daughters, one surviving son, and assorted extended family members. Throughout the night, into the morning, the adults were in the family room, sharing stories of growing up and of their beloved mama.

Somehow, there was an economy of words between my grandmother and me as we shared this humble, modest household, filled with nurturing love and the greatest values: treating others with kindness, and caring for your neighbors and family.

Life went on. My parents divorced when I was nine. Nobody told me about their separation, but I eventually figured it out. Both of them continued to visit frequently, my father always bringing me some luxurious gift: a bright red brand-new bicycle, the *World Book*

encyclopedia, a black and white television, or my first record player. I had an allowance and would go to downtown Durham on Fridays with Mama and purchase the latest 45 rpm records. I treasured each of the items he gave me.

My mother had left my father because she thought she could do better and had planned to marry another man who was slightly more affluent than my father. One morning, not long after the divorce, she got an invitation to that man's wedding, to another, younger, woman. That broke my mother's spirit, forever. She became ill after that. Her hair turned white, prematurely, and she had a sort of meltdown that resulted in her trying to set her apartment on fire. And on top of it all, she refused even the smallest amount of alimony she was entitled to by law. She simply handed him the way out of their marriage and soldiered on financially but became cruel and bitter emotionally. She would come visit us in Durham, and she would go to church and be part of everything, but there was never much of a conversation to be had between the two of us. I would talk to her, but she barely said anything back. While I knew she loved me, I don't think she liked me.

Like most Americans, my grandmother and I watched the presidential inauguration of John F. Kennedy, as it was a defining moment in a new era for our country. It symbolized hope and it also symbolized glamour. Jackie Kennedy was the youngest First Lady and she was an influencer—perhaps the first influencer of the modern world. I was in awe of her, the way she walked at the inauguration, in her cloth coat. I was obsessed with her pillbox hat, and her little snippet of fur at the collar, and her fur-edged boots, as well as the muff she carried to keep her hands warm during the freezing-cold January day.

My captivation continued when on Valentine's Day, in 1962, *A Tour of the White House with Mrs. John F. Kennedy* aired in black and white on all the networks. I was so caught up with the sheer magni-

tude of this glance inside the First Home of our nation. Jackie Bouvier Kennedy, and her style, truly resonated with me. I knew I had witnessed a moment, one that was sure to be the beginning of many.

There she stood, hair perfectly coiffed and curled, in her Chez Ninon line-for-line copy of an original Dior from Paris. She spoke of the White House with knowledge and eloquence. It was then I learned the word "Porthault"; the Parisian linen firm had donated a long white tablecloth for the State Dining Room, hand-embroidered in gold thread. I learned that she wanted simple glasses for water and wine. She revealed she had found them in Virginia. She spoke of the Stanford White moldings, painted white, from 1902. And she recalled that Teddy Roosevelt had commissioned a fireplace surrounded in marble, with images of American buffaloes.

From her quiet, elegant manner of speaking, her control of her message, her focus on the history of this great edifice, I learned my passion and love for antiques and the finer things. So in life, I followed Jackie Kennedy. She was my heroine in all things that mattered: clothes, decorating, and the way she presented herself as First Lady. My aunts copied her style, according to their budget, with pillbox hats and elegant chain-strap handbags. Gloves, of course. All respectful Negro church ladies were inspired by Jackie Kennedy ("Negro" was the proper term then; "African American" is proper today).

My grandmother had a drawer full of gloves, her most luxurious accessory, for every season of the year. Another drawer held cherished handkerchiefs, which she slipped into her Sunday handbag. Mama wore medium-heeled shoes, which fascinated me to watch on our walk to church, especially her navy blue leather ones, with the grosgrain bow, by Naturalizer, bought at great expense, and with a matching handbag.

The orchestrated funeral of President John F. Kennedy was the most incredible pageantry of dignity. There was Mrs. Kennedy, in her black Givenchy suit, with the tassel fringe as buttons, her face covered by a veil attached to her pillbox. It was a message to the

world that she was a mother and a wife, and created a symbol of strength and style. Jackie Kennedy seemed more like a film star than the wife of the president. She had more impact on me than any actress.

I created my fantasy world through Jackie Kennedy. A hefty diet of fashion glossies and fashion supplements taught me everything I needed to know.

I knew about Jansen, the Paris-based decorator, and Monsieur Boudin, who helped C. Z. Guest, this über-Wasp icon of style and affluence, decorate her rooms.

I knew about Bunny Mellon, who lived in Upperville, Virginia, the best friend of Jackie Kennedy.

I knew about Lee, Princess Radziwill, sister to Jackie Kennedy, living a gilded life in London, with a house in the country decorated with the help of Mongiardino of Italy. I remember so fondly making mental pictures of Lee Radziwill, dancing in her silver Mila Schön couture dress at the Truman Capote Black and White Ball.

With the massive influence of fashion magazines, I became a devoted Francophile. My favorite show on television was Julia Child's, on Sundays. I loved her irreverence, and I loved her manner of speaking French. I took four levels of French, from junior to senior high school, and I majored in French studies at North Carolina Central University, a Negro state university in Durham. There, I excelled, and received a full scholarship to Brown University in Providence, Rhode Island, where I would receive my master's degree and begin pursuing doctoral studies. My plan was to become a French teacher, at a private school somewhere. I didn't much mind where; I just knew I wanted to be out in the world.

On the very day I was going off for graduate school at Brown, with a full advanced-degree scholarship, my mother turned to me and whispered, "I don't know why you are going off to this college for another few years of studies. You have your BA. Why don't you go and join the army so you can have benefits?"

I thought to myself, *What is she talking about?* Brown's an Ivy

League school. She didn't understand what a high honor I had achieved.

My grandmother overheard this whispered conversation and bullied her way right through the cracks. She said to her daughter, "Just leave it alone, he will be fine. Let him go!" Mama understood and always encouraged and supported me all the way. She had faith and knew it was going to be fine; she just kept packing my cardboard boxes with quilts made by her mother's sister, Aunt Luna, that I cherished for my dormitory room, as well as sheets and towels. It was modest, but that soon changed once I got to Brown and had a monthly stipend, with which I splurged on Yves Saint Laurent sheets, lengthy brand-stamped lush yellow towels, and Rive Gauche clothes, on sale.

At Brown I studied the culture of France, the brilliant, intellectual bohemian lifestyle of the nineteenth century, Charles Baudelaire, Rimbaud, Verlaine. I felt free, no longer restrained by the rigid, judgmental community I had grown up in. Now that I was out in the world, I didn't give a damn what anyone thought about me. I wore a vintage surplus navy admiral's coat, in perfect condition. All the brass buttons were intact. It was a maxi, almost to my feet, and I'd wear it with scratchy sailor pants—four inches above the ankles—and lace-up oxfords with small flamenco-dancer heels.

During the first winter break, I brought the coat home to North Carolina. I was so proud of that coat. My grandmother could not have cared less, but my mother refused to attend church with me while I was wearing it. As we got out of my cousin Doris Armstrong's car—she always drove across town to pick us up and take us to our country church—my mother held me back.

She glared at me and said, "I can't be seen walking with you up the aisle in this *Phantom of the Opera* look."

"Go ahead," I said. I waited outside a few minutes while she went in, smarting from her comment. My mother could be quite nasty to me, but I still respected her. That did not mean I had to like her.

I was a fashion addict, dramatic in attire and appearance, even then. I would wear kabuki makeup like Diana Vreeland, legendary *Vogue* editor in chief, or Naomi Sims, the first black model I ever saw in *Vogue*. On any typical day, I would layer Estée Lauder's latest shade of deep grape on my temples, top it with Vaseline, and head off to class.

My wardrobe caught the attention of affluent students at the Rhode Island School of Design, also located in Providence. I began to live two separate lives: the one on campus for my studies at Brown, and the one at RISD, where I made friends with Jane Kleinman and Reed Evins. Jane's father was then head of Kayser-Roth hosiery, and Reed's uncle was David Evins, the shoe magnate. They lived off campus, in a big floor-through apartment filled with sunlight and incredible antiques. Reed came to RISD with a huge van of furniture. There were Chippendale dining room chairs, a beautiful mahogany leaf dining table, Baccarat glassware, sterling flatware, damask tablecloths, and beautiful china with gold-leaf borders.

One weekend, Jane went home to New York City and came back to school with a Revillon skunk coat purchased on sale at Saks Fifth Avenue. She was so proud of that coat. It was the exact same coat Babe Paley owned, South American skunk—Chilean skunk, in fact. Diana Vreeland's favorite!

Reed and Jane ruled: They seemed to have it all—the best clothes, the best furniture—and they were New Yorkers. On my birthday in October 1974, they brought me to New York to attend the Coty Awards fashion show, at FIT. I don't remember anything about the show, except meeting Joe Eula, who was an important illustrator for Halston, then the hottest designer in America. Joe Eula invited me to a party at his house after the show, where I met Elsa Peretti, as well as Carrie Donovan, with whom I had corresponded years earlier.

Carrie was a madcap and very talented fashion editor, a cross between Kay Thompson in *Funny Face* (the best fashion comedy film ever) and Maggie Smith in a movie that won her an Oscar, *The Prime*

of Miss Jean Brodie. I absolutely adored Carrie's boutique pages at the back of *Vogue*.

I walked up to Carrie Donovan and introduced myself. "You wrote me a letter," I said, and reminded her that I had written to *Vogue,* inquiring as to who had discovered the model Pat Cleveland. Carrie had written me back and said it was she who had discovered Pat Cleveland on the Lexington Avenue subway, traveling to work one morning. The note was brief but beautiful, typewritten and signed in electric-green ink.

Carrie was warm and gracious, and told me to stay in touch. "And if you want to work in fashion, you have to come to New York," she said.

As soon as I arrived back in Providence, I made plans to abandon my studies at Brown and move to New York. I already had my master's but was working on my doctoral thesis, with plans to become a French teacher. While I'd been recommended for teaching positions at private schools up and down the East Coast, I was unable to procure a job. I was eager to see what awaited me in New York and in the world of fashion.

Reed had finished his studies at RISD and already moved back to Manhattan. He offered to let me stay with him until I got myself situated. In one large soft Louis Vuitton zipper satchel, I packed my most precious items: my navy coat, two pairs of velvet Rive Gauche trousers, two silk Rive Gauche shirts, and my first bespoke black silk faille smoking shoes, custom-made by Reed Evins himself. They were blunt-toed slip-ons, lined in flaming red.

Jane Kleinman's father wrote me a letter of introduction to the Costume Institute at the Metropolitan Museum of Art, where Diana Vreeland was hiring volunteers to assist with her curation of an epic exhibit: *Romantic and Glamorous Hollywood Design*.

The letter worked and I was hired, with no salary. I didn't care; I was going to meet Diana Vreeland, the grandest and most important

fashion empress! The famed editor in chief of *Vogue* for almost ten years! Considered to be one of the great fashion editors of all time! Running the Costume Institute was Vreeland's dream job and my own dream apprenticeship. It was highly selective; there were only about twelve of us.

My first day as a volunteer, I was handed a shoebox filled with metal discs and a pair of needle-nose pliers.

"Fix this," I was told.

"What is it?"

"It's the chain mail dress worn by Miss Lana Turner in *The Prodigal*. Mrs. Vreeland will be here shortly to inspect your work."

Left to my own devices, I laid out all the pieces and quickly figured out the complex puzzle pattern. Eventually I was able to craft the shoebox of metal back into a dress.

"Who did this?" Mrs. Vreeland asked.

"The new volunteer."

"Follow me," she said, and I did. We went into her office, where she sat down and wrote my name in large letters. "HELPER," she wrote underneath it, and handed the paper to me. "You will stay by my side night and day, until the show is finished! *Let's go, kiddo. Get crackin'!*"

Mrs. Vreeland spoke in narratives, in staccato sentences. You had to figure out what she wanted. The next dress she assigned to me was from *Cleopatra,* worn by Claudette Colbert. "You must remember, André, white peacocks, the sun, and this is a girl of fourteen, who is a queen. *Now get crackin'! Right-o!*"

It was a gold lamé dress. I spray-painted the mannequin the same color gold.

"*Right-o, right-o, I say, André!*" Mrs. Vreeland responded.

Over the next six weeks I became one of Mrs. Vreeland's favorite volunteers in what was really like a fine fashion finishing school. Through Diana Vreeland I learned to speak the language of style, fantasy, and literature.

I listened to and I learned from Mrs. Vreeland. I hung on her

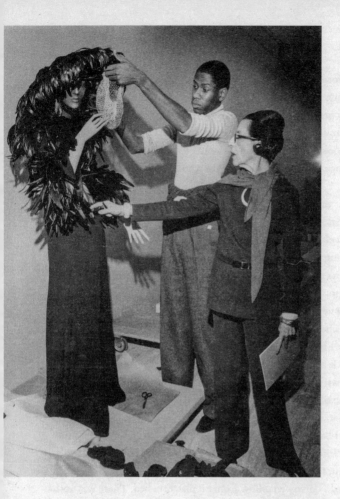

In 1974, my first year in New York,
I was a volunteer for Diana Vreeland
at the Metropolitan Museum of
Art Costume Institute. She and
I spoke the same language of style,
fantasy, history, and literature.
Here we are assigning silver hairnets
from Woolworth's to cover what
Mrs. Vreeland called the "hideous"
faces of the mannequins.
Photograph © The Bill Cunningham
Foundation. All rights not specifically granted
herein are hereby reserved to the Licensor

every word, every utterance. I towered above her physically, but I was utterly respectful and properly reverent, and she in turn treated me with great respect.

She must have loved the idea of my presence, the combination of my looks, tall and honey colored; my impeccable manners and grooming; and my blossoming unorthodox style. Plus my master's degree!

After the exhibit's opening night in December, I needed a job. I tried working as a receptionist at the ASPCA but it was too tragic. Mrs. Vreeland called me into her office late one afternoon, just before taking off for the Christmas holiday season.

"Don't go home to Durham, André!" Vreeland pronounced. "If you go home to the South, you will get a teaching job of course, but you will never come back to New York. It will happen for you, just sit tight and don't run home."

"But I have no money, I need a job!"

"Stick it out! You belong in New York. Do not go home for Christmas!" With that I was dismissed, and she was off to the beautiful home of Oscar and Françoise de la Renta in Santo Domingo.

Christmas Eve 1974 turned out to be one of the darkest nights of my life. I had no money, and I was sleeping on the floor of the studio of my friend Robert Turner, a fellow volunteer. He was out of town for the holiday. I slept on a horse blanket, found at a local thrift shop, and a borrowed pillow from his platform bed. There was nothing left in the refrigerator and not one cent strewn around for a greasy hamburger.

I opened the cupboards and found a can of Hershey's chocolate syrup, which I devoured with a fine silver teaspoon and followed with glasses of water to chase the thick, dense syrup down.

The phone rang at ten P.M. It was my grandmother.

"Ray"—she never called me André—"your father is here next to me. I am sending him to drive through the night and bring you home. You need to be ready, because he will be there tomorrow, on

Christmas Day. You come home. You belong home. You have never been away from home at Christmas."

I insisted I wasn't about to come home. Mrs. Vreeland had said it would happen for me in the New Year! Mama hadn't put up an argument when I left for Brown; why was she so adamant now?

So I asked her, "Why? Why do you want me to come home so urgently?"

Silence. Pause. Then she shouted into the telephone: "Come home, because I know you are sleeping with a white woman up there!"

That was the furthest thing from reality. I laughed out loud and assured her this was not the case. She uttered something and hung up the phone. I knew she was upset, but I had faith in Mrs. Vreeland.

During that long and lonely Christmas week, I visited Saint Thomas, an Episcopal church, often. There I would meditate and pray for my parents and my grandmother, and thank God for the gifts and opportunities I had been given. I was grateful to be in New York, even if my future was uncertain. I was confident that my faith and my knowledge would see me through, even if my stomach continued to rumble.

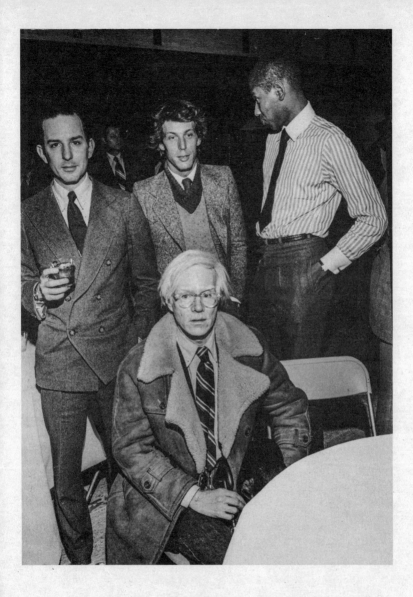

All staffers of Warhol's Factory and *Interview* magazine:
Fred Hughes, Peter Lester (center), and Andy Warhol,
seated at a Halston fashion show in 1975.

II

First thing in January, Diana Vreeland wrote letters on my behalf to every important figure in fashion journalism. Like a trumpet, with her booming voice, she built me up to everyone. Halston, Giorgio Sant'Angelo, Oscar and Françoise de la Renta, Carolina Herrera, all her friends; she never let up speaking on my behalf.

She also made sure I was invited to all the right parties, including Halston's legendary soirees, attended by anyone who was anyone in New York: Liza Minnelli, Martha Graham, Bianca Jagger, Elsa Peretti, Diane von Fürstenberg, and the entire Warhol upper echelon. I was there one night with Tonne Goodman, another favorite volunteer of Mrs. Vreeland's and a well-connected New Yorker herself. As we dragged along the pale-carpeted floors, Fred Hughes, right-hand man and business partner to Andy Warhol, came up to me. "André, do you think you could come to the Factory and meet with Andy and Bob? Diana Vreeland says we must have you work with us."

I of course said, "When do you want me? I'll be there."

The following Monday, I began my career as an assistant for Andy Warhol's *Interview* magazine. I moved off my friend's floor and into a small room at the Twenty-third Street YMCA, where I bat-

tled numerous cockroaches in the public showers, real ones and human ones.

Interview was a lean office, adjacent to the big Factory space, where Andy's loyal staff worked at a long makeshift desk in the open reception area. There was the elegant boiserie-paneled boardroom, where Andy took his lunch. His workspace, or his artist's studio, was the entire length of the floor, divided by a wall just behind the *Interview* offices.

Fred Hughes set the tone. He was the sum total of elegance, with hair like Tyrone Power and a definite snobbish Continental accent. Diana Vreeland loved him, and it was rumored that she considered him her beau.

The space was clean and light filled. Huge Jean Dupas art deco posters hung throughout. The whole atmosphere was lighthearted, but in a serious kind of way. We were expected to be at work on time and no one spent hours on the telephone social networking. My job was really just to be a glorified receptionist, buzzing visitors through the bulletproof steel door Andy had put in and taking messages for all the freelance talents. My duties, which included picking lunch up for Andy at the local health food store Brownies, started at twelve noon and ended at six P.M.

Everyone was freelance, so people were always coming in and out and you never knew who you were going to see on any given day. Fran Lebowitz made regular appearances. Her major bestseller, *Metropolitan Life,* had just come out. She'd walk in, very serious, chain-smoking, and ask for her messages. She was intimidating. A great intellect and succinct in verbal sparring.

No one messed with Fran. Not even Andy. Everyone was afraid she would torch the place. Metaphorically. Her grumpiness was part of her façade. Fran praised me, saying I was the only receptionist who took the job seriously and actually wrote down accurate messages.

Fred Hughes liked having society ladies flitting about the office, not doing much of anything. They served as ornamentation. Catherine Guinness, of the Guinness beer fortune, was working on a

piece exploring the underworld of sadomasochism with her gay friends. She would wear leather jackets to the office, playing around with whips and things like that.

Fred always wore bespoke everything, including tennis-stripe jackets and skinny jacquard silk ties. His shoes were polished, the way English dukes polish the same pair of shoes for decades until they become like soft gloves for the feet. Fred's apartment was decorated with first-rate antiques, and he let his house become a bed-and-breakfast for all the young ladies who wanted to be part of the scene. Some would stay indefinitely. Everything was kept in a state of pitch-perfect perfection, including Fred's highbrow fake English accent, hysterical considering he was from Houston, Texas. His mannerisms, his dandyisms, his snobbism were toxic to my budget but auspicious for my aspirations.

Casual dress was the regular uniform, which made it easy for me to create a distinctive imprint. I wore fine vintage topcoats, found in a local thrift shop on Fifty-fifth Street for ten bucks, and tweed trousers, never jeans, as I never felt comfortable in a pair of jeans.

Mrs. Vreeland would often take a taxi down to the Factory for lunch. On those days, sandwiches would be ordered from Poll's on Lexington Avenue: chicken on brown bread, and a small shot of Dewar's for Mrs. Vreeland, her healthy tonic. Just a shot glass at lunch and that was it. It was a different time.

One day, Mrs. Vreeland came to the Factory with Gloria Schiff, a great beauty and twin sister to Consuelo Crespi, Italian editor for American *Vogue*. I overheard them having a highly pitched debate: "Gloria, what do you mean you discovered Marisa Berenson at a debutante ball!" exclaimed the imperial Vreeland. It was, in fact, Vreeland who had put Marisa Berenson on the map, having seen her at Elsa Schiaparelli's house in Paris! Elsa was Marisa's grandmother, and Elsa never forgave Mrs. Vreeland for introducing her to the world of high-fashion modeling.

For all that I made seventy-five dollars a week; the social life that came along with it was surely priceless.

. . .

When it came time to assign fashion stories, I was the go-to fashionista in the office. My knowledge and passion in this area were recognized and I was quickly promoted to fashion editor. I now had the opportunity to interview some of the most exciting stars of society, fashion, and international jet-set acclaim, including Carolina Herrera, the elegant designer from Caracas, Venezuela, who later dressed Jackie Kennedy when she lived in New York. I did Carolina's first official interview, in a lavish spread.

Bianca Jagger was my favorite stylish subject. It was her time; she had wed Mick in the south of France, wearing an Yves Saint Laurent suit and a sweeping portrait hat with a veil. The Rolling Stones were playing at Madison Square Garden and Andy sent me to the Pierre hotel to pick up Bianca, and her wardrobe, and bring them to the studio to be photographed for a cover. Bianca answered the door and motioned to me to walk quietly. Mick was asleep. We tiptoed around the rock star to the huge walk-in closet off the bedroom suite. Quietly, we piled up her beautiful clothes and her favorite shoes that season, Charles Jourdan espadrilles on a high wedge sole. She had a half dozen of that same ankle-wrap wedge platform sole, in an array of colors.

All of this was packed in tissue and layered in extraordinary Louis Vuitton cases, unlike any I had previously seen. They were actually custom-made hunting cases, used to pack guns for grouse shoots. Because of the length, she could pack her Zandra Rhodes crinoline evening gowns flat, no folds, in these coffinlike cases. She had bought them in Paris, at the avenue Marceau Louis Vuitton store.

Bianca and I took a taxi, piled high with her Vuitton luggage. We bonded over our deep admiration for her friend the shoe designer Manolo Blahnik, and we went on to become friends.

. . .

When it came to having access to the elite echelon, Andy provided it, taking me everywhere I wanted to go, from dinners at Mortimer's to movie premieres in subway stations. I met everyone at some movie premiere—C. Z. Guest, Caroline of Monaco, Grace Jones, Arnold Schwarzenegger.

With Andy, anyone could be anyone and everyone was equal—a drag queen or an heiress. At the Factory, if you were interesting, you were "in." And while he could be seen out and about at night, Andy also went to church every morning to thank God for his life, his money, and his mother.

Andy could be naughty. He could also be vicious, but never to me. From time to time he would put his pale white hands in my crotch (always in public, never in private) and I would just swat him away, the way I did annoying flies in summer on my front porch in the South. Once, we went to see an afternoon movie with Azzedine Alaïa on the Upper East Side and Andy kept grabbing me. Every time, I would scream out, "Andy!" Azzedine was in hysterical tears. Andy was naïve; nothing he did offended me. He saw the world through the kaleidoscope colors of a child. He was a kind person, and I considered him a very dear friend, too.

When Andy was in a good mood, he created small, signed pieces of art for his staff. A silkscreen print from one of his series, or a small painting, like a candy heart in lace on Valentine's Day. It was a quite generous perk.

While creating his so-called Oxidation paintings, aka the "piss paintings," Andy asked me to participate.

Instantly I said, "No thank you, Andy." All I could think of was my grandmother, or my mother, or father, hearing about me. Peeing for art? It would have broken Mama's heart to think that although I was living a successful, adventurous life in New York, I was spending my time creating paintings with urine.

Andy also asked me to participate in the Sex Parts paintings. We were in *Interview* editor Bob Colacello's office and Andy said, "Gee,

André, just think, Victor Hugo is doing it. You could become famous, make your cock famous. All you have to do is let me take a Polaroid of you peeing on the canvas. And I will give you one as a gift."

Victor Hugo the writer is *not* whom Andy was referring to, but rather Victor Hugo the male escort, who was Halston's lover. Handsome, from Venezuela, notoriously well-endowed, and possessed of beautiful skin, he was also a window display artist for the Halston boutique and had apparently now somehow gotten a gig at the Factory, doing these outpourings of overt sexual exploration.

Was his name really Victor Hugo? No, of course not. There was nothing really remotely Victor Hugo about Victor Hugo. He never quoted the literary giant. He never spoke about him. He didn't subscribe to literary brilliance. But he did piss on a canvas for Andy Warhol, and his penis did indeed become famous.

Andy loved hanging around with Victor and often included him in his Factory workshop life. I knew him well, but I was not witness to his thrusting full, erect penises into his mouth in a working session with Andy, while others were going about their duties, putting out *Interview*.

As ghastly as it seemed, at some point Andy did indeed elevate pornography, or pornographic interests, through Victor Hugo. (For the record, I have no doubt: Andy never had sex with Hugo, except with his Polaroid and his art.)

Victor invented himself as an artist, as a disrupter, as a unique individual in New York's cultural mix. One of his Halston windows featured a hospital tableau, with a woman giving birth in a Halston dress. He once had a live chicken dipped into liquid the color of blood and left it alone to walk along the corridor, *the white-carpeted corridor,* of Halston's East Side Paul Rudolph townhouse. Just to "shock" Halston. It worked; he was shocked.

American designer Norma Kamali worked on Madison Avenue and befriended Victor. He would pass by nearly every day. One day,

Norma was draping a new swimsuit; the next day, the design had been leaked and ended up as a Halston original on page 1 of *Women's Wear Daily*. Norma confronted Victor, who responded like a naughty child, caught doing something forbidden.

Later, he was forgiven: Victor arrived in Norma's studio with a gift—huge surplus silk parachutes. She skillfully turned them into high fashion, jackets, shirred trousers, ball gowns, and jumpsuits, with the pull releases intact. Diana Vreeland later insisted they be included in her *Vanity Fair* Costume Institute exhibit. Norma turned defeat into victory!

One night around this same time, Reed Evins and I were house-guests of Calvin Klein at his home on Fire Island, in the elegant Pines section. We ended up sharing a bed, and as we were falling asleep, Victor came in and crashed on top of us. *Uninvited*. He fell asleep like a bear in winter hibernation. Reed and I, curious about the legendary size of his penis, pulled back the white sheet and exposed the family jewels, which Reed described as the size of "a Schaller and Weber salami." It was uncircumcised is all I remember. That night, we slept with Reed in the middle, Victor on one end, and me on the other.

In 1975, Karl Lagerfeld was already head creative designer at Chloé and perched to take his place at the top of the fashion world. Chloé had been a staid, bourgeois house for housewives who could afford good ready-to-wear in Paris. After Karl got there, Chloé became extremely influential. Grace Mirabella, who had replaced Mrs. Vreeland as editor in chief of *Vogue,* was married in a Chloé white turtleneck blouse, embroidered with pearls. That was a big thing—to pick a Chloé look, as opposed to an Yves Saint Laurent.

Prêt-à-porter, aka ready-to-wear, was taking off, and Karl always had a knack for delivering bizarrely innovative clothes that were unanimously acclaimed by retailers and press alike. He'd make

a print with robots and space mobiles and turn it into a $1,000 dress. His jewelry could be big plastic red roosters or chickens, or plastic Magic Marker–colored tulips on a necklace, over a luxurious foundation, like a black redingote wool coat, exquisite and expensive, made to last through generations.

The clothes were surreal and sophisticated, but most important, they were youthful and inspired. This was represented in Karl's approach to the Chloé fashion shows. They purposefully didn't have an assigned lineup of models and outfits. Backstage, Karl would tell the models to pick whatever they wanted to wear from the rack. That is unheard of even to this day, where shows are micromanaged down to the smallest details. After the show, he'd tell the models to keep the clothes they'd worn. They didn't make that much money at that time and this was a way of saying thank you.

Interview was planning a Paris-themed issue, and Karl was due in New York to promote his new Chloé fragrance. Karl had never been profiled for *Interview* before, and Andy suggested that I conduct the interview, for which I am forever grateful.

I did everything I could to prepare for meeting Karl. Serious research. I knew Karl was influenced by eighteenth-century French style and that he was emulating it in his own personal life. As a longtime Francophile I knew the basics, but I dug deeper to prepare. I read every interview he had done and researched as many of the references he'd made as possible.

When we arrived at the Plaza, we were directed upstairs to a large suite. I sat down across from Karl in the living room, my notebook ready. Members of Lagerfeld's entourage floated in and out of the bedrooms. Seated next to him was his boyfriend, the handsome and debonair Jacques de Bascher. Andy and Fred Hughes had accompanied me, as well as famed fashion illustrator Antonio Lopez and Juan Ramos, friends of Lagerfeld's who had just returned from Paris to take up residence in New York. Antonio was creating visuals for the Paris *Interview* issue. In previous years, Antonio's creative energy had helped drive Karl Lagerfeld. Now there was a noticeable

chill between them. I wondered what the story was but focused instead on what I had come to do.

Lagerfeld was bearded and dressed in a bespoke crêpe de chine shirt and a six-foot-long muffler. I had on khaki Bermuda shorts, a pin-striped shirt and aviator glasses from Halston, knee socks, and moccasin penny loafers. We spoke about the eighteenth century: the style, the culture, the carpets, the people, the women, the dresses, the way the French entertained, set a table. It wasn't labored or anything especially deep, but I learned a lot in that conversation and was grateful for the knowledge.

"Fashion's fun and you can't really take it too seriously. Frivolity must be an integral form," Karl said to me. As we spoke, Antonio drew us, while Juan directed him on the right position and attitudes to convey. Andy and Fred sat quietly, the minutiae of proper attire in an eighteenth-century court likely going right over their heads. How exhilarating, being able to prove myself to Andy and his team as they sat quietly and listened. Karl seemed impressed by my desire to learn and gave me a great interview. My Southern manners helped, I'm sure. It would be easy to imagine how cocky and brash a young editor at *Interview* had the *potential* to be.

Afterward, we all had high tea. The whole thing was so elegant. Then, quietly, Karl asked me to follow him into his private bedroom.

Andy smiled widely and shyly, as though he couldn't imagine what this was. I smiled too, nervously. I could imagine, but I was trying my hardest not to.

I followed Karl into the huge bedroom, crowded with Goyard jacquard trunks and suitcases of every possible size and dimension. He opened the trunks and, out like a geyser spitting forth toxic ash, he threw beautiful silk crêpe de chine shirts in kelly green and pink peony, each with a matching scarf.

"Take this. It will look good on you. Take that. I am tired of these shirts! You should have them." He'd had these shirts specially made by the gross at the Paris firm of London haberdashery Hilditch

& Key. They had long sleeves and beautiful buttons, like smocks. I took them happily.

Those shirts were the stars of my wardrobe; I wore them like a badge of honor, until they wore out. That's how Karl and I first met. We would stay friends for forty years. Until we weren't.

III

Andy poached Rosemary "Armenia" Kent from *Women's Wear Daily* (*WWD*) and made her editor in chief of *Interview*. Rosemary lasted about a year, but Mr. John Fairchild, whose Fairchild Publications owned *WWD,* held a grudge for much longer. A mandate had been handed down—no pictures of Andy or Fred would run in *WWD*. Everybody from *Interview* was exiled.

John Fairchild, the king of fashion journalism, the master of *WWD,* and the inventor of *W,* could be cruel. Downright blood-thirsty. His rancor was all-consuming. For example, Valentino, early in his career, gave Rosemary Kent exclusive access to cover his vaca-tion. Subsequently, Valentino decided not to invite her back. For that, Valentino and his partner, Giancarlo Giammetti, were air-brushed out of photographs at parties. If Mr. Fairchild couldn't get Valentino's face out, he would resort to assigning the generic label of "an Italian designer" to the caption.

Carrie Donovan, who was now the fashion editor of *The New York Times,* called me and said I should get over to *Women's Wear Daily*. There was an opening. I was interviewed by *WWD*'s Michael Coady on a Friday and was offered a job as fashion accessories editor,

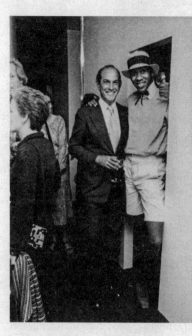

With Oscar de la Renta, in his showroom. Back then, I didn't have a lot of money for fashion. I wore Bermuda shorts and knee socks to make my style statement. That hat is by Karl Lagerfeld and the shirt also. We are drinking white wine, which was served after fashion presentations in the Golden Age of Fashion.

covering scarves, belts, earrings, jewelry, and ancillary social night-crawling of New York fashion society.

The following week I started at a super salary: $22,000 a year. A massive leap from my $75 a week at *Interview*. I called my grandmother, my mother, and my father to share the good news. They were extremely happy, even if they didn't quite understand what my job was.

Mr. Fairchild poached me, his revenge for losing Rosemary Kent; that's how the fashion world runs. I'd worked at *Interview* for eight months and experienced some incredible moments in that brief tenure. I was grateful for everything Andy had done for me, but I knew this was an opportunity I couldn't turn down if I wanted to pursue a career in fashion journalism. While I knew it might anger Mr. Fairchild, I planned on staying friends with Andy, knowing we would have to keep it on the down low if I wanted to keep my new job.

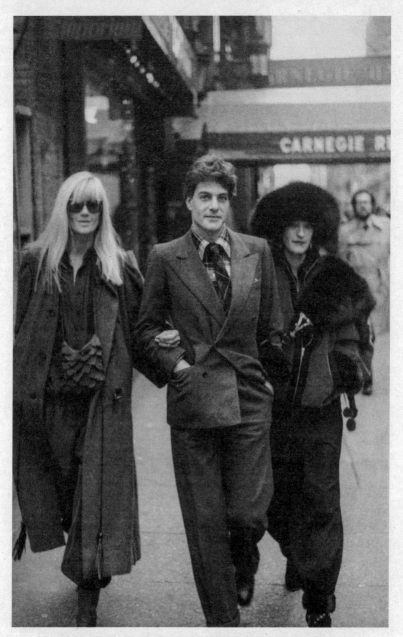

Photograph by André Leon Talley for *WWD* page one. Betty Catroux, Thadée Klossowski, and Loulou de la Falaise in New York.

My first day at *WWD,* I arrived confidently wearing my hand-me-down silk tunics and mufflers from Karl, with a Fruit of the Loom T-shirt and gray custom-tailored glen plaid trousers, with zoot suit–sized cuffs and wide hems. Mr. Fairchild didn't say hello or acknowledge my existence. I would have to earn his greeting.

WWD was considered the fashion bible by most, which therefore made Mr. Fairchild a kind of god. He could destroy a designer by refusing to cover them. Pierre Bergé, Yves Saint Laurent's business and life partner, would pick Mr. Fairchild up himself at the airport when he came to Paris. No chauffeur-driven ride would do. And Saint Laurent always gave Mr. Fairchild an exclusive private preview of his collection. For some (Bill Blass, Saint Laurent, Oscar de la Renta), Mr. Fairchild was a kingmaker. But many others (Geoffrey Beene, James Galanos, Pauline Trigère) had long-standing feuds with him, and their careers suffered because of it.

He was cruel and vicious to the late Marie-Hélène de Rothschild, the undisputed social queen of Paris. Marie-Hélène, always elegantly dressed in Saint Laurent or Valentino couture, suffered from a rare debilitating disease, resulting in crippled and deformed hands. It was savage, his personal revenge. Maybe she snubbed Mr. Fairchild at some grand Paris social gala; who knows? For his revenge, he had her body printed on page 1 of *WWD,* with her face airbrushed out and her deformity in clear view.

During my first few weeks at *WWD,* I was receiving handwritten letters from Karl Lagerfeld in Paris almost every day. We had bonded during our interview and now kept in touch regularly. Surely that would have gotten Mr. Fairchild's attention, but still, he did not acknowledge my presence.

Finally, nearly two months after I'd started, Mr. Fairchild started asking me about who I'd seen the previous night, what parties I had attended. He eventually realized I had something to offer and could analyze, report, sum up, and write clean copy, fast. I had no choice. We had daily issues, and content needed to be generated to fill the

pages. It was a major newspaper under the leadership of John Fairchild, who had inherited it from his father.

"I am the boss, and don't you ever forget it," Mr. Fairchild once said to me as we sat together on the front row in Paris, during haute couture. While he could be intimidating and threatening, I still had so much respect for him. He taught me how to analyze the beat of fashion and the rhythms of the high rollers, the social doers and achievers of the fashion battlefield. "I don't give a damn about clothes, I care about the people who wear them," was a phrase he oft repeated. From him I learned how to embrace what was going on around me in 360 degrees. What makes a beautiful dress? Hems, seams, the way it's put together. The ruffles. How's the ruffle? How's the bow tie? What's the combination of colors, what's the combination of fabrics? There's Mounia on the runway, in what? What was Yves's inspiration? What is the music behind her? And what is the chandelier behind her? And there are roses, why are they there? Why is she wearing that shoe? And what is the lipstick? What is going on in the mind of the designer? That's my role, taught to me by Mr. Fairchild.

There was no set standard of writing style at *WWD,* not like *The New York Times* with its manual that all reporters had to follow. We wrote at a brisk pace, hoping it was all up to Mr. Fairchild's standard. People at *WWD* were thrown in the tank and sank or swam, and I just happened to swim.

My first reporting assignment was to cover a party given by Diane von Fürstenberg. She was married to Prince Egon von Fürstenberg. They were the current "it couple," appearing on the cover of *New York* magazine. I stood outside of her apartment, having not been able to score an invite to the actual party, along with a bunch of other journalists and photographers. I wore a silver asbestos fireman's jacket as an evening topcoat as I jotted down the names of all the various people going into the party. I recognized almost everyone; that's the kind of knowledge I'd gained from reading every issue of *Vogue* since I was a child.

I soon made it from the sidewalk to the sitting rooms of the plush homes of the fashion elite as they began inviting me *into* their parties. *New York Times* fashion editor Bernadine Morris wrote about my attendance at a party thrown by Calvin Klein: "André Talley, reporter for *Women's Wear Daily,* wore white Bermuda shorts with a striped high-collared Victorian shirt. Mr. Talley kept telling people that the initials on the pocket were not Kenneth Lane's but Karl Lagerfeld's."

It was the first time my name appeared *in* a fashion column.

I assume my Southern manners were considered appealing, paired with my knowledge and sense of style. Halston had already gotten to know me quite well from my time at *Interview,* and he invited me to his house often. He dressed me in his beautiful old cast-offs, as I was tall and thin, with the same measurements. Thanks to Halston, I had incredible cashmere sweaters, summer smokings, and five or six Ultrasuede safari jackets that could be thrown in the wash and come out of the drying machine looking perfect, no wrinkles. Halston even sent over an antique Chinese chest, which I used to decorate my room at the Twenty-third Street Y.

Mr. Fairchild saw in me, as Mrs. Vreeland saw in me, that I loved fashion. And for that, a great deal is owed. And after being assigned to write about the legions of friends of Mr. Fairchild, I started to become friends with many of them myself, including the de la Rentas, who took me under their wings like I was an orphan child. When Oscar de la Renta presented his collection, in his narrow showroom, I would be seated on the front row beside Françoise (his first wife). On the other side would be the guest of honor, Diana Vreeland one season, Pat Buckley or Nancy Kissinger another.

During an August resort collection, Françoise turned to me and said, "Now, DéDé, you know Oscar and I are going to build a pool at our country house, in Kent, Connecticut. Don't you want to be invited to swim in that pool when it's completed?"

I smiled politely as though I hadn't quite heard her blatant quid pro quo over the preshow musical arrangement. I never shared that exchange with Mr. Fairchild. The de la Rentas would have suffered.

Mr. Fairchild fueled his viciousness with the details of the parties his editors had gone to the previous evening. I once told him Maxime de la Falaise, a French high society transplant, had complained that Oscar and Françoise de la Renta's shih tzus had remarkably bad breath. Mr. Fairchild immediately went to his desk and phoned Françoise, to share what I had just told him.

This caused a major scandal. Mr. Fairchild was amused. I got on the phone and told Maxime what had happened, and she asked me what to do. I told her to call Mr. Fairchild directly and ask him what to do. He recommended Maxime send along something special, like her homemade preserves or jelly. She did, and the whole thing cooled off.

I still went out with Andy Warhol sometimes, but I would never tell Mr. Fairchild. He would have been livid. The friendships I made at *Interview* proved useful and beneficial for Mr. Fairchild's paper, however.

Bianca Jagger was in New York and invited me to see her at the Pierre hotel. With her was Betty Catroux, one of the permanent icons in the pantheon of Saint Laurent androgynous style. The three of us talked while Bianca ironed her Valentino couture clothes on a board set out between the two twin beds in her room.

The next time Betty came to New York, she called and asked if I'd go shopping with her after lunch. Shopping with *the* Betty Catroux, the woman who inspired Saint Laurent's pantsuits? How glamorous.

Or so I thought.

"Meet me at Woolworth's, I have to buy T-shirts," Betty said.

As we strolled the Woolworth aisles, I discovered the same hairnets my grandmother wore. Three for twenty-five cents. *How fantastic,* I thought. *World-renowned Betty Catroux, who could freely wear whatever finest-quality designs she wants, buys her clothing from the same place my grandmother buys hairnets!*

"Why on earth do you need these Woolworth shirts?" I asked Betty.

"I have to break down the elements of my Saint Laurent couture suits."

Totally matter-of-fact. All of the beautiful Yves Saint Laurent couture pin-striped suits, Betty wore with T-shirts she bought as a pack of three. Most women would wear a pussycat-bow blouse, but Betty Catroux couldn't have cared less about what "most women" would do. It was a very original way of thinking at the time.

Betty met Yves in 1967 and it was like lightning. She loved to tell people, "He cruised me in a nightclub." It began a close brother-sister bond; Yves and Betty, attached at the hip, were the closest of friends. Never officially on the payroll, Betty abhorred fashion. Refused to be a slave to the rhythm of *la mode*. She had worked as a *cabine* model for Coco Chanel herself for two years but hated every minute of it. Of the great lady of twentieth-century fashion, Betty told me, "She was a viper, a mean viper. Yves was also mean, two fashion dictators who found everyone else atrocious."

Be that as it may, Yves wanted to *be* Betty Catroux. Once they got together, she forever became Yves's surrogate and alter ego.

Betty always dressed, impeccably, like a man. Tall and lean, throughout her entire adult life. She has never slipped into a full, sweeping evening dress, as best I can recall. She simply refuses. For the grandest ball in Paris, she would ring up the house of Saint Laurent, as she did every day in Yves's lifetime, after which a little black van with the YSL logo would arrive at her apartment and drop off the look she'd selected, and the same van would pick up the original sample the next morning. This was her routine every day of her life when cocktail or dinner dressing was required.

Betty Catroux is the ultimate rogue, always in vogue. She never wears color, not even red. No prints, ruffles, or flounces. She loves everything black except for those ubiquitous white T-shirts. If she could wear a black leather jacket or biker-style look every day, she would. No jewelry adorns her neck, nor her ears. Her only great accessories are her long, long sheets of platinum hair, airborne once

she hits the dance floor. Betty dances like a dazzling rock star in high-gear performance mode.

At times, her look could be interpreted as somewhat "butch." Marlene Dietrich and Katharine Hepburn had already been credited with creating androgyny, but with Betty, it existed spiritually and sartorially. Yves was inspired by Marlene Dietrich, who had gone to her husband's Austrian tailor to have her pantsuits made for her. But Yves was more directly inspired by Betty and her effortless, impeccable style. With the master touch of Yves, Betty made the evening or le smoking pantsuit an international and global fashion trend. She was, and remains, one of the most influential personalities in high fashion. So many women and men—gay, straight, gender fluid, and transgender—and designers owe much to the Betty/Yves female-dandy style.

Most of the fashion elite, including the top-tier designers—not the established designers, like Bill Blass, Oscar de la Renta, and Ralph Lauren, but the new wave of designers—were working, loving, and living on a regular diet of cocaine, then the drug du jour. Everyone was high on coke and cock.

Halston thrived on it. He was known to partake and afterward stay up and change a whole collection overnight. Presto: a masterpiece. I remember billowing, long grand taffeta evening dresses, floating away from the body, worn over Lycra one-piece leotards. The great Scottish photographer Harry Benson shot them for *W,* and they are some of the finest illustrations of American high style of the era.

If I went to Françoise de la Renta's house for dinner, and said I had been to Halston's, she would tell me that was "the wrong crowd."

She of course was right. Halston used to have me over for dinner, just the two of us, and he would serve a baked potato with caviar and

sour cream. For dessert: a small mountain of high-class cocaine served in an Elsa Peretti sterling silver bowl.

I snorted a line or two, to be polite to my host, and that was it. I never wanted to feel out of my sphere of control. My destiny was not to be hooked on coke. I feared God and my "ancestors as foundation," to quote Toni Morrison, always lived invisibly on my shoulder.

My only addiction was pure Russian vodka, which I usually drank in Diana Vreeland's red seraglio. We were always two, elevated by conversation, drinking small shots, one after the other, after dinner, in her dining room. I often left her apartment on weekends at three or four or even six A.M.

I managed to master social nuances between the old guard of fashion, like the de la Rentas, and Halston's new wave of partying. I glided through this world with extreme caution and my usual armor: my fashion choices. Banana cable knee socks and elegant moccasins. Or Brooks Brothers penny loafers. Neckties, my Karl Lagerfeld castoffs, and Turnbull & Asser shirts. I never spent a dime on drugs. My money was spent on luxury. Massive bouts of high-end retail shopping.

In this, Manolo Blahnik and I were kindred spirits.

Manolo Blahnik, the sum total of human genius in designing shoes for women, invited me to Fire Island one weekend. He arrived with matching sets of Louis Vuitton cases, filled with matching sets of tone-on-tone Rive Gauche shirts and custom-made linen trousers. If he wore a cerulean shirt, he had cerulean linen oxfords. If he wore a geranium-red silk Mao Rive Gauche shirt, then he of course wore matching Fred Astaire linen oxfords.

We went to a pool party where they spiked the punch with something, causing us to have nonstop fits of laughter for nearly fourteen hours. We took a walk along the beach, he in his matching look, me with a big panama hat, a huge Japanese parasol, and a black and white oversize cashmere blanket, wrapped over me like a pareo. We were quite the pair.

The half-nude men in thongs and Speedos near the surf kept screaming at us, laughing at us. "Get off the beach, you faggots. This isn't the beach for you!"

Next we sauntered off to the woods, as we heard that was where men gathered in full view, to have group sex. There, under a tree, was a circle of men wearing leather chaps and nothing else, participating in group masturbation. It made us both burst out giggling, which caused the participants to boo and hiss at us until we left.

While I enjoyed checking out the scene under the influence of whatever I had been exposed to, when it came to sex, I was repressed. It was a conscious choice I had made. Sex confused and bewildered me. In respectable Southern black households, it was simply not discussed. Physical intimacy of any kind was kept to a bare minimum. I can remember only two times in my childhood when my grandmother hugged me: The first time, in my early teens, was when I had an asthma attack. Then once again, when I was sick, lying on the sofa, she walked over and pulled up a throw blanket to my neck, and hugged me. Mama was not demonstrative of her love, not on a daily basis. She was loving but also stoic, strict, and severe. Too busy washing, ironing, preparing chickens, doing all the daily routines of a humble domestic maid who was also, in essence, a single mom to me.

I grew up with no inkling of what physical intimacy was, my parents long divorced and my grandmother widowed. My interior monologues about romance and love were confused. My only crush, like many others', was on Anne Bibby, our high school homecoming queen. While I was in college and at Brown there was no one, no sexual interludes. But in New York sex was impossible to ignore; everyone was doing it and everyone was talking about it. And that forced me to come to terms with something I had long tried to forget.

During my childhood years, my innocence was shattered by a man who lived on the next street. His name was Coke Brown, or at least that was his nickname in the neighborhood. He lured me into the woodshed, directly underneath my wood-framed house, in the

damp, dark earth, where he proceeded to take advantage of my youth and my naïveté when it came to sexual encounters. Afterward, as he zipped up his fly, he said, "This is our secret game."

Was this happening to all the boys my age? I had no idea. I thought this was supposed to happen, and it did happen over and over again, in the dark place, often in daylight. Coke Brown was the first. He must have shared his conquests with others in the neighborhood. A series of older brothers often lured me into their woodsheds as I played innocently with their younger siblings.

Confused and deeply afraid of being discovered, I went about my daily life as if these dark games didn't exist. As they progressed to frequent interludes, I retreated into my own world of silence. I couldn't dare tell my grandmother that I had been under the house, in the dark, with a grown man. She would have been devastated, and I would have been shamed. I feared that telling my father, a wonderful man who loved me, would be wrong, and that I would possibly be blamed and sent away to some sort of sanatorium as a result. Or I would be brought before the church deacons and censured, which equaled exile. I felt I had no choice. I kept it all to myself. I simply pushed through the pain and betrayal in silence, never having counsel or seeking psychiatric help. I felt my childhood traumas were little compared to those of the rest of the world.

What saved me from my shame and silence was the sanctuary of church and the sanctuary of my grandmother's house. But this dark zone of trauma consumed me and stunted my emotional evolution, until I sprouted up like a bean stalk and left for college, far away from my abusers. Somehow, I grew up, and eventually I realized there were others who had experienced the life I had secretly lived.

I survived the destruction and taking of my innocence, though I know it is the cause of many of my personal issues as an adult. The hard drive in my brain was scrambled early on. It kept me from ever knowing how to respond to romance. All I ever wanted up until that point was the approval of Diana Vreeland, Andy Warhol, and John Fairchild.

I shied away from dipping my fingers into the decadent, hedonistic cauldron of New York City, but I enjoyed hearing about it. One person I could always depend on to make me blush was the famous Picasso expert John Richardson. The darling of all of Park Avenue, he was a dashing figure of aristocratic provenance and a close friend of Paloma Picasso and Maxime de la Falaise, as well as Françoise and Annette de la Renta (Oscar's second wife) and Mica and Ahmet Ertegun. He moved in the best tone-on-high-tone circles. Yet he would tell me debauched stories about his Saturday afternoons at the West Village hard-core club the Anvil, a gay leather bar for men who preferred their sexual pleasure in harnesses, leather chaps, and slings hung from the ceiling. I sustained a long, long crush over the decades on Sir John Richardson. While I never told him about my feelings, his gaze remained intense. We remained good friends until his death in 2019.

Sometimes I'd go to the Anvil or another of these dens of S & M, as a fashionable last-minute visit after a night out on the town. One night, I went with Andy Warhol and Rudolf Nureyev. A black man in crotchless leather pants sidled up beside me and I accidentally made eye contact with him. He began making gestures, rubbing his arm, from his elbow to his wrist, and nodding.

"What is he doing with his hands?" I said.

"He is trying to seduce you," Nureyev said. "He wants you to anally fist him in the back room."

Wearing matte jersey by Scott Barrie, a necklace made from a metal pipe on a grosgrain ribbon, and my Rive Gauche velvet trousers, when I was told this, I shrieked and ran toward the door.

Studio 54 was more my scene, where everyone danced with everyone. People just navigated from one end of the dance floor to the other and danced with total strangers. I would head to Studio 54 four nights a week, making sure I got to work at WWD by nine-fifteen the next morning. I was at the apex of my good-looking young self. And although I had just barely escaped the segregated Jim Crow South, I had style and attitude. I could shine with the best of them in sartorial splendor and élan.

Often one danced alone; it was all good in the neighborhood. No one judged you. When I was not alone, my three favorite people to dance with were Manolo Blahnik, John Richardson, and Loulou de la Falaise, accessories designer and muse of Yves Saint Laurent (honorable mention goes to Diana Ross, with whom I danced one night in her Saint Laurent dress, dipping her head within inches of Studio 54's parquet floor).

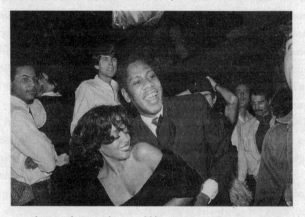

Studio 54, where anything could happen. Diana Ross is wearing a velvet and taffeta evening dress, from YSL's opulent Russian collection of 1976. I loved to dance and I loved that moment, that great fandango dip of Diana Ross.

Loulou had come to New York along with the rest of the Saint Laurent group. Saint Laurent had created the masterpiece of his career, the Russian collection of fall/winter 1976. Loulou could borrow anything she wanted. I first met her at her mother Maxime de la Falaise's annual New York Christmas party. Loulou wore a giant faille silk twill, with a full sweep of skirts hinged on inset velvet hip bands, rigged with silk tassels and passementerie, and with contrasting silk petticoats underneath. And the accessories: rows and rows of

rock crystal and pearls, as well as exotic Turkoman silver cuffs and gold high-heeled sandals.

Loulou was like a pied piper. She was the catalyst for Yves and his life/business partner, Pierre Bergé, to go out and have a good time. When Loulou and the YSL clan—Yves, Pierre, Betty Catroux—would hit New York, all of fashionable Manhattan took notice.

Loulou was a rag doll in my hands when we danced at Studio 54. I'd toss her high up in the air and way down to the ground. Then Sir John Richardson, in a bespoke chalk-striped lounge suit, would dance up to me and fling me as far and as firmly as he could in his arms, in a vortex of French Apache-style dancing; just the two of us, in a make-believe world. Cool as a cucumber, no language shared, no furtive obscene gestures, just good old-fashioned fun. I loved every second of it!

During the holiday season, Paloma Picasso came to town and installed herself in a suite of rooms at the Waldorf. She got a limousine, and her entourage would sardine itself into the stretch on our way to a marathon of clubs. Eventually, Loulou and I would drop Paloma and her boyfriend off, and she'd let us hang on to the limo. She didn't want to go to the after-hours bars we went to, not dressed in YSL! We'd go to Mineshaft, Eagle's Nest, decadent places. I was out with Loulou, cruising in Paloma's limo, and we stopped into a dark, happening place in the Meatpacking District. No one would talk to us. Women, especially those in couture YSL silk taffeta and high gold sandals and ropes of rock-crystal beads, were not welcome in this dark cave of louche and deviant sexual pleasures.

Suddenly, a man stood on top of the bar and started urinating on revelers below him. I screamed out to Loulou, "We have to leave, my *peau de soie* dinner slippers Reed Evins made for me are going to be splashed by a stranger's urine!" The men hissed at us as we left but we didn't care. We were having too much fun.

. . .

A few months later, I received an invitation to Loulou de la Falaise and Thadée Klossowski's wedding, which would take place in Paris. *WWD* let me go; what could they do, I was invited to the ball! But I had to pay my own way, in coach.

Loulou and Thadée's marriage was all the scandal. Everyone knew that Thadée, the handsome son of Balthus, was the longtime boyfriend of Clara Saint, public relations directress of Saint Laurent Rive Gauche. That was a powerful position. The chic Clara Saint was always something of a recluse, but now she was in social Siberia. Still, she kept doing her job. She had to; her money was gone.

Yves and Pierre Bergé threw the wedding party for Thadée and Loulou, which surely complicated matters. One hundred thirty invitations went out. I got one, but Clara Saint did not.

Karl Lagerfeld also received an invitation, and asked me to go with him. Not as a date, but as a buffer. Few people could navigate the social circles of both Karl Lagerfeld and his rival Yves Saint Laurent. Paloma Picasso was able to do it, and somehow, so was I.

The wedding party was held outside, on an island in Paris's Bois de Boulogne. There was a definite awareness that Karl was there with me and not with his boyfriend, Jacques de Bascher. Yves was mad for Jacques and constantly begging Karl to give the handsome young man up. Perhaps Karl could be persuaded to exchange Jacques for a tapestry or something? Everyone knew Yves was madly in love with Jacques and hopelessly bitter. None of this was talked about, but it was known. In French they call it *frisson*.

Karl and I spent the night seated and snobbish. We didn't interact with others; very grand. Yves spent the whole night high, redesigning the Zandra Rhodes ball gown Bianca Jagger was wearing. He pulled fresh ferns off the bushes and pinned them right on her ball gown. Bianca stood in quiet agony and let him do it. Yves had a huge, monstrous ego, as big as anyone's. No one said no to him.

Everything at the ball was correct on the surface, but once the drugs came out, people were off having sex in the woods and getting

into other kinds of debauchery. Karl and I wanted nothing to do with it; we left early.

The next morning I flew back to New York. It was midsummer and I was still settling into a new apartment, on East Fourteenth Street. None of my lights worked, which meant I must have forgotten to pay my electric bill before I went to Paris. It was too hot to go out, so I went to sleep in the heat.

Not until the next morning, on my way to work, did I realize this was a major blackout due to the heat, one that is still referred to as the blackout of 1977. Didn't matter. All I cared about was my work. I walked down to the *WWD* office on Twelfth Street and got my next assignment.

Sauntering down Fifth
Avenue in a Savile Row
Huntsman bespoke suit, in
December 1986, I believe.
Photograph by Arthur Elgort

In the Tuileries garden, April 1984, telling Bill Cunningham to take a picture of something that caught my eye. The coat is silk wool Perry Ellis. The hat is vintage.
Photograph by Arthur Elgort

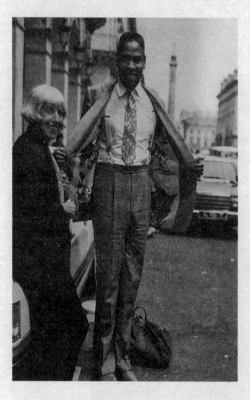

With Bernadine Morris,
of *The New York Times,* on the rue
de Rivoli in Paris. My jacket lining
is made from three full Hermès
scarves! I wonder where that
suit is now? In some attic?
*Photograph © The Bill Cunningham
Foundation. All rights not specifically granted
herein are hereby reserved to the Licensor*

IV

Marian McEvoy, the bright and attractive longtime *WWD* editor in Paris, was returning to New York to be a fashion editor at *The New York Times*. After three years honing my skills at *WWD* in New York, it seemed to me I was the perfect candidate to replace her in Paris.

Mr. Fairchild and Michael Coady, my biggest supporter at *WWD*, devised a final test before they offered me Marian's job. While everyone else on staff went home for the Christmas holiday, I was put in charge of the entire upcoming "In and Out" issue. A concept Mr. Fairchild himself created, "In and Out" was one of the most popular issues: It proclaimed who was *in* because they looked great, and who was *out* because of some flaw, or maybe some spat with Mr. Fairchild.

For one whole week, I sat in the conference room alone and edited the pictures and layouts, making all the choices by my personal instincts. Mr. Fairchild and Mr. Coady came back and approved the entire issue, with no changes or edits. And just like that, I was promoted to Paris correspondent of *WWD*, which meant a massive jump up the masthead and an all-expenses-paid relocation to Paris, France.

A fortnight later, I left New York with thirteen mismatched suitcases. *WWD* put me up in the best duplex at the Hôtel Lenox, a modest Left Bank place on rue de l'Université, only three minutes up the street from Karl Lagerfeld's grand and luxe apartment in the famous landmark Hôtel Pozzo di Borgo.

Upon arrival, on a cold January evening, I dropped off my luggage and went straight to meet Karl at his flat. We then took a taxi to La Coupole, a trendy bistro known as a fashionista hangout. A dinner was being thrown in my honor.

That night, I put on a veneer of sangfroid, while I actually felt quite unsettled by the sudden new life I had agreed to adopt. On one side of La Coupole was Karl's camp, most of whom were supplemented financially by Karl to every degree: Anna Piaggi; her boyfriend, Vern Lambert; Jacques de Bascher; and Karl's expert curator for French antiques, Patrick Hourcade. Across the way, on a banquette, sat Betty Catroux; Loulou de la Falaise with her husband, Thadée; Baron Eric de Rothschild; and Yves Saint Laurent. Neither side openly registered the other's existence, though they loved to sit across the aisle and gaze at each other over sauerkraut and frankfurters or steak tartare. Karl and Yves had once been friends, long ago, but now there was that ongoing *frisson* between them. All over the affections of the handsome French aristocrat Jacques de Bascher. It was like the War of the Roses. The court of Versailles.

Like a fusillade, I fired off into the uncharted domain of YSL versus Karl Lagerfeld. Somehow I felt at home with these newfound friends. All the principals were gay, something that was understood and never discussed. In this world, there were no victims, only high-octane egos.

I had arrived in Paris just in time for the January 1978 couture collections. There was work to be done. As soon as I unpacked, I went to preview Yves Saint Laurent's collection. I was lucky to be there to witness its making, as it was perhaps the last great collection Yves created in his life.

Over the course of three previews, Yves showed me several pieces

and talked about the inspirations and the fabric selections. He told me he listened to Gershwin's Southern black opera *Porgy and Bess* in his VW on the way to work and was inspired, based on his vision of black style and life in the segregated South. "I have simply transformed my classics through *Porgy and Bess,*" Yves told me for *WWD*. I arranged a photo shoot to put in *WWD* in advance of the collection. A teaser, like showing a soufflé before you've finished the main course.

This YSL haute couture collection was my first big show. I was on the front row and center, in the Napoleonic gilt ballroom of the Hotel Intercontinental. A runway was built that was about four feet up from the ground, with a huge arch of luxuriant Casablanca lilies arranged for the models to walk through. Classical music played as everyone took their seats. *Vogue* editors were situated front row on the right, near the windows. Yves's favorite friends, like Betty Catroux and Catherine Deneuve, were seated on the opposite side from me. Prestigious clients, like São Schlumberger, were also front row, with the supreme views. I entered dressed in my best Sunday tennis-striped suit, armed with my mental agility to look at, and sum up, the total essence of what was special about this incredible world. I walked with enough confidence for ten men. Underneath my groomed veneer, I was silently thanking God I had gotten to this point. To me, this was supreme happiness.

The classical music stopped, and the music of *Porgy and Bess* floated from backstage. "*Summertime and the livin' is easy*" resonated with me in the deepest core of my being. Then came the models. I had to look up as the models paraded past, walking on fine beige linen. The heels and the hats caused the models to tower right up to the tips of the Napoléon III crystal chandeliers that went down the center of the ballroom. Kirat Young, an Indian model of great elegance, glided down the runway in her draped satin blouse and wrap skirt and mannish wool tailored jacket. Mounia, a gorgeous black model, floated in pale peony-pink wool, a trouser suit with the pants cropped high above her ankles. The show left me inspired!

The collection was a strong marriage of the *flou* (soft) and *tailleur* (tailored) techniques. John Fairchild had dubbed this the Broadway Suit collection, because it was daring, showing ankles with cropped, tailored, mannish suits and soft, fluid, floating chiffon blouses, rakish silver straw boaters, and ankle-strap high heels. These clothes called to my mind the way my aunts and my cousins dressed going to our family church on Mt. Sinai Road. Every Sunday was an unofficial fashion show. My sense of style was anchored in the women I observed in church, so this struck me as especially fascinating. Yves had never actually been to the American South, but he had captured the attitude of the clothes. There was a boldness about the colors, about the contrasting fabrics, and the way the YSL girls wore their hats was with *attitude*.

Watching the show on the runway, with the inside knowledge of Yves's inspiration, felt like the final step in understanding the deeper artistic nature of true fashion genius. After the show, I went to the office and wrote the most brilliant review of my youthful career. I titled it "YSL: At his most influential." I wrote, "YSL strutted out Broadway, City Lights, Bourbon Street and big-time jazz in a couture collection that is certain to be one of the most influential he has ever done."

It was nearly midnight, and I sat there alone, typing from memory and emotion on an old noisy telex machine and sending the copy off to New York. I fell into the backseat of a cab, exhausted but with butterflies in my stomach—not from nerves, but from the immense excitement I had witnessed. I was part of fashion history, working for a company that wanted my point of view and my opinion. I knew I would wake up the next morning and have Betty Catroux on the telephone, as well as Karl Lagerfeld, eager to know what I saw and felt at the YSL show. My heart was beating in continued exhilaration. This was what I had dreamed of, but I had never dared to believe I would be in this exalted position so young, so naïve, so innocent. I had arrived in a place where I was accepted and where I

now belonged. My blackness was not important. What mattered was that I was smart.

The next day, my review of Yves's show was on the front page, and it was a smash. Yves said it was one of the best critiques ever written about his shows. Diana Vreeland sent a telegram exclaiming the virtues of my recent work, the Broadway collection review especially. Mr. Fairchild was so pleased that he promoted me again, to European fashion editor of *WWD* and *W*.

I walked alone those first moments, never showing how insecure I felt. My cool posturing would serve me well. I was tall, thin, and adored by all who met me: Hubert de Givenchy, Yves Saint Laurent, and most of all Karl Lagerfeld. My life was made for me in the City of Lights. My great friends were the important people of the Paris fashion world. Here I was walking with kings, breaking bread with them, going to meetings in their gilded salons where they shared their designs. It was, to me, the sum total of perfection. How far I had come from the small, insulated, and segregated Durham, North Carolina, where I survived due to my grandmother's values that she shared, and by faith and fortitude. Paris offered great characters and subtle intrigues, promiscuity, drugs, scandals—a whole different world from where I had grown up. In Paris, I was always seated on the front row at the couture and ready-to-wear catwalk shows, the only black man among a sea of white titans of style.

Betty Catroux remarked that I "suddenly became king of Paris overnight." And through it all I wrote. And wrote. And wrote. I'd meet with designers all day, working my way through the throng to see those who were hot and up-and-coming. And then see them and others all again later that night at a party. Then I'd rush over to *WWD* headquarters before midnight to type out everything I'd seen and transmit it to New York for the next day's publication. I never doubted I could be the best writer and stylist for *WWD* in Paris. They had chosen me. So Paris was my oyster. I never felt Karl and Yves thought of me as anything but one of the players who counted.

We all had a certain way of being and we came together as units, little cliques of ego, glamour, and power. I was fully a part of this machine.

I wasn't supposed to be a fashion editor. I wasn't supposed to be in Paris. And I certainly wasn't supposed to be on the front row. Yet there I was.

The reality of the situation is not lost on me; people gravitated toward me because I was smart, but also because I was close with Karl Lagerfeld.

While I was in Paris, we only became closer. We spoke early in the morning, before he left the house, almost every day. He loved socializing by telephone. We'd see each other at lunch, or dinner, or at a party, then go home and talk on the phone for two or three hours before going to bed and starting the whole thing over again in the morning. It was like being with my best friend in college. It wasn't labored; we weren't having deep, boring conversations. It was effortless. Karl always treated me as an equal.

When we weren't on the phone together, Karl and I sent elaborate handwritten letters to each other, often delivered by hand across town in Paris. Just the way people did centuries before. Karl loved stationery, and his paper was designed and made just for him. In his rue de l'Université apartment, there was a storage room solely for reams of letter-writing papers and envelopes of various sizes (another storage room housed his massive collection of Goyard hard cases for travel). Out of these large envelopes, pages and pages came in his very baroque handwriting, which I learned early on how to decipher. Writing by hand to a friend was a luxury to him. For years, we communicated by either fax or marathon telephone calls.

Other editors were baffled: What did Karl see in me? June Weir, the senior fashion editor at *WWD,* asked another editor: "What on earth would Karl Lagerfeld have in common with André?"

People thought I was Karl Lagerfeld's lover. I was not. Nor was I

ever. Nor was I Diana Vreeland's, as some people gossiped. There is always the thought that as I am a black man, it can only be my genitals that people respond to. The only time I ever glimpsed Karl even seminude was when I found his bedroom door ajar and briefly saw him in only his underpants and knee socks, getting dressed. We were sincerely close, but not *that* close.

Toward the end of 1978, I interviewed Karl for *W,* and he spoke more intimately than he ever had before to the press. He said: "When I was four, I asked my mother for a valet for my birthday. I wanted my clothes prepared so I could wear anything I wanted at any time of day. At ten, I was always in hats, high collars, and neckties. I never played with other children. I read books and did drawings night and day."

I so admired Karl for his complete and unfaltering respect for technique and craftsmanship in his profession. I also admired how his mind worked, aligning world history with the history of modern cinema, literature, and poetry. Every moment with Karl was an exciting tutorial; we shared a deep passion and appetite for knowledge. He spoke fluent French, German, English, and Italian. Through him, I learned about everything from fashion to furniture to social history. I learned so much about France, about the eighteenth century. He was a walking encyclopedia. He had more than fifty thousand books, neatly lined in shelves to the ceiling in his photography studio at 7 rue de Lille, and he read most if not all of them. In fact, I owe Karl so much of my literary education. He constantly sent me books he thought I should read. I still have many of them.

It just so happened that my friendship with Karl also provided me with inside news and scoops on Paris and the fashion world from one of the most important sources. And he gave me great quotes: "What is the worst is a fashion designer who talks all the time of his or her creativity, what they are, how they evolve. Just do it and shut up." John Fairchild loved that.

· · ·

Betty Catroux took care of me that first year in Paris. Although I wasn't going to church regularly at that point, I still began my mornings with prayer, and then waited for the phone to ring and connect me to the voice, that deep voice, much like a French Lauren Bacall. "TAAAAAAA-LE! How is my TAAAAAAAA-LE doing today?" She rang every single morning without fail, always on time, the same time. And then in my little duplex room, I would climb the small stairs to the bath and begin my day. Room service was ordered: two hot French croissants with preserves and a big pot of delicious hot coffee with cream.

Well into the third month of our morning wake-up call at the Hôtel Lenox, Betty must have gotten to know my moods well. "What's wrong with you?" she asked, like the nurturing mother of two daughters, Maxime and Daphne, she is.

"Nothing's wrong!"

"I can tell by your voice that something indeed is wrong, so tell me!"

For three months, I had kept it bottled up; I was afraid to voice this to anyone. I finally told Betty: I was tired of the Continental-style breakfast at the Hôtel Lenox. They only served croissants, butter, and preserves. I yearned for a good hot breakfast; I was homesick and wanted scrambled eggs, bacon, and jam with biscuits and butter.

"TAAAAAAA-LE! You've simply got to *ask* for this and they will make it. Are you serious? Is that *all*?"

I had never been away from home, in a hotel, and did not yet realize the polite French waiters would serve me a full breakfast if I asked for it! It was silly, a bit of culture shock. From then on, I had whatever I wanted for breakfast.

I never felt like an outsider in Paris, but there were definitely those who saw me as such. And behind my back, they were talking about it. I had confidence, I knew what I was doing, I knew when I talked to someone I had the background to talk to them. I felt inside the circle, the inner sanctum of high fashion. When most people

avoided me in Paris socially (they accepted me professionally because of my job at *WWD*), Betty Catroux loved me and accepted me for who I was, not for what I did. That was rare in fashion circles.

Betty had no personal agenda. She allowed me to know Yves Saint Laurent, intimately. Yves, who liked to have fun with Betty, would escape from the overbearing Pierre Bergé and land in the zone of cool, with his gal pal and "twin."

One morning she called, as usual, and told me she had arranged for us to meet up at Yves's apartment, and then we'd move on to the gay nightclub Club Sept, just the three of us, come Saturday evening. Buoyed by the great reviews I'd given him in *WWD*, Yves conspired with Betty to see me, without Pierre Bergé, the guardian of the gate at the house of Saint Laurent, who wanted to control all aspects of his former lover's life. Pierre had, at times, a turbulent relationship with Yves. They lived together, and then apart, in separate bachelor apartments. Yet they continued to work together for their joint empire.

I was so excited. What would we do? What would I wear?

"What are you going to wear?" I asked Betty. How silly of me. It was of course going to be something black, borrowed from the archives of Yves Saint Laurent. Which gave me an idea: I asked Betty to please borrow from YSL this marvelous gold quilted brocade jacket, with large sleeves trimmed in black mink, from the Opium autumn/winter collection. I insisted she ask that the original couture sample be sent to her home for me to wear that night. She thought it a bad idea but agreed to ask for it.

At around ten P.M. on Saturday evening, we met in the ground-level all-white library of Yves's apartment. There was Yves, and on the white sofa was the gold coat. Betty said to Yves, "André dreamed of wearing the jacket!" I tried it on, and of course it didn't fit; I was way too tall, even as skinny as I was. It was made for a woman's shoulders. The sleeves stopped about seven inches above my wrists. I looked ridiculous. Betty tried it on and it was stunning, but she

already had her own black YSL pantsuit. The jacket would go un-worn.

Pierre Bergé was always concerned that Yves would go off the rails, drinking and partying too much. And did we that night? Yes. Before even leaving Yves's apartment, we three had consumed a bot-tle each of the best Russian vodka, drinking it straight with no ice, from small shot glasses. Betty and I saw the side of Yves that was supposed to be hidden from view. Wicked, witty, wild, amusing, and fun. He was a happy boy, smiling with Betty, the two of them like the brother and sister in Jean Cocteau's *Les enfants terribles*. We spoke in French about the Broadway collection and my review of it. The collection had been a resounding success, which may be why he was in such a good mood.

As we spoke, there was suddenly smoke rising up, like smoke signals. The ash from one of Yves's cigarettes had fallen into the cushions of the sofa! Yves was a chain-smoker; he is said to have smoked more than one hundred cigarettes a day. We extinguished the smoke with water from an ice bucket, narrowly avoiding disas-ter. After we put out the fire, we hid the dark circle of cigarette singe by turning the cushion over to the clean side. Pierre would be none the wiser! We laughed and giggled like children being naughty in the schoolyard.

You could only imagine how it would have seemed to John Fair-child, in New York, were Pierre to have reported to him that I helped send Yves's legendary, art-filled, antique-decorated (museum-quality antiques!) apartment up in flames. I am sure it would have been cause for me to be sent back to New York in disgrace, fired, humiliated, scandalized.

Off we went to Club Sept, making a fabulous entrance into the downstairs dance area. We were treated like VIPs, positioned to gaze over the dance floor from a small bar at the back. There we stood for about two hours, never uttering one word, gazing in a vodka-fueled fog at the gay French and international set dancing.

• • •

Karl Lagerfeld and Valentino were both holding fragrance launch parties on the same spring night in Paris in 1978. Karl's was at his apartment, so I went to his place first for a quick appearance. I couldn't *not* attend, but I had to go to Valentino as well, to cover the party for *WWD*. The Rothschilds, the Brandolinis, everyone would be there.

Paloma Picasso was at Karl's, as they were great friends; in fact, besides myself, she was one of the only people who could be close with both Karl and Yves. Heir to the great fortune of her father, Paloma was a muse to both designers. She bought her forties-era Bakelite jewelry and antique silk dresses and furs at London's Portobello Road and the Paris Flea Market. Yves found inspiration in her style, and created an entire haute couture collection in spring 1971, long before I arrived on the scene.

When I stepped inside Karl's apartment, Paloma came up and took my arm. Then she doubled around to collect Karl, led us into the guest suite bathroom, and shut the door.

This being Karl Lagerfeld's bathroom, we were not in any way cramped. There was a small set of stairs that Karl and I sat back on, to prepare for what seemed to be big news.

"We're getting married!" she squealed. "And, Karl, I want you to do the wedding dress." We jumped up to congratulate her. Her fiancé, playwright Rafael Lopez-Sanchez, and his best friend from Buenos Aires, Javier Arroyuelo, came in, and we immediately took to planning what was sure to be a momentous affair.

Of course I would be covering the wedding and everything leading up to it for *WWD*. But asking Karl to design the dress was a bold move; to keep the peace, it was decided that Karl would design the evening dress and Yves would do the day dress. That level of diplomacy is exactly what it took to straddle the ice-cold pillars of fashion.

In all the commotion, I lost track of time. If I didn't get to the Valentino fragrance launch party, there would be no story in *WWD*. The problem: Valentino's party was at Maxim's, and a black-tie affair. I needed to go home, way across town in the Fourteenth Arrondissement, then get dressed, then come *back* to the Right Bank for the party at Maxim's. It was already so late.

"It's going to be a nightmare to go through that traffic to get home!" I exclaimed. Paloma was gracious about giving up the floor to my dilemma.

"Oh please, I can find something for you to wear," Karl said.

He went into his closet and took out a custom-made black herringbone cashmere dressing gown, with a long sash trimmed in pale salmon pink, and a black belt with fringe in cherry red. Very Oscar Wilde. I put on one of Karl's white shirts, cufflinks, a black tie, and my own gray trousers. It was stunning but daring. I hesitated.

"Are you sure about this, Karl?" I asked. I was already a tall black man; did I want to meet all the great ladies of Paris at a black-tie Valentino party in a robe?

"It looks great on you, André,". Karl said.

"André, it looks great on you," Paloma eagerly parroted.

It was settled. If Karl Lagerfeld said I was properly dressed, then I was properly dressed. I wore the dressing gown.

The A-list hoi polloi of Paris gasped when I entered Maxim's. It's not like I showed up in boxer shorts. The dressing gown was from Hilditch & Key and likely cost thousands of dollars. They wanted to be scandalized; they were *desperate* for something to wag their tongues about. Word got back to me that Valentino himself found it amusing. But still, breaking the rules of black tie was not something people did back then.

Fingers dialed John Fairchild: How could your reporter arrive at Maxim's not wearing conventional black tie? To me, it was a minor infraction.

The day after, Betty Catroux called to let me know my dressing gown and I were the talk of the town.

"I'm already well aware of it!" I said.

I didn't realize it then, but Betty Catroux fought with her swell friends on my behalf. Through her intervention, the backlash about my wardrobe evaporated. The beau monde of Paris café society and high society would just have to accept this black American string bean.

For his part, Karl found the whole thing amusing. The great Anna Piaggi later wrote about my scandal in her Italian *Vogue* column, with an illustration in color by Karl Lagerfeld.

Paloma was married in a civil ceremony at the mayor's office, accompanied by close friends and family. Karl and I attended together. Yves was there with his group, and Anna Piaggi was also there. For the day, Paloma wore custom-made clothes from YSL's Broadway collection: a white jacket, black skirt, and red blouse, and a red feather hat made by Yves. She looked more like Marlene Dietrich than a bride.

For night, Karl dressed Paloma in a cherry-red evening dress shaped like two hearts, in which she was photographed by all the magazines. He hosted a beautiful eighteenth-century-inspired dinner at his house.

Valentino gave me a linen suit to wear by day, and for night, I had a lapeled smoking jacket and pant custom-made at Christian Dior on avenue Montaigne, where I paid for it at a discount, on a layaway plan. It was my first custom-made smoking. I also wore bowed dinner slippers, bespoke, by Manolo Blahnik.

Everyone who was anyone in Paris was at Paloma's wedding dinner. It was quite literally one of the only occasions that could possibly place Karl Lagerfeld and Yves Saint Laurent in the same room at the same time. It was a table of about fifty people, including Yves and Pierre; Fred Hughes, in from New York (Andy was not there); choreographer Serge Lifar; and Anna Piaggi, who was Karl's confidante in everything and, for some time, his muse.

Anna Piaggi worked as a special fashion editor for Italian *Vogue* and was considered "the dean of Italian fashion." The first black model to appear on any *Vogue* cover was put there by Anna Piaggi, in 1971 (it was Kenzo's muse, Carol La Brie). Anna Piaggi had a museum-like, curatorial approach to her fashion collection; "I must say it is more economical to dress from the antique auction houses than Paris couturiers. I have dresses that should be in museums that only cost me $50," she told me for *WWD*. She'd do things like mix a McDonald's apron with a Lanvin gown from the 1920s. Very eccentric, sort of a Marchesa Casati kind of figure. Karl illustrated an entire book of his personal drawings of Anna Piaggi in her vintage couture wardrobe.

Once, she arrived at Le Palace, the gay disco, with a whole basket of dead pigeons on her head. In an attempt to upstage Karl, she'd gone to Les Halles district and ordered an entire basket of them. Pigeon was a staple of French restaurants. By midnight the pigeons began to stink! I was seated next to her and constantly had to turn my head in the opposite direction to come up for air. Finally I abandoned her and rushed to the dance floor.

With Anna around, Karl felt more daring and would dress more outrageously. He wore a proper smoking to the wedding, along with musketeer-style leather boots that came up, then curled back, above the thigh. The reaction was one of shock.

Anna Piaggi would not be outdone: She wore an enormous 1919 silver lamé ball gown. And on her head: a nickel-plated helmet from some operatic performance, spiked with white bird-of-paradise feathers.

As she got up to squeeze between the huge square tables, she walked past a fireplace with a Louis XV candelabra lit with waxed candles. In just an instant, her plumes caught on fire.

Everyone gasped, "You're on fire! You're on fire!" But Anna Piaggi just kept excusing herself, walking sideways as she attempted to pass by in her huge gown. Attempts to help her were mistaken by Anna for common chivalry and politely declined.

When she finally realized she was in fact a walking fire, she kept her sangfroid and said, "Oh, it's nothing. Would you put it out?"

Someone rose up and threw water on the singed feathers. Anna thanked him with a bemused smile and sailed forward to the powder room.

She gave me a great quote for *WWD:* "It's happened before, there's nothing to do."

After the party, we went to Le Palace. Yves came along, as did Marie-Hélène de Rothschild. Tina Chow came in a first-rate, museum-quality Schiaparelli bugle-beaded dinner suit, with a knee-length skirt. As we all danced together, Manolo Blahnik gathered Tina, this neat vision of chic, in his arms and flung her around the loge balcony. He put her down and picked me up next, like an able champion wrestler.

"Manolo, put me down!" I pleaded under the din of loud, thumping disco music. "My Dior suit isn't paid for yet! Put me down!"

We were all on top of the world at this wedding. We felt free and there weren't even any drugs—well, at least not with any of my close friends. Maybe there was too much fine champagne.

My favorite part of the night: Paloma handed me her evening bag to hold while she was dancing. As small as it seems, it was a great honor. I put it in the pocket of my smoking jacket and kept it safe while she danced all night.

As I lay in bed later, still pulsing from the music, I thought about Karl's thigh-high boots. He had reinterpreted a style from the eighteenth-century courts of France and made it bold and modern.

There was so much freedom in those boots, enough to make me realize I still felt restricted, restrained by my upbringing. People in North Carolina were not outside-the-box thinkers; they were straight, rigid, and judgmental. And now here I was, in Paris, discovering these fascinating people, and yes, I felt liberated in certain ways, but I did not feel totally free.

Up until then I had mostly worn suits to work, beautifully made

suits, yes, but always the comportment of rigid professionalism. I was aware I was the only black person sitting on the front row in Paris at the haute couture. There was a corresponding pressure that I had to behave a certain way. I felt a responsibility, as a black man, not to f——k up.

The anxiety I felt about Karl's dressing me like Oscar Wilde that night in his dressing gown morphed into a feeling of exhilaration. I had trusted Karl implicitly, and I still had my job. My style evolved that moment, influenced by Anna Piaggi and Karl. I depended on sartorial boldness to camouflage my interior vortex of pain, insecurity, and doubt. I realized then that I never wanted to look like anyone else.

So many of my friends were happily in love, and yet my own absence of love did not weigh heavily on my mind. My fondest memory of romance came about shortly after Paloma's wedding. It was with Paul Mathias, a reporter for *Paris Match,* whom I had never heard of. One spring Saturday, I met him at a formal lunch given by São Schlumberger.

Later that night, I mentioned his name while speaking on the phone to Andy Warhol. Andy took this as a signal to play matchmaker. A date was arranged, for me to go to Mathias's bachelor apartment in a fashionable arrondissement. I thought this could be the moment for a real romantic coupling. He was handsome, erudite, witty, and well dressed. I had been told he was a brilliant man, friends with Jack and Jacqueline Kennedy. When he had first immigrated to Paris from Budapest, he had made his living by singing in nightclubs, with his beautiful bass voice.

Mathias's apartment was simple, not overly decorated like the homes of all the other social lions, but it had comfort. Before our dinner date, Andy forewarned me: I must exalt his very expansive collection of Old Master drawings. He was proud of his Poussins and had them framed and mounted on his beautiful walls.

We talked for a while, Paul sharing his knowledge of Old Masters. He must have liked me, because he was gentle, attentive, and careful. He lit a joint and built up to a sexual moment, which, quite frankly, failed completely. As we both climbed into his beautiful nineteenth-century brass bed and slipped under the sheets, I had no clue as to how to proceed. Clearly my childhood nightmares had rendered me inept with my sexuality.

Paul was determined; I guess he wanted signals, but I could send none. It was hopeless, useless. This idea of mounting an individual and causing what I had only known as deep discomfort . . . he gave up and we got dressed.

Nothing came of this one date. Embarrassed but possessed of a deep crush, I hoped he would ask me for dinner, but it was clear he was only looking for sex, and I was a pathetic excuse for a shag. I never saw Paul intimately again. I retreated into my fears like a turtle retreating into his carapace.

Love has not been in my life in any degree. I never learned how to maintain strong self-worth when it came to two people getting down, literally clinging to each other. Yet, I have found love in little interludes of innocence or wonderful, life-enhancing bonds, and friendships that grew out of respect, affection, and admiration. I have had many emotional highs and definite lows when it comes to love and romance, and yet I am alone.

Betty and I were invited to a Saturday lunch at Maxim's by Andre Oliver, who was close to Pierre Cardin. Oliver once ran a very tony men's store in New York on Fifty-seventh Street, where everyone, including Gianni Agnelli and Oscar de la Renta, supported him by buying his expensive cashmere V-neck pullovers, in every color available.

When he invited us to lunch, Andre failed to tell us we would be joined by a fourth: Diana Ross. She was beautiful, with impeccable manners, and completely down-to-earth. After lunch, she wanted to

go shopping for some really good vintage jewelry. E. Oxeda was recommended, and it was just around the corner from Maxim's, on the rue du Faubourg Saint-Honoré, so we walked over.

Upon entering, Madame Oxeda herself greeted us. It was the first time I ever saw a black woman shop in Paris, and Diana shopped just like the society women I had come to know. She selected several diamond bracelets set in platinum for herself and had them delivered to the Hôtel Plaza Athénée, as she wanted to wear one to Club Sept that evening.

I was thunderstruck; if you were a star and black, from the United States, you could go shopping for diamonds in Paris, and like in the movies, they never asked for a credit card or check.

Diana offered Betty and me gifts, instructing us to select anything from the glass cases. We both refused, with me fearing I would lose my job if I were to accept an expensive gift from this star.

Very few people of color existed in the fashion world at this time, except on the runways. Black models had their moment in the sun early in the 1970s, when the Battle of Versailles pitted Paris and New York's top designers against one another, and the New York designers introduced American black models to Paris. By the time I came along, the black models were the stars.

Paris embraced black culture; of course they pirated a lot of things from black culture, too. This was part of a French tradition going back to Josephine Baker, this little girl, a child born in Saint Louis of a poor background, who went from the end of the chorus line in Harlem to stardom in Paris.

Saint Laurent was one of the first to embrace diversity in models. He was born in North Africa; blackness was part of the culture. Mounia, from Martinique, a world-class model, was in his *cabine,* as well as Kirat Young, the stunningly beautiful Indian model. They would stand in the Saint Laurent studio all day and have dresses fitted on them for very little money, but then they also got to walk the runway for the couture. That's how they made their fame. Each designer tried to have two or three stars in their catwalk.

Black girls ruled the runway. Their blackness was appreciated and celebrated.

YSL always had beautiful black models, sure, but in the summer of 1978, Hubert de Givenchy did something marvelous: He showed *only* black models in his High Chic couture collection. Mr. Givenchy was a real French aristocrat; he created the little black dress on Audrey Hepburn in *Breakfast at Tiffany's*. And now to show in Paris with all black models? No designer had ever done such a thing! What audacity!

Imagine my shock, siting on the front row and seeing this powerful statement from Givenchy. There was not one white girl. This was a rarity, and surely it was news. I went right back to my office and typed out a loving embrace of Givenchy on the telex machine, straight from the top of my head to New York. What was I there for if not to embrace such pioneering moments in fashion? If I didn't write about its importance, no one else would. I wrote: "Givenchy has a knock-dead cabine of models, most of them imported directly from the States. Sandy Bass, Carol Miles, Lynn, Sophie and Diane Washington, who is like a marvelous satin doll version of Lena Horne. Carol, from LA, walks like she's ready for takes in a movie remake of *Stormy Weather*."

It was quiet activism at the time, no overt celebration of blackness. I embraced Givenchy, not just because he had all black models wearing his clothes, but because he was smart enough to realize those models gave the clothes new attitude. Putting these elegant clothes on black girls injected fresh air into the staid establishment of Givenchy. The deportment and the carriage of those girls in those very expensive couture dresses created a fabulous modernity.

Soon after my ecstatic *WWD* write-up of Givenchy, rumors came back to me that someone at the house of YSL was going around saying I was stealing Yves's original *croquis* (or sketches) and handing them to Givenchy for money.

Nothing could have been further from the truth. Their collections were not even similar.

This was the kind of racism I experienced in fashion. Subtle, casual jabs that white people inherently make toward people of color. Whispers of some crime behind my back. Jealousy in its most perverted state. It surprised me. A black man is always getting accused of doing something egregious.

I was naïve; I didn't see the connection between my embrace of Givenchy and the snide looks certain members of the Saint Laurent camp were suddenly passing my way. It was bad enough Lagerfeld and I were so close, but now I was heaping praise on one of YSL's main competitors in haute couture. Pierre Bergé was furious; I was oblivious.

Racism is systemic everywhere, but no one in Paris talked about race. Racism was always underneath, sleeping below the epidermis of everything I did. It was mostly dormant but would raise its head every so often. I knew my very being was shocking to some people. That I was black, sure, but also that I was so tall and thin, that I spoke French meticulously. I had a strong opinion and I looked people in the eye. I didn't turn away. I may have been insecure but I was never shy. My knowledge and my passion and love for fashion and literature and art and history gave me confidence. I was in Paris to edit and style pictures, and I intended to do so successfully. I was living my moment. My dream achieved.

I didn't have time back then to contemplate my plight as a black man making it in the world. I was too busy trying to make it work. For the most part I barely noticed it and only now, looking back, do I realize the blinders I had to keep on in order to survive. Instead, I internalized and buried the pain deep within myself, as black men and women have been forced to do time and time again.

One night at a party, Paloma Picasso asked to speak to me privately.

"André, I don't know how to say this, but I think you should know. Clara Saint has been going around all of Paris referring to you as 'Queen Kong.'"

Clara Saint, the YSL Rive Gauche publicist, the one pushed to

the side so Loulou could marry Thadée. What a ton of bricks. I felt my face flush, and for a moment I thought I might cry.

"I thought everyone liked me," I said. I was young and naïve. Here I was, running around Paris, thinking I was successful, and these sophisticated, elegant people in the world of fashion were comparing me to an ape behind my back.

"There are many hypocrites in the world," Paloma said. She took my hand and kissed it. "You are loved."

I thanked her, and left, and did everything in my power to pretend I had never heard the words "Queen Kong." Comparing a black person to an ape is the worst, most institutionalized act of racism. It dehumanizes us, implies that we are less than human beings, attempting to remove all our value and worth. It's the worst kind of pain.

I didn't tell anyone, except Karl, who made some snarky remark, but Karl was used to the evil and viciousness of French fashion; it was just water off his back. Karl had a steel will about that kind of stuff, but my Southern sensibilities were still learning how to manage this environment. And though Clara Saint has always denied saying it, the shock of being called Queen Kong reminded me that in these circles even though people were smiling to my face, they could be plotting against me behind my back.

As much as it hurt, Paloma had done me a huge favor. She had opened my eyes to a reality I so badly wanted to deny.

In his book *Chic Savages,* Mr. Fairchild wrote about why I resigned from my posts at *W* and *WWD* in Paris. He said: "Talley, tall and talented, mixed gracefully in the fashion world and in society on both sides of the Atlantic. He hadn't mixed too well with me, though, and one day, without warning, he had marched over to the American embassy and resigned his posts, at *W* and *Women's Wear Daily,* without warning, declaring, in a written statement, I had treated him, a black man, like a plantation slave owner would."

This is all entirely untrue.

In the fall of 1979, one of my bosses at *WWD,* Michael Coady, made a trip from New York to Paris and sat in on a big meeting we were having.

In the middle of the meeting, Coady stood up and grandly announced, "André, there's rumors that you've been in and out of every designer's bed in Paris. This has got to end."

I responded with stony silence, but in my head I thought, *I must be very busy, because there are many designers in Paris. Have I been in Karl Lagerfeld's bed, as well as the beds of YSL, Claude Montana, Thierry Mugler, Kenzo, Yohji Yamamoto, Comme des Garçons, Sonia Rykiel? All of these designers?* I did sleep in Karl Lagerfeld's guest room sometimes, sure, but I always lay alone, in gilded splendor.

The accusation was stunning in its racism, and it had so many levels of hurt, insult, and pain. Michael Coady was a very important person and had always supported me. Now here he was, insinuating I was just a big black buck, sent to satisfy the sexual needs of designers, be they man or woman—I had no talent, no point of view or knowledge of fashion. And worst of all, he had made the accusation in front of the staff of *WWD,* all the men and women who had come to respect me in the short amount of time I had worked in the rue Cambon office.

The accusation was also clearly not true. No such rumor was going around Paris. It looked to me that Coady had invented it to put me in my place. But it was the wrong thing to say to me. I had grown up in a house with dignity and had no ability to handle such things. The humiliation was intense, and I had no idea how to respond. I quietly got up and walked out of the room.

I left the office at lunch and walked two blocks, to La Madeleine, a great church in Paris, where they funeralized Coco Chanel as well as Marlene Dietrich and Josephine Baker.

In a wooden pew, I quietly meditated, incubated, and reflected. *Do I have to accept this insult? What should I do?*

I lit three candles: one for my grandmother, one for Mrs. Vreeland, and one for my plight as a black man in a white world. By the time I left the church, I knew that to preserve my dignity and value as a man, I had to resign from *WWD*.

That weekend, I was invited to the beautiful Deauville home of Jean and Irene Amic. Betty and François Catroux were good friends of theirs and would also be in attendance. The Amics owned a large *parfumerie* and supplied flowers from their fields in Grasse. I didn't tell any of them my intention to resign. In fact, I didn't tell a single soul because I didn't trust anyone enough. I just walked along the beach and thought about how to handle this the right way.

On Monday, I went to the office and typed up my letter of resignation. I addressed it to John Fairchild, because he was the head of the empire. I wrote eloquently and I don't recall including the words "plantation owner." My letter was not meant to convey any hatred toward Mr. Fairchild, this genius who could make or destroy a company or a person with his brilliant sense of wordsmithing.

I did have my resignation letter notarized at the American embassy. This was important to me; I didn't want reports to come out saying I had been fired for stealing petty cash or something like that. I would not resign without official proof. This was not a game.

To his credit, Mr. Fairchild sent me word that I could stay in Paris and still write or file stories, not having to come to work on a daily basis. I knew I could not be compromised. I was never going to go back but I didn't know where I was going to go next. Everything had been going so well, I had thought I'd be with *WWD* for a few more years at least before I'd have to figure out my next job. I hadn't expected this type of humiliation to get in the way of my career.

For the next three months, I hid away from the world in Karl Lagerfeld's red-silk-upholstered guest room. He never bothered me. He was exceedingly generous, paying for everything, including my laundry, my meals, and anything else I needed. As he left for his studio in the morning, he'd try to coax me into coming along with him,

but I couldn't. My star was diminished, tarnished, by envy and innuendos. How could I show my face to the people of Paris with this scarlet letter tattooed on my silk crêpe de chine shirts?

Oscar de la Renta eventually let slip what he discovered had actually happened behind the scenes with the infamous Michael Coady meeting. Mr. Fairchild had been the one to orchestrate my resignation. Pierre Bergé had given Mr. Fairchild an ultimatum: If I were to stay in Paris, YSL would pull all their advertising money from *W* as well as *WWD*. That would have been a lot of revenue. Mr. Bergé huffed and puffed, and Mr. Fairchild, in a bid to save the advertising, sent Michael Coady to Paris on a mission: to get me in line.

Lagerfeld was the professional and personal nemesis of Saint Laurent, but I had thought I could straddle the fence between both houses. I was wrong. When I was applauding Givenchy for his all-black *cabine,* I was also making an enemy out of Pierre Bergé, who did everything he could to keep me out of the Saint Laurent inner circle, despite my closeness to Betty and Loulou. My wanton promotion of Hubert de Givenchy stoked every ounce of burning jealous rage within Pierre Bergé's body. He swallowed whole the rumor that I had stolen sketches from Yves. And to top it off, I had written a less-than-stellar *WWD* review of a production of Jean Cocteau's play *The Two-Headed Eagle* that Pierre had put up.

Pierre thought I was a threat to the house of Saint Laurent and his own power. I was not a threat. I embraced Saint Laurent and cherished my friendships with Yves, Betty, and Loulou. Perhaps even my praise was problematic to Pierre, because my plaudits made his pale by comparison.

Mr. Fairchild had literally made the career of Yves Saint Laurent at *WWD,* and he supported Saint Laurent in a very big way; I supported Saint Laurent also. I was a big fan of Saint Laurent, as well as a big fan of Karl Lagerfeld, as well as of Hubert de Givenchy.

In January, Karl paid for my ticket back to New York. I had no idea what I was going to do next.

V

Back in New York, people knew I had a reason for leaving *WWD* and they knew what that reason was. I was not the first or last person to run afoul of Pierre Bergé. All of my New York friends were still my friends.

Thus began my freelance career, with Francine Crescent of French *Vogue,* Carrie Donovan at *The New York Times,* occasional pieces for *Interview,* and anyone else who offered me work.

Just like she had at the beginning of my career, Diana Vreeland reached out on my behalf. Carrie said she had never read letters like Mrs. Vreeland's personal recommendations to hire me.

All this kept me busy but I felt adrift. I knew my grandmother and the rest of my relatives in Durham, North Carolina, would take me in with open arms. I'd had my shot at the big leagues of fashion, and it had blown up in my face. What exactly was I fighting for up in New York?

As if she heard my soul crying out, I got a call from Mrs. Eunice Johnson, of *Ebony* magazine, asking if I would fly to Chicago and meet with her and her husband, Mr. John H. Johnson, scion of the *Ebony* empire.

The Johnsons had cofounded Johnson Publishing Company,

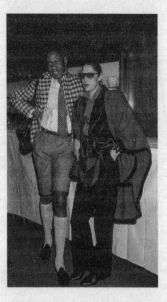

Marina Schiano was head of YSL
in the United States and a close
family member of the YSL clan.
She had a Mona Lisa smile and
nerves of steel. Helmut Newton
once said he wished he could
photograph her voice. She was like
a sister to me. I'm wearing cable
knee-length cashmere socks,
Bermudas, and a tweed jacket that
Manolo Blahnik bought for me.

which printed *Jet* and *Ebony,* in 1942. *Ebony* was the black commu-
nity's answer to the weekly *Life* magazine. Eunice also created and
orchestrated the Ebony Fashion Fair, a traveling charity fashion
show presenting the best of high fashion and style to the black
women of America, as well as Fashion Fair cosmetics, its offspring
and a financial windfall.

The Johnsons flew me out to Chicago, and I went directly to
their glamorous headquarters. I wore one of my Armani suits (as I'd
already been introduced to bespoke dressing in Paris) and a straw
boater. They hired me on the spot, as a fashion editor, to be based in
their New York headquarters. My salary was exactly equal to what I
had been making at *WWD.*

My family did not read *WWD* at all, nor would they even have
known where to purchase that publication. But they all subscribed
to and read the monthly *Ebony,* as well as *Jet,* a weekly publication
that addressed the black community on a national basis. Finally, I

had a job that would make my entire church family and all my aunts and cousins proud.

Mrs. Johnson took her job, and her personal shopping, quite seriously. Her spending budget for the European fashion shows was huge, and she was interested in only the best, most opulent examples of high fashion. With her daughter, Linda, by her side, she broke barricades, shopping at the important Italian houses of Valentino and Emilio Pucci. When she first went to Paris in 1958, doors reluctantly opened to these well-dressed, turned-out, beautiful brown-skinned Americans with a thick checkbook.

It was difficult for her, the only black woman on the front row of houses, navigating and decimating the often-nuanced discrimination. While she quietly built up her reputation, she supported the industry and established a standard for her shows. Normal American audiences were shown examples of high fashion they never could have imagined. And it was all done for local charities.

By the time I went to work for her, Mrs. Johnson was received like an empress by all the top designers. She could do no wrong. Everyone was polite to her, her daughter, and her team, including yours truly. I covered the collections and went to the Paris and Rome haute couture shows with her. Then we would take side trips to Florence, where she would buy gold jewelry. We flew by Concorde, but she wasn't extravagant in booking enormous suites in hotels; regular rooms were preferred.

Mrs. Johnson treated me like family, including me in evening meals and worrying over my welfare like a mother. It was endearing. At hotels, she made sure I was booked on the same floor as her and her daughter, which had never happened and never would happen again at any other magazine I worked for. Once, at the Plaza Athénée, she came knocking on my door at eleven P.M. She said she wanted to make sure I was all right, but I think she was checking to see if I had gone out to Club Sept. Even if I was going out for the night, I would *never* have left that early.

At the Yves Saint Laurent collections, we were front row, and following each presentation she had an appointment at the couture house. There she bought costly original samples for the Fashion Fair, the finest examples of Paris refinement and workmanship. At the same time, she would purchase a dress or coat for her personal wardrobe, to meet her black-tie social demands back home in Chicago. An invoice was handed to her and she never debated the cost, yet with her prominence, she could have whittled the price down to what she thought was fair.

In Paris, she bought one of the most expensive jackets from Saint Laurent. Embroidered with gold, by hand, at the famous house of Lesage for Saint Laurent, it cost over fifty thousand dollars. It was worn by Mounia, Saint Laurent's favorite model, with black trousers stuffed into little black boots trimmed in black mink. On her head was a pagoda with a complete, dramatic black chiffon veil. Mrs. Johnson loved the theatricality of that look. It was inspired by the Far East and the fantasy of Moghuls.

The culmination of our strong relationship came about when Mrs. Johnson asked if I would bring Diana Vreeland to that year's New York City Ebony Fashion Fair. On that Sunday afternoon, I went to Mrs. Vreeland's Park Avenue apartment and picked her up, and we took a cab to the show. Mrs. Vreeland wore her favorite black and white trouser suit, by Mila Schön (someone Mrs. Johnson had supported in Rome *alta moda* by buying her intricate designs), and her favorite polished Gucci bamboo-handled handbag, with her Vivier rock-star vinyl python boots. The audience applauded wildly when Mrs. Vreeland, seated next to Mrs. Johnson, was introduced from the stage.

Kevin and Robert, menswear designers seated in the row behind us, reached over during intermission. Kevin said to Mrs. Vreeland, "May I touch you?" It was as if they had gone to a shrine, or in this case, the shrine had come to them. Kevin gingerly touched the slightly padded shoulder of Vreeland's black and white jacquard suit.

Mrs. Johnson was a true visionary, impeccable in style, and a

self-educated American who loved beauty, art, and most of all, fashion. By the time the Ebony Fashion Fair folded in 2008, after five decades, it had reached over 190 cities in the United States of America and had helped to launch the careers of famous models, such as Pat Cleveland, and a great commentator, Audrey Smaltz, and supported the great black talents: Stephen Burrows, Scott Barrie, and B Michael.

I was only at *Ebony* for one year before Mr. Johnson decided I was too expensive for their payroll. Mr. Johnson fired me, yet Mrs. Johnson and I remained friends. This was important to me and I shall never regret that year.

In between the morning show and afternoon presentation of Karl Lagerfeld's first Chanel couture show, on January 25, 1983. Bonnie Berman was the star American model of the show. She was one of the best models ever, and one of the kindest, too. Here she is wearing her final exit, an exquisite white crepe dress, cut like a shirt with a set of pockets on the bodice, edged in cartridge sequins, hand-embroidered by Lesage. The dress was inspired by the memory of Karl's mother. *Photograph by Arthur Elgort*

VI

In 1982, Karl Lagerfeld announced he was taking over as creative director of Chanel. Paris was abuzz with the news, a beehive of intrigue and envy. *Vogue* wrote at the time that it was the talk of Paris; Karl Lagerfeld, who was not French, going to the top of the fashion hill at Chanel was in fact momentous. Alicia Drake said in her book *The Beautiful Fall* that Karl's ascension "was a black day at the house of Saint Laurent."

Grace Mirabella, *Vogue*'s editor in chief, recommended Karl to Chanel's president, Kitty D'Alessio. For a year, Karl had taken unannounced trips alone to London, where he met with Kitty, who was sure that only Karl could breathe fresh air into the famous brand. Chanel had been on life support and near death since Chanel herself died in July 1971. Karl was secretive about his new job, keeping his contractual negotiations to himself, telling no one except his trusted lawyers.

On January 25, 1983, at precisely three A.M., Karl Lagerfeld's debut haute couture collection took place in the legendary Chanel salon at 31 rue Cambon, with its elegant curving bronze-balustrade staircase, the same one Coco Chanel would often sit atop while watching her own collections parade by. Even though I wasn't con-

nected to any news publication or magazine, Karl flew me from New York to Paris first-class and paid my entire bill at the Saint James Albany. It was the most important debut show of Karl's life and he wanted me there as his close friend. I couldn't help but feel touched.

All of my skirmishes and successes culminated in a front-row seat at the changing of the guard, the new dawn of high fashion in Paris, the very capital of couture. I wore a gray glen plaid suit, inspired by the Duke of Windsor, and an incredibly dramatic fluffy white mohair maxi coat, an original design from Perry Ellis's menswear, which he had gifted to me with great generosity and kindness. My gloves were from London, the best buff chamois that could be purchased at Huntsman, where I went for all my made-to-measure suits.

Like a kid brother, I was in awe of Karl. At that first collection, Karl treated the decades of refinement at Chanel with irreverence. The clothes were astonishingly retro, with elements of Chanel's design aesthetic from the twenties and thirties, but didn't scream a retro vintage, archival mood. There were wrist-length white gloves shown with very beautiful navy or black crêpe dresses, belted with gilt chains; gold bangles with interlocking CCs—the ubiquitous Chanel logo; faux diamonds; and bowed Alice bands that held back sleek coiffures that were right out of Hollywood black and white classics.

Inès de la Fressange, the French model, who looked like and had the nonchalant attitude of Mademoiselle herself, walked out in a black, sleek straw boater, worn for spectator sports, for shopping, or to lunch with the ladies who lunch, and a single strand of pearls. These accessories were worn with silk printed soft day jackets in bouclé tweeds and with gilt buttons, and with the linings anchored in gilt chains, with the lapels hand-sewn with the same print matching the dress.

One incredible dress—Karl's favorite—was worn near the finale by Bonnie Berman, the blond American model. It was a heavy silk white marocain crêpe, lean and slim, short-sleeved, and to the floor.

There were two large patch pockets on the torso, which, along with the notch lapel, were edged in beautiful gold cartridge beads, hand-applied by the famous house of François Lesage, who had worked with Chanel and other famous houses in Paris since the 1930s.

Bonnie walked in this long white evening dress in the casual but spry way Americans do, briskly and with no allusions to any affectation. It was as though she had jumped out of the shower, splashed herself in Chanel No. 5, tied a grosgrain bow to keep her bangs out of her face, and slapped on some lip rouge. She glided along like an athlete, all ramrod-straight back, with a fresh smile, through the tight alley of little gilt chairs on each side. The polar opposite of Inès de la Fressange, whose elegance seemed lighthearted, carefree, but very aristocratic. Inès flowed through her changes and looked at the audience as if she had somewhere else to be, like the Prix de Diane or an embassy reception, just stepping from a gleaming chauffeur-driven car, the chauffeur in a gray uniform and matching gray gloves and cap.

Seated in this room, where the clothes came quietly by to soft recorded mixes of Karl's chosen music, I felt the immediate emotional exaltation of being seated on the first row, the most important seats in any fashion presentation. This was the apex for me. I was lucky to be a friend of Karl Lagerfeld. The color of my skin, my humble background, my current lack of work mattered not. There were maybe two hundred–plus guests crammed into the salon, and there I was, on the front row, when fashion history was made.

One didn't talk during the show. The front row was a phalanx of silent sphinxes in rigidity. Any applause could create the effect of a firecracker going off in the room; it could distract the fluid pace of the fashion parade. For so many decades, people followed the norm at the Paris couture. No clapping until the end. Silence, no exchange of conversation. It was like going to mass, except the main function was to sell the designer's ideas for affluent women. As the show progressed to a climax, although the press seemed somewhat neutral about this first collection of Karl's, my emotions went into overdrive

and I clapped loudly, profusely. I didn't care; I always clapped and I never felt as if I behaved inappropriately.

This collection happened to have been a great one, inspired by the very life of Chanel. "It's like doing the revival of a play," Karl was quoted as saying after the show in an article by Suzy Menkes of the *International Herald Tribune*. "It's important for young people to touch her style—it must be fun."

Karl Lagerfeld was that day established as a new fashion emperor, giving the house of Saint Laurent a most worthy genius to reckon with. "Kaiser Karl" is what John Fairchild called him. A year later, he presented his first ready-to-wear collection for spring. And until his death, he created a global brand and image that Coco Chanel herself could never have done.

This was his moment: Karl Lagerfeld.

I interviewed twice to work at *Vogue*.

The first time was in 1980, soon after I left Paris and *WWD/W*. I was friendly with the great Alexander Liberman, the editorial director of Condé Nast. He was the one who fired Diana Vreeland; she never got over it. She called him the "yellow Russian." But I had been to his house in the country with the de la Rentas and knew his wife, Tatiana, a great woman.

Mr. Liberman wore a simple navy blue and black suit and a neat, trimmed mustache. He had a buzzer under his desk that would automatically shut his door, so when I sat down in his office the door clamped shut behind me. I told him I wanted to work at *Vogue*, and he smiled warmly and said, "I think you're brilliant, but if you want to work at *Vogue* you have to go downstairs and convince Grace Mirabella."

"That's all?" I said. I only knew the editor in chief from seeing her out socially—I had just barely said hello to her—but I knew by reputation she did not suffer dramatic people. Grace Mirabella was all beige cashmere and very subdued. She had been Diana Vreeland's

assistant, but she was the opposite of Mrs. Vreeland in almost every way. Mr. Liberman was very gracious, even though we both knew he was giving me an impossible task.

I went down to Grace's office with a prepared speech ready. She wore impeccable Saint Laurent trousers, which was so *Vogue,* and had wavy, silvery hair, worn in a classic, traditional way. Very elegant and very straightforward.

As I began to speak, so did she, and I respectfully demurred.

"I remember you, from Paris. You were with Marian McEvoy, sitting in the front row at Claude Montana, madly applauding the collection on the runway. And then I saw you at Thierry Mugler, clapping loudly. Why is that?"

Claude Montana was a young upstart designer at that point, and a total genius. And Thierry Mugler was an outlier, very talented but part of a new generation of designers. They represented youth, which I loved, but not everyone in fashion is quick to embrace new designers.

Grace stared at me, very dry and cold. Honest indignation felt an appropriate response, and so I sat back, folded my arms, and said, "I react *exuberantly* when I see a talented designer and I love what they're doing. Both Claude Montana and Thierry Mugler have *wonderful* things to say!"

"Hm, hm," she said. Completely unmoved. Then, with a snide smile: "Okay, thank you very much."

I left the office and I knew it was finished. I wasn't going to work for Grace Mirabella or *Vogue.* She thought of me as superficial, some loudmouth on the front row, clapping like a seal for designers she could not understand or appreciate.

No matter. *Vogue* was a dream job but there were plenty of other stimulating opportunities. I continued to work at other magazines.

In 1983, two years after my first interview, Grace called me back into her office. Photographer Arthur Elgort had shown her a video of me interviewing Karl Lagerfeld in the backseat of a car, heading to a fashion show. It was an experimental interview, but it was a se-

rious, passionate conversation about fashion. I guess Grace realized what I was capable of and rethought her initial impression of me.

She asked me about the Lagerfeld interview and praised me for it. "Clearly you know how to talk to designers. We're going to try you out as a fashion news editor," she said.

I said, "Thank you very much," and left before she could change her mind.

On my way to the elevators, I saw Anna Wintour, who had recently, famously, been named creative director of *Vogue*. Anna and I did not know each other, but I knew her reputation quite well.

As I walked by, she smiled politely and I smiled back, but we did not exchange words. I took the subway to my Union Square apartment, a mere two stops away from *Vogue*'s offices. A messenger envelope was waiting for me beneath my door. Inside, a beautiful, handwritten note:

"Welcome to Vogue. I look forward to working with you. Anna Wintour."

That was fast, I thought. But it also sent a clear message: I had an ally at *Vogue*. A formidable one.

I did not know Anna Wintour at all, but even still, I was terribly terrified of her.

Whenever I went out with Andy Warhol, we would usually end up attending the same parties she did. She wore four-inch-high stilettos and simple, elegant clothes, like her Chanel coats, purchased at Bergdorf Goodman. Her bob, à la Louise Brooks, was more extreme, shorter at the nape of her neck. Otherwise her style has not changed much since.

Andy knew I was intimidated by her, and he would poke me in the ribs and say, "Oh, André, go say hello to Anna Wintour."

"She doesn't even know who I am, I cannot speak to her!"

"Oh, geez, of course she does, go say hello."

"No, no, no, I can't, she's too *intimidating,* too *famous*!"

Anna Wintour was well-known for her time at *New York* maga-
zine. When she went to *Vogue,* everyone knew it was Mr. Liberman
who had hired her. Actually, he had imposed Anna upon *Vogue* . . .
and upon Grace Mirabella. Publisher S. I. Newhouse and Mr. Liber-
man were smitten with this young English rose, taking over Ameri-
can *Vogue* and branding it with a European sensibility. Anna clearly
knew how to behave to get the best out of them. But behind that
was the structure; she was an instinctively good editor. They be-
lieved in her. As Mr. Liberman often said, Anna Wintour "had the
visions."

Being close to Mr. Liberman meant Anna could say and do things
other editors could not. "Creative director" was essentially a job he
made up for her, giving her an ill-defined authority. Still, she had to
gingerly walk the line with Grace Mirabella in order to keep the
peace.

It had to be Anna Wintour's intuition that told her I was going to
be someone close to her. She knew it before I did. As soon as I started
working at *Vogue,* we became fast friends. We never really spoke
about our friendship or worked to develop some long-lasting bond.
It was just perfectly understood between us, like a silent language.

When Grace Mirabella gave me assignments, I would often de-
pend upon Anna's help. I had two pages to fill of contemporary fash-
ion news that would go in the front of the book. Once, I wanted to
write about feathers for my column. YSL had feathers, and I found a
photograph by Leni Riefenstahl of an African tribal man with a
feather on top of his head. I showed it to Grace and explained my
thought process. She threw her arms in the air and said, "What have
I done to deserve this *underground* influence?"

To Grace, Andy Warhol was still the underground. I told Anna
Wintour what Grace had said and she shrugged. "Don't worry about
it," she said. "Don't . . . just don't worry about it."

Grace could be cold, but she also had a warm smile and engaged
in a meaningful way. She had a great deal of respect from the in-
dustry; Bill Blass, Calvin Klein, and Ralph Lauren were all her

favorites. As an editor, Mrs. Vreeland had been an extraordinary romantic—romantic about her work, romantic about her inspirations, and romantic about people. In contrast, Grace Mirabella was more mechanical in her focus and decision making.

Longtime editor Polly Mellen was using one of Calvin Klein's skirts in *Vogue*. Calvin sent one over, but Grace and Polly sent it back, requesting a modification. Calvin happily complied . . . and the skirt came back again. There was something else they wanted changed, but they could not explain what was wrong with the skirt. Over the next few days, Calvin Klein sent the simple skirt back and forth to *Vogue* seventeen times. That's not very inspiring. Maybe they were seeking perfection, but it seemed labored. How can you be enthusiastic about a skirt after seventeen send-backs?

Grace wasn't always clear about what she was trying to get across, but she was democratic and inclusive of everyone. Absolutely everyone. Once I was hired, she did not exclude me from any of the fashion meetings, despite my low positioning on the masthead. In many ways, she was a good balance to a cast of eccentric creatives. Very organized and totally aware of the times, but not in an emotional way. It was important to her that *Vogue* represented the best in the industry. She loved Geoffrey Beene and had a fondness for Emanuel Ungaro, but she also knew that Yves Saint Laurent and Karl Lagerfeld were the giants.

Meetings with Grace would go on for hours. We'd see a fashion show on Friday night, then come into the office on Saturday to labor over the light boxes: "Did Bill Blass have a good collection? Are we sure? Should we address this?" Hours.

In Paris, it was the same tedium, everyone sitting around a table, painstakingly going over every little decision. At that point, *Vogue* was sending twenty-two people to Europe four times a year for the shows in Milan and Paris. Anna and I would share a car and go as a team; sometimes Vera Wang would be with us as well (she worked for *Vogue* at the time). For the big moneymaker shows, Anna would

sit on the front row with Grace and Polly Mellen. I would usually sit in the second row, which made it easier to comport myself in the way Grace expected; there's no reason to clap profusely when you're in the second row. The more up-and-coming designers would show on the weekends, and I went to as many of them as possible, even if the higher-ups at *Vogue* weren't interested in attending.

There was a push-and-pull between Grace and Anna; they each had their own idea of what *Vogue* should be. Anna's position as creative director was vague enough to give her both total control of the magazine and zero control, depending on whom you asked.

It was Anna who sent me down to meet with Andy Warhol and commission a drawing of Diana Vreeland for *Vogue*. Nineteen eighty-four's fashion exhibition at the Costume Institute was titled *Man and the Horse,* and *Vogue* wanted to commemorate Vreeland with an on-theme portrait.

Andy had the idea to take Jacques-Louis David's painting *Napoleon Crossing the Alps* and impose Diana Vreeland's head onto the image. Anna loved it but didn't trust Andy to get the work done on time. She sent me, as well as her second assistant, Isabella Blow, down to the Factory every day to check on the silk-screening. I was supposed to just be writing a story about the process, but Anna insisted I take control of the situation. Every day, we would take Polaroids to show Anna the progress being made. We were literally watching paint dry! Finally I imbued Isabella with the power to watch the painting process by herself. It really was just busy work, which was just right for Isabella. She wore opera gloves while she typed, not an ideal fashion choice for a second assistant, but Isabella Blow's style was too sophisticated to give her such critiques.

In 1984, Anna Wintour married psychiatrist Dr. David Shaffer. She got married in the middle of the day, in the middle of the week. I was invited, but I did not know anything else about the cer-

emony. I wore my best gray glen plaid bespoke Dior suit and left straight from the office, arriving at Anna's Sullivan Street home at twelve-thirty P.M.

Inside, there was a luncheon table for about forty people. I looked for Mr. Liberman, and for Grace Mirabella, but did not see either. The only other person from *Vogue* was Anna's first assistant, Laurie Schechter. Not even Polly Mellen was in attendance. The banquet table was filled with family and, strangely, Anna's ex-boyfriends. They all came over from England for her wedding. I guess it was some kind of English custom.

Anna wore a pale Devonshire-cream silk Chanel dress from the boutique to be married in. After the ceremony, she changed to her honeymoon dress: a navy and white striped silk ankle-length, button-front dress, from the Chanel Paris boutique. When she re-emerged, she had to walk down the stairs of her apartment, back into the party. Everyone crowded around the bottom of the staircase, thinking she was going to follow tradition and throw her bouquet. There were no bridesmaids; her only attendant was her friend Joan Juliet Buck, whose close friendship with Karl was integral to procuring the wedding frocks.

Anna ignored the eager crowd, walked down the steps, came directly to me, and thrust the bouquet into my chest. "Here, take care of this."

I got back to the office around four-thirty (of course I had to go back to the office) and walked straight to Grace Mirabella's office. I had a feeling she'd be waiting for me and I was right. Mr. Liberman was there as well.

"Well?" Grace asked. "How was it?"

"She thrust the bouquet in my chest!"

Two years after the wedding, Anna left American *Vogue* to be editor in chief at British *Vogue* and asked me to come with her, as creative director.

I said yes at first, and announced my exit from American *Vogue*. Then I hesitated. I had no illusions about Anna's ambitions, though she never discussed her career strategies with me. However, it was my grandmother who gave me pause; she was now getting to an advanced age and living by herself. If something happened to her, I wouldn't be able to get home to Durham fast enough from London.

Also, I suppose I was afraid to go to London. *WWD* had planned everything for me when they sent me to Paris; all I had to do was pack my belongings and get on a plane. Anna wasn't offering me a furnished fashionable apartment suite; the British *Vogue* budget would not allow this.

Instead of my going to London, Alex Liberman graciously installed me at *Vanity Fair* as style editor, under the visionary editor Tina Brown. Surely Anna Wintour had something to do with the ease of this transition.

Vanity Fair gave me a level of freedom that didn't exist for me at *Vogue*. For the first time, I was generating my own concepts. Plus I enjoyed working with Tina Brown but still got to spend some time with Anna Wintour. Whenever I would go to London on assignment, to work with Lord Snowdon, I could stop by Anna's offices, and she would tell people to let me use their desks, so I would have a place to sit for a day or two. I mean *important* people, people like creative director Patrick Kinmonth! She would show me layouts and we would review designs, as though we still worked together. Our devotion to our work continued to keep us aligned.

In 1987, Andy Warhol died unexpectedly at the age of fifty-eight. A grand funeral mass was held at St. Patrick's Cathedral on Fifth Avenue, and all of New York was there. The entire church was fully packed for the somber affair. I was seated next to Isabella Blow, who wore a beautiful black Bill Blass couture suit (that she'd paid for) and a proper hat. We sat in the same pew with Dominick Dunne. During the funeral, I thought about the career trajectory Andy had launched me on. He was a wonderful boss, and a loyal friend to me up until the end. The thing about Andy is that he was truly inclu-

sive. Diversity was never an issue; he *wanted* you to be special. I was lucky to have that kind of acceptance in the early stages of my career. He was one of the great twentieth-century artists, and his legacy will continue to astonish.

Soon after the funeral, Anna came back to New York, as editor in chief of *House & Garden*. Her first task was to rename the magazine *HG*. Her second was to name me creative director. She didn't tell me how or why she made the move, but she didn't have to. I wasn't stupid; it was clear where all this was going. It was a well-known secret that Anna was working her way up to Grace Mirabella's job.

Anna's move to *HG* was bold, and garnered a lot of attention, not all of which was positive. However, we had a lot of fun at *HG*. We would both get to the office by seven-thirty A.M., and often our dark Big Apple Car sedans, provided by Condé Nast, ended up parallel on Madison Avenue. We would roll down our windows and wave to each other as we crisscrossed through early morning traffic heading uptown.

Anna moved fast; she made decisions quickly and she did not change her mind. In the beginning, the first hour of every day at *HG* was spent emptying the art department of all the existing portfolios that had been shot and never used. We were reinventing the brand of interior decoration and none of these dusty old photos needed to take up precious space.

HG subscribers, largely situated on the Upper East Side, were all awhirl, canceling subscriptions. Anna was thinking outside the box, and Mr. Newhouse supported and trusted her implicitly. For the September issue, Anna had Lord Snowdon take portraits of the great interior decorators of America in their own homes. He photographed Sister Parish for the cover, Mark Hampton, all the great interior designers. And for each one, he covered all their furnishings in dust sheets, so you couldn't see their personal interior style. That was odd, but it was a great way to shoot these grand people, who all had strong personalities.

Hyatt Bass, the daughter of Sid and Anne Bass, interned for me at *HG*. Sid Bass was a famous Texas billionaire and Anne Bass one of the top customers of Parisian couture, especially Valentino. I could always use an assistant, so I said okay. Hyatt was a wonderful intern, nice and quiet as a church mouse in response to my constantly barking instructions to her at the end of my office, near the door, where her desk was backed up against a wall. At the end of the summer, we went for a celebratory lunch with her mother at La Grenouille. Anne Bass came in a Christian Lacroix jacket. When I sat down, she looked at me and said, "You're a good man, André. You know, I've had you checked out."

"I beg your pardon, what do you mean?"

"I had you investigated, to make sure you're legit. I couldn't have my daughter working for just anyone."

I guess she wanted to see if I was a former felon, had a drug charge or something. She was a mother and rightfully wary. I took no offense. After that we became good friends, meeting each season at the couture collections in Paris.

At *HG*, I started doing house sittings. We did traditional houses, grand homes in Europe, and even Christian Lacroix's couture house. It was Anne Bass who arranged for me to photograph Badminton House, a grand seventeenth-century English estate with three hundred rooms. It was the family home of the Duke and Duchess of Beaufort. I was there for three days photographing that grand pile.

Anna Wintour sent me to Regensburg to photograph Princess Gloria von Thurn und Taxis for *HG*, in the royal palace of Thurn und Taxis. Karl had told me about this German princess, who had married Johannes von Thurn und Taxis, one of the richest men in Europe. She came to Paris and made quite a splash, ordering dozens of Chanel suits and a bunch of Lacroix; she had acres and acres of couture clothes.

When she first came to Paris, Princess Gloria was very conservative, all strands of pearls, cashmere twinsets, and tweed skirts. By the time I met her for *HG*, she had transformed herself into an extrava-

gant image of couture punk. She had spiked hair and played in a band. She had this great tiara, with a large blue sapphire in the middle, that had once belonged to Marie Antoinette. It was part of the Thurn und Taxis family jewels.

I arrived at the palace and it was overwhelming—the courtyard, the whole thing was just bigger than life, bigger than Buckingham Palace, even. I was taken to a reception room, where the photographer Max Vadukul and I waited a very long time for the princess to come down. While she was having her hair and makeup done, we scouted the palace, so we'd know where to photograph. In one of the state bedrooms, we found an Empire bed shaped like swans. Princess Gloria came down in the midafternoon, sat on the bed, and strummed her guitar. The pictures ran and we became close friends.

The following year, Princess Gloria's husband died, leaving her with a surprise: untold millions in debt. She found a great lawyer in New York and had a big sale of vintage furniture and antique cars from the palace. Through her business savvy, she saved the family fortune.

HG was a dream. However, everyone knew *HG* was just a trial run. It only lasted for nine months, and then, finally, Anna Wintour got the job she'd been gunning for.

Just like with Diana Vreeland, Grace Mirabella was the last to realize she had been replaced. WNBC-TV's *Live at Five* broke the news to her.

Anna Wintour took over as editor in chief of *Vogue*.

I was named creative director. There was no higher accolade she could give me, as the masthead portrayed. Anna Wintour made me the highest-ranking black man in the history of fashion journalism. (If the importance of this is lost on you, please remember again that this was 1988, and I was not superseded in that ranking until Edward Enninful's momentous rise as editor in chief of British *Vogue,* thirty years later.)

Vogue was an institution. I became, for a moment, the most important male in fashion journalism. As an African American man born in the ugly and racist Jim Crow South, I understood how monumental this was. I was the first.

What exactly a creative director does was never explained to me. In the world of fashion, things go unspoken. Anna Wintour saw something in me that others did not see, the same way the great Delphic oracle Diana Vreeland did. I never quite understood it. As I saw it, I was meant to be by Anna Wintour at all times and encourage her visions.

My new office was larger, situated near Anna's but not adjacent. I decorated it with Aubusson rugs woven in Portugal (which Mr. Liberman loved because they were reminiscent of old Russian interiors).

There was no "transition period." Once Anna's reign was announced, it was simply bullet speed and lighting bolts ahead. There was no time to celebrate; we had a magazine to put out. We all worked with such energy, presenting dynamic, youthful ideas.

Polly Mellen was kept on as fashion director, despite the histrionics she engaged in when Grace Mirabella was tossed out. Histrionics were her thing! "The stage lost its greatest actress when Polly Mellen turned to fashion," Diana Vreeland said.

Carlyne Cerf de Dudzeele, one of the greatest fashion editors who ever lived, formerly of French *Elle,* also came on as a fashion director. She styled—invented—Anna's first *Vogue* cover. It was a Lacroix couture jacket worn with frayed and well-worn blue jeans worn by a young model named Michaela Bercu. Never had jeans appeared on the cover of *Vogue* in its history. The jacket front was implanted with a giant gold cross, blazing with faux stones, something a young couture client might order at the time.

Grace Coddington was also hired, also as a fashion director. A longtime fashion director for British *Vogue,* Grace had fled for New York during Anna's leadership over that magazine and taken on a lucrative job at Calvin Klein. She missed the magazine trade, how-

ever, and the creative freedom of working with different designers. Anna was happy to have her come to American *Vogue*. Grace Coddington is a genius, truly illuminating and creative.

Each of these women had a strong, independent personality. By naming all three fashion directors, Anna gave each equal billing on the masthead, and each could do her own thing. It was a brilliant move, politically. The equality of their roles also reflected the fact that at Anna Wintour's *Vogue,* there was no hierarchy. There was Anna Wintour, and there was everyone else.

To Anna Wintour, a good meeting was over in eight minutes. If a meeting went beyond fifteen minutes, it meant something was seriously wrong. If she relied on your taste and your thought process, there was no need for a conversation with an editor to last more than a few minutes.

The first meeting I ever had with her outside the office was at Bice, where we went for lunch. I wore my favorite custom-made double-breasted navy blue suit, with a pink shirt. Before the first course came out, she got up and said, "Okay, let's go back to the office." As I passed the maître d' on the way out, his *"c'est la vie"* expression assured me they had already gotten used to Ms. Wintour's "lunch meetings" and had likely not set the grill to whatever she had ordered. Anna didn't want to waste time sitting around thinking about something; she wanted her editors to get out and do it.

One of my first big assignments was Madonna's first *Vogue* cover, shot in 1989. I was in Paris covering the collections and had to fly out to Los Angeles with a bag of clothes for the shoot. Madonna's Hollywood pad was spacious, with a minimalist décor. She smiled warmly when she introduced herself and said, "Hi, I'm Madonna, you want a blow job?"

"No thanks," I replied. I am sure she was joking and just breaking the ice, as we had never met before. I was flattered and continued to unpack my large black cases from Paris.

One was expected to behave a certain way when representing *Vogue*. I played it cool and I behaved in an aloof, distant, somewhat

disdainful manner, the way people usually conduct themselves on the front row. It's rare that you see a major editor emote. Polly Mellen constantly emoted and verbalized little utterances. She was unique. I can count on my fingers the number of times I saw Anna Wintour raise her hands and clap them above her head, as if to register to the world, *This is a masterpiece*. She did it once for Alexander McQueen's show inspired by *They Shoot Horses, Don't They?* with Jane Fonda, based entirely on the dramatic scenes of marathon dance competitions during the Depression era in the United States.

People often stood at Saint Laurent collections to cheer him like he was a sports hero. His front was loyal. Everyone who was a friend of the house stood. *Vogue* editors and *WWD* editors simply sat there, clapping yet sphinxlike. No one dared shout, "Bravo, bravo!"

People never cried; okay, I did cry once on the front row of a runway, but only the once! Karl opened Chloé's fall/winter 1978 show with Pat Cleveland and Carol La Brie, two extraordinary African American models. They were standing behind a gray grille, like they were in a prison. Or was it a giant birdcage? It was magical. I always made it a habit to show my admiration and sincere emotion when I felt something was truly worthy.

Editors take on the role they are expected to from the top; one just didn't clap out of control at an opening when you represented *Vogue*. But oftentimes I just couldn't help myself. That was part of my being; my very life was sustained by the glamour, the guts, and the glory of front-row reporting at a great fashion show. It was my professional hallelujah.

At Chanel's haute couture show in January 1998, inspired by Misia Sert, a true friend of Mademoiselle Chanel, I said to Anna: "We must stand up and applaud Karl." Karl had returned to the famous rue Cambon salon and we were packed in like sardines. I bolted to my feet and Anna Wintour sat there, as she was expected to do, as editor in chief of *Vogue*.

Culturally, *Vogue* is an institution with unspoken rules and unspoken mannerisms. *The Devil Wears Prada* inaccurately portrayed a

lot of things that never would happen at *Vogue*. For instance, Anna Wintour would *never* throw down her bags and coats. And girls didn't run up and down the halls in high heels. People did not carry on like that. *Vogue* was a culture of deportment, a culture of manners. This was all unspoken, yet it was crystal clear. Flowers were sent and thank-you notes were handwritten. You established relationships and you adhered to them. You were meticulously groomed. There was no vulgar language, you did not walk into the office drunk or hungover, and you certainly did not bed designers.

We embraced the fashion world and they in turn embraced us. *Vogue* has the highest standards of excellence in publishing journalism. It stood for that in the day of Diana Vreeland and the day of Grace Mirabella, and it certainly stands for that in the day of Anna Wintour. When one is aligned with *Vogue,* one is aligned with the best team in the world of fashion. A designer wants to be associated with *Vogue*. A designer wants to have Anna Wintour endorse them, embrace them. It's a culture.

It must be said that my role at *Vogue* was no doubt secured by my relationship with Karl Lagerfeld. His importance in my life and career is without parallel. When Anna wore Chanel to her wedding, she had to go through Joan Juliet Buck to gain access to the dresses. Otherwise she purchased her Chanel at Bergdorf Goodman. My friendship with Karl was already poured and molded solid, like gold bricks. This closeness gave me an inside take as well as leverage: A lot of people wanted to get to Karl Lagerfeld.

Karl would listen to me. He would sit for hours and look at the fittings, at Chanel, at Lagerfeld. He'd turn to me: "What do you think, darling? What do you think?" He'd say, "Oh, change it. Change it. What do you think?"

I was always incorporated into conversations about him at *Vogue*. It wasn't like Anna would ask me to get Karl Lagerfeld on the phone for her, but when we were looking at his dresses, she'd ask me what I thought, knowing I would also know what Karl thought. Whenever Anna and I were in Paris, we'd go up to see him together at

Chanel, to see what the collection was like. Anna prefers to see clothes in previews before any other editor, of any magazine. That is her power. I was there as a valued ambassador; it was where my opinion mattered. I know that she and Karl felt I had something special, a keen talent to see the magic in the moment, of the creative process of refined dressmaking.

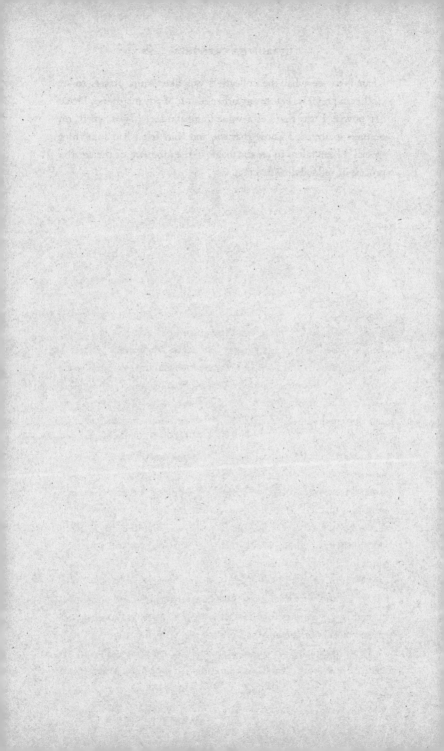

VII

Now that I was high up the masthead at *Vogue,* I wasn't surprised to get a call from Pierre Bergé. He wanted to meet at his avenue Marceau office, the grand Second Empire salon and headquarters of the couture house, where everything was conceived.

We sat in his office and got to business quickly. "I want to give you the opportunity to write the definitive biography on Yves," he said.

In true French fashion, I was out of favor with Pierre Bergé one moment, and the next he was offering me a huge sum of money. What a total turnaround, a volte-face! Here was the powerful man who once loathed me so much he had me shipped back to New York, shrouded in a false scandal, and now he was handing me a gilded laurel leaf. He realized I had staying power and was still a force, a fierce force, so he was sincere in offering me this most extraordinary opportunity of a lifetime. He also knew, instinctively, that Yves adored me and that Yves knew I passionately understood his genius, his crafting of clothes that danced with the wearer, of clothes that spoke volumes of romance and luxury and refinement.

I enthusiastically accepted; despite all, it was such an honor. To write a book about Yves Saint Laurent, with his cooperation, would

That's Liz Tilberis sitting in front of Bob Colacello, and
behind him is Franca Sozzani, Irene Silvagni, Colombe
Pringle, and Anna Wintour, sexy as ever in a short
sundress. I am wearing a bespoke seersucker suit, Chanel
sunglasses, and a straw newsboy cap by Jean Paul Gaultier.
Marina Schiano took this photo, circa 1989.

be a career highlight. A financial advance on the book was sent to me
via the publishing house, Knopf.

It was a heavy workload, a major time commitment, on top of
my demanding job at *Vogue*. Anna supported my doing it, but I was
naïve as to how consuming it would be and failed to properly navi-
gate those waters. Looking back, I realize now that I should have
quit my job, or gone on sabbatical from *Vogue,* and spent a year or
two researching and writing the book. Instead, I was still at *Vogue*
running around with Gianni Versace and covering the shows and all,
assuming I could just do the book on the side.

When I sat down to start writing, I realized I did not have the
capacity to see chronologically the magnitude of what YSL was. I
felt like a fish caught and thrown in a boat, flopping around.

I was in the south of France on assignment for *Vogue,* doing a
story on antique shops in a small village, and I called Pierre back in
Paris. I was taking too long to do the book, and we both knew it, but
I didn't want to admit it. He asked when I expected to have a manu-
script. Not a word had been submitted to him.

I said, "Pierre, the Bible was not written in speed time. It takes time!"

Pierre just laughed. When I arrived back in New York, I heard through the grapevine that a French lawyer, Alain Coblence, a friend of the house of YSL, was busy finding another writer.

During my marathon daily phone call with Karl, he tried superficially to console me. "Poor boy!" he chirped over the phone. I am sure deep down, Karl was thrilled it had gone like this. When it had been announced I would be doing the book, he never said a word; he just shrugged his shoulders and went quickly to the next moment in his day. "Don't give that terrible man the advance money back," Karl said now.

I hadn't even thought of that. So much of the money had already been spent. Years later, I wrote a check to the Pierre Bergé–Yves Saint Laurent Foundation for half the amount, along with a personal note to Pierre that I would pay the rest as soon as I was able. I never got a thank-you note, but the check was definitely cashed.

Not writing Yves's book is one of my greatest regrets in life. I had a tremendous opportunity, but I was too naïve to see what a gift Pierre had offered me. They got a great writer, Laurence Benaïm, from Le Monde, to do the book, and it is an extraordinary biography, published recently in English by Rizzoli. It doesn't mention me at all. I recommend it anyway.

After a decade and a half of friendship with Karl, I began to see a pattern emerge: He had a tendency to dismiss people he loved from his life.

Frances Patiky Stein, a favorite American Vogue editor, moved to Paris, worked on accessories for Chanel, and had a fight with Karl, and Karl never spoke to her again.

Inès de la Fressange infuriated Karl when she modeled for a bust of Marianne, an iconic symbol of France. Why should she be the Marianne when she was supposed to represent Chanel? He dropped

Inès with terrible innuendos in the press. Somehow, she got back in favor with Karl before he died.

Patrick Hourcade, who worked for French *Vogue* under Francine Crescent, hunted for valuable French and European antiques on Karl's behalf for years. He found one of the original Aubusson rugs in Versailles. One year, Karl found out Patrick had moved in with a partner. He was dropped.

Kitty D'Alessio, who got Karl the job at Chanel, was on the list. She changed the history of Chanel by hiring Karl, and perhaps she said so too loudly and too often. As a result, Kitty was not only fired, she was banned from ever attending a Chanel fashion show again.

As was Antonio Lopez, the fashion illustrator, one of Karl's closest friends in the early years. Antonio's fashion sketches had been a major inspiration for Karl when he was first designing for Chloé. In the seventies, Karl included the Puerto Rican artist and his best friend, Juan, in everything.

Karl gleaned all he could from Antonio and Juan, and they bathed in the luxury that comes with being in Karl's inner circle. Entire apartments were furnished with lavish art deco antiques for Antonio and Juan. In return, they introduced Karl to the inside characters of the Warhol Factory, like Donna Jordan and Corey Tippin. There are wonderful photos of Antonio and Donna Jordan on the beach in Saint-Tropez, guests for the entire season at Karl's villa. All the best models knew and loved Antonio. He taught them how to pose!

When I first sat down with Karl for *Interview,* it was Antonio and Juan who had arranged the entire thing. And then one day Karl had had his fill. He asked them to return all the art deco furniture in their Paris apartments to him. And then he simply never spoke to them again.

This demanding back of presented gifts was nothing new for Karl. He once sent me (from his storage) a rare eighteenth-century French *canapé* for my drawing room. One day, abruptly, he asked for it back. So my drawing room went without a *canapé.* He probably wanted to sell it. Jerry Hall once warned me that Karl always took

back precious gifts, and he did. Any fine antiques he gave others were considered to be loans.

Why Antonio and Juan were suddenly expunged from the inner sanctum, who knows? I'm sure Karl had his reasons. Very likely they were simply no longer useful to him or his career. Plenty of others suffered the same fate, and I always knew in the back of my mind that at any given moment I could be next on the chopping block. Karl resented people for being close to him.

The only one who seemed to avoid this fate was the one true love of Karl's life, the handsome Jacques de Bascher.

Jacques never went to an office, never really worked at all, which meant he could devote himself to being attentive to Karl. Jacques did not wake up until midafternoon. All he had to do was get up at some point in the day and look elegant. He was from a noble French family—a bit down on their luck, but a good name in Paris counts for a lot, nonetheless, especially to someone like Karl. It's all very European, very French.

I went to Jacques's family manor one summer; Jacques and I stopped by and had lunch. I met his mother and his sister. Then we moved on by car to Karl's sumptuous eighteenth-century château in Brittany. The de Bascher family had (and still owns) a vineyard, and Karl always had their white wine on hand.

In many ways, Jacques was the ideal love for a person like Karl Lagerfeld. Jacques was truly handsome and he dressed with style. Everyone adored him. He was friends with Loulou as well as Kenzo, the Japanese designer. He wasn't just a stud; he could have a conversation. He was complicit in Karl's obsession with the eighteenth century and the French kings Louis XIV, Louis XV, and Louis XVI. He lived in beautiful decorated rooms, heavily researched, organized, and paid for by Karl.

Karl invented the world he wanted to have, and that meant everyone around him had to play their part. More important, they had to *dress* their part, and Jacques was a perfectly willing and stunningly attractive mannequin to dress. Karl styled him like an extravagant

eighteenth-century dandy, and he did not skimp on the fur coats from Fendi.

If you were in Karl's life, he dressed you. When he gave me those shirts the first day I met him, that was his way of inviting me into his world. Paloma Picasso and Inès de la Fressange were dressed free of charge at Chanel and Fendi. As was Tina Chow, one of his favorite friends and muses.

Paloma, Inès, and Tina would all find themselves cut off from Karl, eventually. Tina went first, and I played an unwilling role in her banishment. She had come to me seeking Karl's help, on behalf of Antonio Lopez, who was dying of AIDS.

"Antonio needs money," Tina said to me. "Can you ask Karl to help him? He'll listen to you."

I told her that I would ask. What's the harm in asking? Karl and I had dinner later that night on the Left Bank and I broached the subject.

"Karl, Antonio is now ill and he needs money, you know. Tina Chow is concerned, she asked if you could help. . . ."

"What are you talking about?" He was angry that I had put such thoughts into his mind. And he never spoke to Tina Chow again.

Antonio had given Karl so much inspiration when they were younger, but Karl did not like being asked for help, as I would come to learn over the years. The generosity had to come from his own mind. It was peculiar, as I personally knew how generous a man Karl could be. But it had to be on his terms.

Bill Cunningham stepped in to provide help, purchasing one of Antonio's drawings to help pay his medical bills. He paid for it in cash, then resold it for an extraordinary sum, and that money was given to Antonio as well.

Perhaps the influx of cash helped Antonio die more comfortably, but there was simply no working treatment for his illness. He died in 1987, of complications from AIDS.

No one understood what was happening at first, this so-called gay cancer that was tearing into the fashion industry. Of course it

wasn't really a gay cancer; Tina Chow herself soon passed away from AIDS-related illness.

Joe McDonald, a successful male model, was one of the first to die of AIDS. Peter Lester, of *Interview,* died. Fabrice Simon, a wonderful Haitian designer, died. Designer Ronald Kolodzie. Scott Barrie, one of the most successful black designers ever in America. Barrie lived in an elegant art deco brownstone, furnished with banquettes covered in flawless, and expensive, ivory satin. I often think about what the world would be like if Scott Barrie had lived.

I'm not belittling myself to say my strength was in my ability to be beside a small, great, powerful white woman and encourage her vision. In exchange, Diana Vreeland always showed me unconditional love, and Anna Wintour and I became extremely close. To be clear, however, neither of them ever felt like small women to me. Except when it came to clothes fittings.

Anna treated me like family and she was there for me when I needed her most. When I wanted to buy a house for my grandmother in Durham in 1988, Anna went to S. I. Newhouse and got me an interest-free loan. I was so happy to do this for my grandmother but she was not able to enjoy it for long. A year later, my grandmother, Bennie Frances Davis, died. In August of that same year, Diana Vreeland passed away as well.

These two women shaped me into the man I am today. Mama radiated true unconditional love, and I thrived in the safety and security she provided. Diana Vreeland gave me the confidence and the grandeur and the boldness to be who I was, just by example. Losing them both, back-to-back, was devastating.

After burying my grandmother and attending Mrs. Vreeland's very private family funeral mass in the small chapel in Saint Thomas Episcopal church, I found that my grief was overwhelming. I turned to food for comfort. I went into a major binge-addled diet. Some take to drink; I took to eating two packs of Fig Newtons every

night. I binged and then suffered all the shame, self-loathing, and misery associated with overeating. The pounds soon started to find their way onto what had up until that time always been a slender frame.

I didn't tell anyone the depth of the depression I was going through. I put on a brave face during the day, keeping up the veneer of presentation, my sartorial armor, but at home I was alone and lonely and missed these two important women in my life. My light shined because of the man my grandmother raised and the example she set forth in front of me. I walked with dignity, the way she did, although she was not afforded the pleasure of advancing because of her lack of education and the culture of Southernness. She did achieve the impossible later in her life, becoming chairwoman of the church deacon board. To mark the occasion I donated a communion room at her church, in her honor.

Upon my grandmother's death, I joined the Abyssinian Baptist Church in Harlem. Church had always been a part of my life, though I kept it private. My friends knew I went to church every Sunday, but I didn't talk about it at work. My work life and church life were two separate worlds.

Through the sanctuary of the church, I gird myself in spiritual armor. The tradition of churchgoing is like new fresh oxygen to my blood. It is renewed every seven days. For so long I was absent. I had issues not with the church but with myself; I told myself that church was inside of me. To reject the routine of formal churchgoing, which I was brought up in from the age of eight, causes peril in my emotional stability. Somehow, I always return, to be reminded through the ministry of song, prayer, and communion that there is sanctuary and love in the black church.

As part of an extended family, I find it heartwarming when the deacons at Abyssinian greet me with comforting smiles before the commencement of the morning service. And when fellow congregant Cicely Tyson says, "You're back. Where have you been for so long?" it also warms my heart. Strangers—yes, strangers—in the

Sunday morning church service manifest sincere respect and love for me. I depend so much on my faith and churchgoing. I just sit there, rolling back and forth in my pew, and thanking God for how I got over.

After my grandmother's death, my mother and I grew estranged. I simply refused to speak to her. It was the culmination of so many moments when my mother was verbally abusive, to me and to her mother, my grandmother. They had such a terrible relationship, because my grandmother did what my mother did not want to do: take care of me. My mother resented her for it, but I was better off. My grandmother instilled in me the values of family, love, and tradition. And yet there were a handful of moments where I was able to connect with my mother, often through clothes. Like when she took me to buy my first custom suit, navy blue wool serge, double-breasted, made by the best tailor in Washington, D.C. I told him I wanted it to be stovepipe skinny like the Beatles' suits, but it had to be church appropriate. After all, where was I going in the suit but to church?

One Easter, my mother came home to Durham wearing a pale blue Fragonard suit in wool. I asked her where she got the beautiful Sunday suit, and she said, "It's not a Sunday suit, it's a walking suit."

That was the moment I knew my mother had good taste. She was informed by New York manufacturers and instinctively knew good, simple lines in clothes. This suit, I realize now, relates to Diana Vreeland's creed: "Elegance is refusal."

My mother loved clothes, though I am not sure that she ever fully loved me.

Few survived the AIDS crisis of the 1980s and 1990s, including the love of Karl's life, Jacques de Bascher.

When Jacques got sick, he became impossible to be around, a dreadful person. The last time I saw him was backstage at one of Karl's shows and he was unimaginably ugly toward me, hurling insults. As he spewed out hatred, I just walked away quietly. It wasn't

personal; clearly he wasn't in his right mind. I knew in that moment he was sick. He didn't look sick, but there had been rumors. That was the last time I ever saw him, but that wasn't the real Jacques. He was in pain and lashing out. It wasn't just me; he was pushing away everyone he knew and all of Karl's close friends, including Anna Piaggi.

Karl visited Jacques in the hospital every single day. Princess Diane de Beauvau-Craon, a friend of Jacques's, would go with him most days. She was like a soul mate to Karl and stayed by his side at this most crucial moment of loss, the demise of Jacques de Bascher.

Jacques died two weeks after Diana Vreeland's passing. Karl never discussed Jacques's illness with me, nor his death. Not once. There was no funeral, just a small service with Karl, Diane de Beauvau-Craon, and Jacques's mother. No one else was present. According to Diane, Karl fainted when he saw Jacques in his coffin. Jacques's ashes were divided; half went to his mother, the other half went to Karl's château in Brittany, where they were kept in a private chapel.

That year, Karl invited me to spend Christmas and subsequently two weeks in January at his country house in Le Mée-sur-Seine, twenty minutes outside of Paris (he later gave the house to Princess Caroline of Monaco). I figured Karl would be grieving, and since I myself was still grieving my grandmother, and Diana Vreeland, we could mourn together.

"*Come to Le Mée-sur-Seine, stay as long as you want,*" Karl wrote to me.

On Christmas Eve, he sent me by Concorde to Paris. After church, with all my Louis Vuitton luggage packed, I arrived at the Air France terminal in New York. I simply said, "I'm André Leon Talley," and they handed me my ticket. When I landed in Paris, Karl's personal driver/bodyguard, Briam, met me and drove me straight to the country manor, in Le Mée-sur-Seine.

Just after midnight I arrived, and Karl was up waiting for me. Laure de Beauvau-Craon, stepmother to Princess Diane, was also

present, as well as Eric Wright, Karl's longtime assistant. Before turning in for the night, everyone opened their Christmas gifts. I had none for Karl, as was his wish. It was impossible to give him anything—maybe a book, but he had access to all the books from the great Paris bookstore Galignani on rue de Rivoli. Karl gave me a small paper cone, populated with German images of Christmas elves. Inside the cone, nestled in tissue paper, was a Fabergé pin, the initials "ALT" written out in fine cursory lettering and mounted in pale blue opal, framed in diamonds. Stunning!

The Le Mée house was big enough that each of us had our own en suite rooms, beautifully appointed beds, fine linen bath towels from Porthault, and flowers driven in from Karl's favorite Parisian florist, Moulié-Savart. All the furnishings were fine French antiques, with huge early twentieth-century pale peach lampshades, typical of German houses. They reminded Karl of his childhood in Germany, where he was surrounded by many of the same type of fine furnishings. Every bedroom had wonderful views, and the thick walls kept sound from traveling room to room.

Breakfast was always in bed. Lunch and dinner were impromptu and totally dependent on Karl's work schedule. He had an atelier in a separate building above the garage, which was off-limits to the rest of us. In any house he was in, you did not go in Karl's work studio. If you saw his drawing equipment, you saw it because he allowed you to see it, and he stood there with you. He was not to be disturbed when he was drawing.

Even on vacation Karl still worked on his couture collection every day. He'd go to town and buy some newspapers, play with his little terrier, and then close himself off, put on music, and draw his collections. We dressed for dinner, Karl always in his stiff Victorian collars and white shirts and ties, while I wore ties and sweaters in the Tyrolean style, bought at Comme des Garçons. Laure de Beauvau-Craon dressed in Chanel, of course. We would wait for him before we had our meals, according to his wishes. Each meal was sumptuous and served in beautiful porcelains.

During those two weeks, I only saw Karl at formal occasions, lunch, and dinner. Not once did he mention Jacques's illness or death, or the death of my grandmother, or of Mrs. Vreeland. Any idea I had of our mourning together was quickly destroyed. And now that I thought about it, Karl had never once asked me about my grandmother, in her sickness or in death. Karl never allowed any looking back. He abhorred subjects of personal loss. I never saw Karl cry, or grieve, or in a state of mourning, for anyone.

That doesn't mean Karl wasn't silently mourning. For although he was with us in body, he seemed far away. It was hard to tell, since he was always wearing sunglasses. The rest of us had to carry on and sing for our supper. Laure de Beauvau-Craon's step-daughter and I were on high alert, trying to amuse him the best we could. Every meal was a conversation on his various favorite subjects: literature, art, music. Karl was the kind of person you didn't take for granted. You had to be on your toes when you went to see him, and dressed to the nines whenever he saw you, and you could not let him see you wearing the same thing twice, even on the same day.

As I planned to stay with Karl at Le Mée for more than a fortnight, Anna Wintour decided I could do shoots for *Vogue* while I was there. I organized a shoot featuring Laure de Beauvau-Craon's daughter, Princess Diane de Beauvau-Craon, Jacques's friend, on the lawn, in Chanel couture.

Immediately after the issue with the story hit newsstands, Karl had Briam remove all of the de Beauvau-Craons' personal belongings from the house and deposit them with their apartment concierge in Paris. He never spoke to them again. No explanation given. Maybe Princess Diane reminded him too much of Jacques. But to pack her bags? It was ghastly.

The following March, Roy Halston Frowick, the king of fine American fashion and custom, also died of AIDS, at the age of fifty-seven. Halston spent his last months in California, being driven in his Rolls-Royce up and down the Pacific Palisades between Santa Barbara and Los Angeles.

Soon after, Victor Hugo died of AIDS as well, penniless, long removed from Halston's Paul Rudolph townhouse.

What if Halston had lived to be my age, or older? His talent was equal to that of Saint Laurent or Hubert de Givenchy. The sheer minimalist elegance of his cashmere twinsets that extended to the floor, worn by Jackie O and Lauren Bacall, were the last word in fashion.

During this terrifying time, my sexual repression saved my life. Fran Lebowitz called me a "nun" and she wasn't that far off. Despite all the sex and drugs going on around me, I rarely ever partook. Part of it was fear. I didn't trust people. Perhaps due to the whole situation with Michael Coady and Pierre Bergé, I worried that if I even thought about sleeping with someone I was inviting gossip into my life. And in my experience, gossip was detrimental to my employment.

Really though, I was too uptight to have a lover. I had internalized my childhood abuse and was too afraid now to have a relationship. I put love in the back of my mind. Instead, I continued to focus on my career and never even considered the need for a separate social life until it was too late to really have one. My friends were my work friends, Betty Catroux, Loulou de la Falaise, and Karl. My social life was attending fittings with São Schlumberger. I thought myself so clever then.

Sex was not on my radar. Success was. And if I felt sad, I would eat. If that didn't work, I would keep eating until it did. I claim it! Yes: I claim it! For all the pain I must endure in the absence of love, binge eating is mine.

VIII

There was so much death in the air back then. Internally, I felt like I was beginning to spiral out of control. And perhaps Anna Wintour could tell. Early in 1990, she asked me if I'd like to get out of New York, and live and report for *Vogue* out of the Paris office on boulevard Saint-Germain for a few years. It was a generous offer, one that truly speaks to the grace and love in Anna's heart. She didn't respond to my loss like a boss would. There was no "nuclear Wintour," as the tabloids called her. She responded as a caring friend.

I of course said yes.

Everything was arranged by American *Vogue*'s Paris bureau chief at the time, Susan Train, a Colonial Dames member, who went to Paris in 1951 and became the toast of the town. She had been Diana Vreeland's favorite American-born fashion editor, and because of that, she had been unofficially exiled by Grace Mirabella. Susan was also loved by S. I. Newhouse and his wife, Victoria, so Grace had never "technically" fired her.

In my early days at *Vogue*, Mrs. Vreeland called and asked me to dinner to discuss "the Susan Train crisis." She was very worried about Susan's health, because her entire life was *Vogue*. Never mar-

ried, no children, nothing except a petite pair of cognac-colored dachshunds, called Nicely and Gogo.

"Take an appointment with Susan when you go to Paris to cover the collections," Mrs. Vreeland said.

Over the years, Mrs. Vreeland would keep the friendship fueled with personal requests, like taking her exquisite needlepoint cushions and tasking Susan Train with finding the best needlepoint restorer in Paris. I was glad I took the time. Susan made sure my move to Paris was as seamless as possible. As soon as I was settled, Susan invited me to her flat for my first dinner back in Paris.

She gave me a tour of her apartment and told me about being the darling of Paris in the 1950s. In her bedroom, in pride of place over her convent-style décor, she had hung the famous René Gruau drawing of her in a Wedgwood-blue Balenciaga suit and pillbox hat with long white gloves.

We talked about the greatness of Diana Vreeland and how hard it was to lose her. "Do you know what Grace Mirabella said to me when she took over? She called me on the phone and said, 'Susan, take it easy now, relax.'" Typical Grace, always beating around the bush.

Susan was fascinating for her knowledge and her American style; she wore elegant, simple clothes, beautiful scarves, trousers, and the same uniform of sensible low-heeled shoes. She summed up the impact of Saint Laurent in these words: "We were wearing pants. We found ourselves with long skirts with boots. While remaining invisible, he had his finger on the pulse of the time. He seemed to know what we wanted before we realized it. He put everything into place."

Susan Train never really truly retired, and was made a member of the Ordre des Arts et des Lettres for her brilliant book on haute couture fashioned on dolls during World War II. David Seidner did the photography.

"André, these young fashion editors today know nothing. They don't even know the basics, like what is a martingale tab on the back of a Balenciaga coat!" she would say. Her frustration was palpable.

There were intervals of *frisson,* when she overpoliced my expenses. This was Condé Nast! This was *Vogue*! My apartment on the boulevard de la Tour-Maubourg, which had a view of Les Invalides, where Napoléon is entombed, was paid for by the company. The television was rented by the company. Restaurant accounts were paid for, as long as one kept receipts. I had a full-time assistant, Cyril, who was also my full-time driver.

I was suddenly using Lagerfeld's costly and very rewarding hand-wash laundry service, housed in a cul-de-sac on the Right Bank. My sheets, shirts, everything was dry-cleaned, and it was all expensed and submitted to the Paris office, and I imagine shipped off to New York. My life was cushioned to the hilt.

I developed a great friendship with Miuccia Prada and Tom Ford. Some weekends I'd spend with Gianni Versace and his partner, Antonio d'Amico, at Lake Como, whiling away all day in our dressing gowns and bingeing on movies long into the evening, when we had a light supper and then continued to binge on old black and white Hollywood films.

W orking for *Vogue* as the Paris editor was a serious job. Anna sent me there not only because she thought I was in need of a change, having just gone through the loss of my grandmother and Mrs. Vreeland, but because she believed in my abilities and my taste. I scouted locations for important stories, was an ambassador to the major houses and the European titans, and had the privilege to explore and discover emerging fashion trends. I couldn't believe I was in Paris, again, living at the epicenter of style and fashion, seeing Karl almost on a daily basis: having dinner and going on his daily rounds to his favorite bookstore, and then on to Café de Flore for some cheese and boiled frankfurters, and a salad. Of course, the job came with great duties.

Anna would send me direct, specific assignments, often aligned to something Karl was doing. "André, we're going to be doing a

profile on Karl, we're going to have Helmut Newton come up from Monte Carlo and you will supervise the shoot."

I was like an unnamed Karl Lagerfeld editor; he was very important to *Vogue,* both editorially and financially. Anna didn't ask me to write profiles on Karl myself, as it would be too nepotistic. Instead, she'd get a great writer from *The New Yorker.* I would be there on hand to oversee and facilitate. Karl on the sofa, a bit overweight, with a lot of makeup on and a fan he could hide behind. I had to keep Karl happy and keep *Vogue* happy, and since I was right in the middle of everything, it was a perfect marriage.

Karl and I were aligned in most everything. His mother spoiled him. My grandmother spoiled me. He loved his distant father. My father and I had a similar relationship. And we both were in the beginning stages of putting on considerable weight. I think we both may have suffered abuse in our childhood, but Karl never completely defined his personal experiences to me. He did tell me that at a young age, his mother would strap him to his bed at night with leather restraints. It was done to prevent him from eating during the night. He also mentioned that when he was eight, his mother told him, "You look like an old dyke." She would also say, "You look like me, but not as good."

We both shared a love of books. And we both loved and lusted for luxury in all its forms: fine linens, fine scents, finely shaped bodies of both sexes, fine clothes, furniture, cars, and people. And we both found inspiration in classic cinema. When he was a child, Karl's mother would let him skip grade school and instruct their driver to take Karl to the theater, where he'd sit in the movie house all day.

I learned so much from Karl. This man had knowledge that was almost as vast as that in the Alexandrine Library, especially regarding the history of haute couture. At a casual dinner, he could spit out the entire history of the great and venerable house of Christian Dior, drawing the timeline of every Dior couture collection in the designer's ten-year span on a dinner napkin. I loved so much his passion for eighteenth-century France and the refinement of the *arts de vivre.*

He could go straight into addictions: his art deco period, which was just ending when I met him in 1975; his Memphis period, which didn't last more than a minute; and collecting museum-quality tapestries and porcelains, which lasted nearly two decades. In his final years, he went all modern, erasing the past, shedding that rare Aubusson carpet from Versailles, keeping one favorite Kandinsky painting and, for a long time, one incredible Nicolas Poussin painting, which he treasured.

Just walking down the street with Karl, on our way to Café de Flore, was exciting. Sharing a ride home from Chanel on rue Cambon at two A.M., after a great couture or ready-to-wear show, riding ten minutes home, tired and spent, but satisfied, having made the scene and stood the test of exhausting fittings, seated next to him right to the very end. After every collection, I would send him my typed or handwritten faxes or letters on what I felt was great about the collection, also injecting lines about what I thought might have been weak: the makeup, a hat, a passage of taped music, the set.

I never fought with him once over a Chanel collection. Well, there *was* one time; he made these huge matching portrait hats in gold lamé tweed with lamé fringe dangling like a curtain in front of the wearer's face. I didn't understand them and thought the show was ugly. I told this to my colleague Carlyne Cerf, who told Karl's first assistant, Gilles Dufour, that I thought the new couture was grotesque. And I suffered in exile for a season but learned a valuable lesson: Never trust anyone close to Kaiser Karl. Like in the court of Versailles, people are always ready and waiting to destroy your place in the line of courtiers, and to decimate your influence with the king.

But ultimately, we always came to an accord. There was a way I could talk to Karl that no one else could. That's why I always sat next to him. I was always supportive when he asked my opinion; I'd never call his work ugly or tacky. I wouldn't overtly criticize or put down anything he'd done. If I didn't think something worked, I would simply offer suggestions, different things he could try. Sometimes he would change it and sometimes not.

. . .

Besides my monthly column, my main job at *Vogue* was to go on shoots, often with Helmut Newton, one of our top photographers. He worked with me exclusively.

To work with Helmut, I had to travel to his home in Monte Carlo on the French Riviera and have dinner with him and his wife, June, in their apartment. These dinners could go until two or three in the morning. The next day, you had to get up early and get out on the streets, to look at locations in and around Saint-Tropez and Nice. Exhausting, but once he found the place to shoot it would go quickly. Helmut would take no more than nine frames, and we'd spend the rest of the day around the pool.

I met Caroline of Monaco in Helmut's apartment, for dinner. Before she arrived, June told me, "You cannot get up from the table and leave before Caroline does. It is protocol."

Caroline stayed until three in the morning, drinking champagne. She was very entertaining, but she kept going! Finally I proclaimed, "I am falling asleep either at this table or in a bed in this apartment!"

I did a shoot with Bridget Fonda in Monte Carlo. And a beautiful swimsuit shoot with Cindy Crawford. Always with Manolo Blahniks. I never did a shoot without Manolo Blahniks; I didn't care what the shoot was for, there was always a Manolo Blahnik made just for the shoot.

When Iman announced she was going to retire from modeling, Helmut was hired to do her final shoot, and Anna sent me down to Monte Carlo to style the shoot. It was one of my favorite shoots; Iman was nude in one shot (she didn't pose nude for just anyone), with brocaded gold Yves Saint Laurent knee-high boots. In another, she wore jeans with a Chanel couture jacket. Diana Vreeland always called Iman "Nefertiti reborn." Helmut loved working with her, as she always worked 200 percent harder than the other models. Stunning photos. And of course she didn't *really* retire.

Once Anna sent me to do Antonio Banderas with Helmut. Antonio was rough around the edges at that point, still up-and-coming in those Pedro Almodóvar films. He was wearing a gold lamé Versace swimsuit, like a brief. "André, get me a mirror," Helmut said, and I rushed to find one. Helmut did not discuss his ideas with me; I was basically like a steward for him. He sprayed talcum powder on the mirror and had Antonio simulate sniffing a substance.

Soon after the pictures arrived at *Vogue,* I got a call from Anna. She screamed at me, "This is a woman's magazine, what were you thinking?!"

I tried to explain that it was not in fact cocaine, but that did not stop the guillotine. I was silently flabbergasted. She did not yell at Helmut. I was the editor of the shoot and I was supposed to be responsible. The pictures were excised, and I was never sent to work with Helmut Newton again.

It was one of the few shoots I did that Anna ever expressed a verbal opinion on. She knew what she wanted and that's what she would get. There was no need for protestations; she wasn't changing her mind. She was very hands-on with editors, but once the work was in, she edited by herself and didn't share anything. The pictures were taken to the art department, and maybe she discussed them with the art director. Then the pictures would go up on the light board in the art room. It was a large layout board, with room for each numbered page. If your layout was up on the board, great! Though it could still end up getting cut further down the line.

If your photos were not up on the board, then they must have been hidden away in a drawer somewhere, never to be mentioned again. Since I was in Paris, after I sent in my work I'd call and ask one of the assistants in the art department if it was on the board or not. If my story wasn't used, there was no explanation given. And I wasn't going to call up Anna Wintour and say, "Why isn't my work up there? Did you not like the hair? Was it the shoes?" If your work wasn't up on the board, Anna didn't like it and there was nothing else

to talk about. No nonsense, all business. It was simply an unspoken rule; Anna had to make the decisions, and the rest of us had to accept them. No one dared question her. No one had the nerve.

Except Grace Coddington.

If Grace Coddington had *one* picture cut from a photo spread, she would have a breakdown. She'd try again and again to get Anna to change her mind. Sometimes she would wear her down with style. On the very rare occasion that Grace had her shoot totally killed, she would spend weeks in orbit.

I understood how she felt. Many of my shoots were trashed, with no explanation given. Many. *Many.* It could be devastating, going through the whole process of a shoot, knowing the expense to the magazine, and then having the whole thing dropped? It's hard not to be crushed. "These editors should get a life," Anna would say in response. All the great editors at *Vogue* dealt with these blows, but some took it harder than others.

Grace Coddington and I never had any real problems between us. Sure, there was a silent tension, but Anna never pitted us against each other. Anna would ask my advice for certain things and Grace's for others. If there were black models, for instance, Anna would ask me if I thought it was a good picture or not. When she did ask me about a shoot Grace had done, Grace would walk around the office in deep, deep dismay.

There was a Bruce Weber shoot with Mike Tyson and Naomi Campbell that Grace was especially proud of. It was bold and daring, sexy and dangerous. Anna called me into the art department and asked if I thought it was offensive and I said no. No no no. Grace was sitting right there and she didn't say anything, but her knitted brow told me she was furious another editor was even consulted. Anna was just being prophylactic. And it ran, as did most of Grace's pictures. Grace was a consummate professional and a brilliant human being. I was aligned to her; I supported her and her creativity, and she, mine.

· · ·

Catie Marron, a *Vogue* contributing editor, commissioned Lee Rad-ziwill to help her decorate the dining room of her first apart-ment on Park Avenue. They scheduled a lunch meeting at Harry Cipriani while I was in New York and Catie asked me to come along. How exciting! I had interviewed Lee Radziwill on the phone during my *WWD* years, but this would be my first formal lunch with American society royalty.

Before the occasion, Catie pulled me aside. "There's an unspoken rule with Lee. Never mention her sister Jackie. If you ask anything about Jackie, Lee will shut down and never talk to you or see you again."

"Of course!" I said. I had *manners,* after all; I'd never have been so *vulgar*. But the warning was appreciated.

For the Cipriani lunch, I knew just what to wear: my best custom-made taupe cavalry twill suit. I was so proud of this suit; it was completely lined in Hermès silk scarves, in a Napoleonic-themed print of pink, yellow, and gray. The sleeves had Edwardian cuffs that, when unbuttoned and rolled back, revealed a hint of the Her-mès lining.

When Lee sat down, she remarked that my suit reminded her of suits her father, Jack Bouvier, wore when she was a young girl.

"Of course it does. I took a photo of your father and told Mr. Morty Sills, master tailor, that I wanted a suit just like Jack Bou-vier's!"

I loved the suit, and so did Lee. I was heartbroken when it was later stolen from one of *Vogue*'s go-to dry cleaners, Ernest Winzer, located in the Bronx. The only time that ever happened. It was prob-ably lost in delivery, no doubt due to the flamboyant Hermès silk-scarf lining. I had another made, in periwinkle-blue linen, lined in a series of bright pink Hermès silk scarves. For summer.

Whenever Lee came to Paris or I came to New York, we would

get together. I've sat next to Lee at dinners given by Eric and Beatrice de Rothschild, in their beautiful Paris home, with the Zurbarán and Gauguin and Lucian Freud canvases, and the famous bed Madame de Maintenon slept on. Trophies from hunts in Siberia were strewn across huge sofas, and underground was a garage full of Warhol portraits of Marilyn.

I would often go to Lee's home for dinner, which she loved serving in her impeccable kitchen. I went shopping with her, to Yohji Yamamoto, to Chanel couture, to Comme des Garçons, and to Roger Vivier, the creator of the Pilgrim-buckle shoes she wore in the sixties. Lee was always the advance guard; she was the first to wear André Courrèges, brilliantly, and Ungaro. She loved Halston custom, especially his luxurious, simple fabrics and silhouettes. She wore Givenchy before her sister Jackie did. She loved Zandra Rhodes.

Landing a job as Diana Vreeland's assistant at *Harper's Bazaar* back in 1950 was one of the most significant victories in Lee's young adult life. "Diana Vreeland was a mad fashion genius," Lee recalled. "I loved her, I idolized her. I loved the way she walked and talked. She was creative and daring. I wanted to walk into a room and feel just the way I imagined she felt, with all eyes on her."

Mrs. Vreeland told me that it was Lee, not Jackie, who had the taste, the true chic, an intuition for good clothes and quality. I believed her, as Mrs. Vreeland was also close to Jackie Kennedy. She told me from her bedroom, propped up in her Porthault symphony of printed layers, that it was from Lee that Jackie learned how to dress.

Lee was one of Truman Capote's "swans," the term Truman used for his favorite society and best-dressed women friends. I'll always think of her as the best-dressed woman at the legendary Truman Capote Black and White Ball. Designed by Italian couturier Mila Schön, her gown was a floor-length column, with hand-embroidered silver vertical waves running up the sides. A bold move; no one else

at the ball would be in that particular Italian couturier's dress, even though Mila Schön happened to be a favorite of Diana Vreeland. Lee was at the height of glamour, perfect in her original choice.

For the incredible Black and White Ball, Lee's hair was combed out by the famous Kenneth, whom she and her sister Jackie Kennedy would see for comb-outs before catching a flight anywhere. Gloves and a comb-out: de rigueur.

Lee loved true creative types, people who lived life, as Yves Saint Laurent once said, "with the eyes of a child." She was bold enough to be friends with Andy Warhol, she went on a tour with the Rolling Stones, and Truman Capote put her onstage and on television.

It was John Fairchild who initially introduced me to Lee by telephone back when I worked for him in 1977. One Saturday I called and I think she had been drinking. The conversation was odd; I vividly recall her saying in a boozy, languid drawl, "André, who are all these people?" I took it she meant that the people taking over the Hamptons were not up to her standards.

That's how I met Lee in the seventies; then she moved back to New York and lived in a sprawling Fifth Avenue apartment, where she ordered Halston custom charmeuse and was known to have a huge triptych by Francis Bacon. Lee sold her Bacon early on; she could have kept it and sold it for at least sixty million dollars.

No decision was ever regretted; Lee simply moved quickly to another passion or addiction. She was a fashion plate, an icon, a couture muse. Tory Burch, Carolina Herrera, Marc Jacobs, Ralph Rucci, and Giambattista Valli were all her friends and inspired by Lee.

In my favorite photograph of Lee, she is with Truman Capote, before they had a huge falling-out, in 1977. There are Lee and Truman, the same height and size, in modern elegance: Lee with her natural beautiful hair (which had been washed when she was a child in pure egg yolks) and big television-screen sunglasses; a shirtwaist dress, single-buttoned and cinched in a tortoiseshell belt made of

circles hooked by gold links; and her Roger Vivier low-heeled Pilgrim-buckle shoes. This is the modern, of-the-moment "It girl," Lee. To Lee Radziwill, every friendship was approached as if she were carefully navigating a serious love affair, or at least a heavy seduction. To me, she gave nothing but unconditional love.

IX

John Galliano was a unique visionary, but in the early nineties he was an underground success in the world of fashion. His clothes weren't commercial; he wasn't in any stores. I'd seen him around London, but I didn't know he was a great designer until Emmanuelle Alt, from French *Vogue,* said to me, "You just have to see a John Galliano collection."

"Describe it to me," I said.

"It's hard to describe, you just have to see one."

Finally I got to see a Galliano collection, and Emmanuelle was right.

The way Galliano cut clothes was magical. He approached it in a younger, sexier way than had ever been done before. He broke all the rules and made his own. Grace Coddington was sent, along with Steven Meisel, to shoot Galliano's clothes for *Vogue.* Suddenly Galliano was on everyone's radar.

After the 1993 autumn/winter Milan Fashion Week, I came back to Paris late at night, with Anna Wintour. I dropped her off at the Ritz and took her car to see Galliano. I found him and his assistant, the caustic Steven Robinson, in a scene right out of Charles Dickens. They were sitting on the floor, heating up cans of food over a Bun-

sen burner. Behind them was one mannequin, with a big, amazing ball gown on it.

Looking at that dress, I knew Galliano was creating one of the greatest collections in Paris. It wasn't even finished yet but I could just tell. It was a big hoop skirt, with plastic tubing—from the hardware store—sewn into the fabric. The effect made the skirts so light they would fly when a girl walked, going way up, all over the place. Nothing like it had ever been seen in fashion before, and yet it was so clearly inspired by the nineteenth century.

"This is going to be amazing," I said.

The synopsis of the fashion show had been written by Amanda Harlech, Galliano's creative director and muse. Her idea was that the models were Russian tsarinas, leaving the Winter Palace during the revolution, and ending up in Scotland on their way to Ascot in England. This was the narrative of fashion; this was how Diana Vreeland spoke about fashion, and this is how I spoke about fashion. And this is the idea Galliano took and made into a collection.

The first models to walk were portraying the Russian tsarinas, Russian grandeur, running from the revolution, bloodied, traumatized, and still in little skinny stiletto heels. The models ran down the runway in huge, impossible crinolines and little frail blouses. They wore camisoles, tattered and torn, and big, exposed petticoats, as though they'd been ravaged and were running away with their jewels sewn into their clothing.

Cut to part two: The models have reached Scotland, the high mountains, stalking deer in jaunty micro-mini kilts, each of them like a heroine in a historical novel, with feather bustles sewn on their backsides like a duck's bottom, and lace camisoles falling off their shoulders.

The third act had the girls reach the Ascot of the 1930s, wearing long, fluid bias-cut evening dresses in charmeuse and silk satin. Over the top they wore huge Russian-military-style topcoats, flung over their shoulders, the remnants of what they took with them out of Russia.

That was in March. Everyone in fashion was talking about Galliano; what was he going to do for the next season in ready to wear? In the summer, I called to check in on Galliano again.

"I don't have any money," he said. His financial backer had pulled out, withdrawing their funding for his collection.

This was terrible news, for Galliano, for me, and for the whole of the fashion world. Talent like his is the lifeblood of our industry. Everyone was waiting to see what he would do, but they might not be waiting anymore next season.

We met for lunch, and Galliano and Steven Robinson were nervous and shaking as they told me more about the situation. Galliano's backer, Plein Sud, was used to big commercial collections, very bread-and-butter, clothes for everybody. It sounded to me like they had no idea how to handle a personality like Galliano's, and they didn't think his collection was commercial enough for their investment.

And so, Galliano, an undeniable artistic talent, had no money, no means to manufacture his clothes, and no way to put on a show. He was literally sleeping on the floor of Steven's apartment.

"You can't just miss a season, you have to go on," I said and I promised I would do whatever I could to help him.

I told Anna Wintour what was happening and went into my now-well-familiar praises of how brilliant Galliano's collection was, full of bias-cut dresses that were accessible to everyone. There's never been a more feminine dress than a Galliano. He reinvented the bias-cut technique.

"Galliano is a poet," I said. "He's the Baudelaire of couture!"

"Do whatever you need to do to make Galliano happen," Anna told me.

Vogue paid for Galliano to come to New York that Christmas, 1993. For three days, everyone at *Vogue* introduced him to all the important people he needed to meet. He and I spent those three full days together, roaming around New York, Galliano in his everyday garb of pasted and powdered white hair and some sort of eighteenth-century waistcoat.

I then threw a dinner party in Galliano's honor at Mortimer's on the Upper East Side. Anna Wintour and Catie and Donald Marron were there, and I invited Iman, who showed up wearing a sizzling red horizontal-band jersey long dinner dress by Azzedine Alaïa, with matching gloves. (Breathtakingly stunning!)

Also in attendance was John Bult, an investment banker with PaineWebber and a friend of the Marrons. The small dinner was really held expressly to finalize a deal for Bult to fund Galliano's next show.

Galliano doesn't talk much to strangers. He has since evolved and can articulate his vision, but back then, at dinner, he was practically mute and visibly shaking.

As the dinner ended, Bult offered to come to Paris to see what Galliano had been working on. "And maybe I can give him some money for a show?" he said.

In January, Bult took the Concorde to Paris and met Galliano and me in the hotel Bristol's lobby for afternoon tea. Galliano was once again extremely shy, nervous, and trembling, but I filled the blank space with my pronouncements of love for his work.

"What kind of money do you think you need?" Bult asked.

Galliano didn't have a clue.

I said, "We can take whatever you can give us. How about fifty thousand dollars?"

Bult flew back to New York and returned the next weekend, and we again met at the Bristol, this time with Galliano's right-hand man, Steven Robinson.

"You can do the show on fifty thousand dollars?" Bult asked.

Galliano said, "Yes, I think we can."

"Yes, we could get fabrics, do samples, and get fittings and have them sewn for that," Steven said.

"My lawyer has the money in escrow for you. You can access the money as you need it. Use it wisely. Do the show."

Galliano and Steven got to work. I checked in on them from time to time, and I'd take out petty cash from the Paris office to buy

McDonald's for their crew when it seemed necessary. They were poor, and every cent of that fifty thousand dollars was being put to use.

There was one big problem: Galliano had nowhere to put on the show.

I racked my mind, driving up and down the streets of Paris, looking for a proper venue. There was the idea that it could be shown in the Institute of Islamic Culture or the Mona Bismarck Foundation. Then it came to me . . . Madame São Schlumberger's private residence!

São and I would often have lunch at the Ritz and then I'd go to all her couture fittings at Saint Laurent, Lacroix, and Chanel. São had just moved from the seventeenth-century landmark Hôtel de Luzy, on rue Férou on the Left Bank, to a newly decorated apartment on the Right Bank. The Hôtel de Luzy was empty. It was five floors: a library, a silver vault, and a fur vault, as well as a discothèque in the basement, with floors that lit up as you walked on them.

We took São to lunch and I told her I needed a favor. Could we use her house for a fashion show?

She loved the idea. "Of course you can," she said.

"I'll sit you in the main salon on a sofa and these clothes will glide by you!" I said.

"Oh good, I'll go get a little face-lift," she said.

It was extremely generous of her to give us her house, for free. She had no idea who Galliano was, but she was a good friend of mine and trusted me.

Everyone worked for free to help Galliano. The entire *Vogue* staff was at his disposal. Manolo Blahnik donated the shoes for free. Stephen Jones created a hat for each look, free of charge. Hair and makeup were done gratis. None of the models, including Linda Evangelista, Christy Turlington, Kate Moss, and Naomi Campbell, collected a fee. Amanda Harlech picked up jewels on loan from Cartier, Van Cleef & Arpels, and Harry Winston. We all nurtured

Galliano because we all understood the enormous brilliance of his work.

The night before the show, São's house was overrun with preparations. As I ran around setting up seating arrangements and fog machines, I realized the crew were all down in the basement, dancing and carrying on on the lit floors that pulsated from underneath. And there was Galliano, in the mix, having fun like this was some discothèque party! I saw Amanda doing her best to direct and style, pushing around furniture and moving speakers. She was the only one doing anything.

I screamed to Amanda, "Get this crew together or I'm calling São and halting everything and I'm pulling out!"

Amanda got everyone, including Galliano, back to work.

It was a small collection, only seventeen looks, but from those seventeen Galliano began a legendary career. We had two shows, one at nine-thirty and another at eleven-thirty. Kate Moss was still being sewn into her dress when the first show started. Both were completely packed. Everyone wanted to get in, all the society ladies. Fashion was a smaller world then, but all the players were there. *Vogue, The New York Times, WWD*.

The world stood up and saw the great gifts of Galliano. It was a day of reckoning in the industry. Anna came to the show, in a Chanel suit, and embraced the whole thing, totally. That show was the template for fashion from then on. People started picking historical places to show, not just a runway or hotel lobby, or in the formal tents constructed in the Tuileries for ready-to-wear, or in the basement of the Louvre.

Now every designer does big runway spectacles, but it was Galliano who started it. Not a designer in the world can say they didn't copy Galliano in some way. Even Karl Lagerfeld changed the way he did shows after Galliano's breakthrough. Of course Karl took it to a much higher level; he would create villas, spending four or five million dollars for a fifteen-minute Chanel show. Galliano did it on a budget, with barely a dime.

Afterward, everyone came to Galliano. Bergdorf Goodman and Saks Fifth Avenue wanted his clothes. Society ladies like Anne Bass and São Schlumberger would have him design pieces for them. People were clamoring for those clothes.

I had managed to do all this and still maintain Karl Lagerfeld's approval and friendship. This was really because he didn't consider Galliano a threat. And at first he was right; Galliano was not a threat, early on. But this show launched his career, and he soon got the big job designing for Givenchy. Then after a year he left Givenchy and got the biggest job: artistic director and designer of haute couture for Christian Dior. That made Galliano the most important person in fashion.

Dior is legendary, the biggest fashion house in the history of modern fashion. Yves Saint Laurent had started there, briefly, before he had a nervous breakdown and opened his own couture house. Chanel was the great designer but Dior was the name people associated with Paris couture.

At Dior, you could have everything made to order, even a fine thin silk umbrella you carried as a walking stick. Dior was opulence, over-the-top. Film stars like Marlene Dietrich, Rita Hayworth, and Sophia Loren, they all went to Dior.

Princesses, including Diane von Fürstenberg, had wedding looks made at Dior (DVF's was made by then–house designer Marc Bohan, who had replaced YSL).

One late Saturday night, several years later, I got a call from Galliano, asking me to come to his studio to see his new collection. We didn't speak regularly as much anymore, so I was surprised to hear from him. I took a car over and it was like not a day had passed since we last spoke.

"This is for you," he said, and handed me a little blue box. Inside was the CBE medal, presented to him by Elizabeth II, queen of his native England.

"You were like the pied piper leading people to me," Galliano said.

His gift and his acknowledgment had me in awe. It was one of the most significant moments of my life. I keep the box and the medal in my safety deposit box.

Galliano understood me and I got him. I knew his wavelength, where his inspirations came about. I'd been accused of sleeping with all the designers, but the truth is that I embrace their dreams, step inside their dreams, and become part of their dreams. I bonded with Galliano on a human level. He is a genius, a visionary, a poet. A mad poet, like Rimbaud, or Verlaine, or Baudelaire. Underneath all his extraordinary romanticism is serious craft, superior skill. He understands how to manipulate a dress to make it float elegantly around a woman's body.

That fashion show at São Schlumberger's was a crossroads in the fashion industry. I don't think John will ever forget that. He got bigger and bigger, and grander and grander. It was his destiny. Of course, like Icarus, he was also destined to fall.

Steven Robinson came right along with Galliano to Givenchy, then to Dior. He was Galliano's right-hand man. But somehow, his creative director, Amanda Harlech, was overlooked.

From the outside, this might not have seemed like a big deal. But I truly understood how important Amanda Harlech was to Galliano's creativity. One of the first times I met her, Anna sent me to shoot her home at Glyn Cywarch, the ancient Welsh seat of the Harlech family. It had formerly been a grand country house, but now its condition was . . . well-worn chic. All the fine gilt leather volumes should have been sent to museums. The George III chairs had stuffing and padding bursting from sun-rotted silk seats. Bats, hundreds of them, and their toxic bat dung, were slowly taking over a stone barn on the property. Amanda lived there in grand, rise-above-it-all elegance.

Isabella Blow was supposed to be the shoot's editor. Anna asked me to be on hand to oversee everything. Naturally Isabella couldn't

even compel herself to fluff a pillow, so I ended up doing all the work while she ran around talking. We had a big fight over her unwillingness to run a vacuum cleaner.

During a break, Amanda and I escaped Isabella's ranting and adjourned to the beach. As we strolled, Amanda collected pieces of glass and rock from the frothy Irish Sea.

"What are those for?" I asked.

"I'm sending these to John, these are the colors we should use in the next collection."

That was how she worked. We became great friends from then on.

Amanda's a unique woman, slight but sharp. Oxford educated. She would write a narrative of a show, like an essay, and that's what John would use to start his collection.

Knowing this, I was puzzled to learn Galliano had not assured Amanda an appropriately prominent position at Givenchy. She had long been his muse and had stayed with him through turbulent years. I'd just assumed she was being taken care of. There were rumors going around that this was not the case.

Amanda was in the process of divorcing her husband, Lord Harlech. Suffice to say, she required a paycheck worthy of her contributions. Lady Harlech (she kept her title) moved to a farmhouse in Shropshire with her two children, Tallulah and Jassett. I went out to Shropshire to shoot for *Vogue*.

A passionate equestrian, Amanda had horses, huge horses that she'd climb up on, light as a feather. They would jump fences, that kind of thing. I photographed her riding one of those giant creatures, a lovely shoot.

That night it was cold, and Amanda and I sat over a fire and she filled me in. Her expenses were extraordinary, and her salary at Givenchy had been paltry. Dior had hired Galliano and Steven Robinson at great salaries, with great perks. But somehow, Dior hadn't made Amanda an offer at all. Galliano was so focused on himself he didn't give a second thought to Amanda. He wouldn't even take her calls.

During each of my nightly marathon calls with Karl, I casually mentioned how Amanda was being treated by Galliano. Karl was never quite negative about Galliano because he knew there was real, inborn talent there. Though I never heard Karl say anything great about Galliano's clothes, either. We talked about who was ordering Galliano's clothes—Madame Schlumberger, Anne Bass—and what Anna Wintour was ordering. And then I casually mentioned, "You know, they're not paying Amanda at the house of Dior."

If I spoke to him a certain way about it, something would happen. He didn't respond right away, which meant he was thinking about it.

"Bring her to the show tomorrow," he said, "but take her to the boutique first and tell her to get anything she wants." Those were the magic words. That meant he was interested.

I called Amanda and told her to meet me on the steps of the Chanel boutique on rue Cambon at nine forty-five sharp the next morning. The show started at eleven, but they were opening early just for us. "You run in there, pull anything you want—hat, shoes, gloves, bag, whatever. Get dressed, leave your old clothes there, and we'll get a car straight to the show."

Amanda picked out a gunmetal-gray suit with gold buttons, and we were off. No one asked or expected to be paid for any of it.

I had no idea how this would go. Karl had never even met the woman; he could have responded any which way! But I had a feeling.

When we arrived, Joan Juliet Buck, the editor in chief of French *Vogue,* was standing right at the entrance, her eyes bulging as she watched Amanda and me get out of our car. Amanda was clearly dressed in Chanel; the gilt buttons, the cut, the shoes were unmistakable. Joan Juliet sauntered over, like a cat ready to pounce upon a mouse.

"Why are you here, Amanda?" Joan said, her eyebrow raised, feigned innocence.

"Oh, I'm just visiting," Amanda replied, and kept walking.

That wasn't good enough. "André, why is Amanda with you?"

"Keep walking, don't say another word," I whispered to Amanda.

We went directly backstage before the show began, and I introduced Amanda to Karl. They got on like fireworks. Love at first sight. He was so taken with her proper English breeding, sound education, and impeccable manners. And he was clearly impressed by the choices she made at the Chanel boutique (of course I advised Amanda on what suit and what accessories she should select!).

Before we left to take our seats, Karl pulled me aside. "Take her to the couture and tell her they will make anything she wants."

This was Karl's big trophy. If Karl liked you, he would say, "Go to Chanel and pick out anything you want." There's a big monetary difference between the boutique and the couture. At the boutique you're picking dresses off a rack, but couture requires fittings! That's major money. And Karl didn't say pick one thing; he said she could pick anything she wanted. For free!

Only a woman Karl thought very highly of was given carte blanche in the couture. His contract required that he could dress whomever he wanted. So many were lucky, including all the supermodels, Naomi, Linda, Christy, and Claudia Schiffer, who would stock up on dozens of expensive cashmere twinsets at the boutique or rue Cambon.

The next day, we called up and went to the haute couture. Amanda wasn't a rich white lady like São Schlumberger or Anna Wintour; she didn't normally dress in couture, she just had great style. She went in there and was very respectful. She ordered a long black maxi coat, seriously severe, like a monk's coat, and a long white pleated dress.

Karl called me that night and told me he'd heard what she had picked. "That was a perfect choice," he said. "Do you think I should have her at Chanel?"

"But of course!"

Amanda was reluctant to go right away. She was close to Galliano; they had been friends for years. Karl asked me to go home

with her, to Shropshire, over Thanksgiving, and convince her to come to Chanel. It was frigidly cold, so cold I was collecting my own firewood and had to have the Ritz overnight me my Fendi shearling coat. It saved my life, as it took me an entire week of cajoling and persuading before Amanda agreed to go to Chanel. She went back to Paris, into the Chanel archives, had Coco Chanel's famous suits from the sixties pulled out, and was photographed in them. That was how she announced her new job. And that's where she's been ever since.

Although he didn't end things the right way with Amanda, Galliano remained close with her while he completely revitalized Dior. What he did at Dior cannot be repeated by anyone. Only his mind could have done it. Galliano did a great deal for fashion. He's a wicked kind of person, an exhaustively self-indulgent human being, but he came from humble beginnings. The greater his success, the more spoiled he became, causing havoc because of his genius. At his shows, he demanded his own VIP dressing room, to be decorated with zebra rugs and sofas and such. It started as a little makeshift room to greet people but became a lavish endeavor.

John Galliano is truly a poet. I don't judge anyone in life for anything. He had problems, including substance abuse. Whenever he had meltdowns at Dior, they would send him away to clinics in Switzerland.

Steven Robinson died of what appeared to be a heart attack at thirty-eight years old. He was the creative director of Dior and Galliano's own line, and he knew what Galliano was going to say before Galliano even thought about it. Steven dedicated his whole young life to Galliano; he did everything for him.

I went to the funeral in Paris. Galliano was destroyed by this man's death and was never the same. Steven was his best friend. In all the success at Dior, with all the perks, I think John just felt alone after Steven's death.

Many years later, Galliano had a breakdown. To make matters worse, it was in public, and it was recorded. I was shocked when I

saw the tape. I still find it hard to believe he said what he said, even though there is tape, and I've heard it myself. I believe he was very intoxicated when he made those anti-Semitic remarks. Maybe he was in a dark, demonic place in his mind. It was devastating to me, to everyone in the fashion world. Galliano was fired by Dior.

Later, Anna Wintour took Galliano under her wing but none of the big design houses would take him on. He went to rehab, got sober, and continues to be a talented designer. Whenever I run into him, he's always kind. He's a different person in sobriety and wonderful to be around. He will always be a friend, he will always be the imperfect human being that he is, and he will always have the most supreme talent. Nothing can take away the enormity of that kind of visionary genius. He now designs couture at Maison Margiela, Paris. Anna Wintour remains loyal and frequently orders dresses to this day.

Life changes. Life has to go on. You have to keep going. I, too, am a sinner, flawed and fallen from grace, getting up and trying for salvation, over and over.

X

High-profile people walked the halls of *Vogue* under Anna Wintour. She surrounded herself with strong, independent thinkers, which could sometimes lead to differences of opinion. Carlyne Cerf de Dudzeele wanted a Bill Blass dress for a cover. But Anna Wintour had asked me to talk about that same dress in my column. There was a big fight in the fashion closet about that dress, and Anna ended up giving it to me and not Carlyne. Carlyne and I didn't speak to each other for five years because of that dress.

I admit that I can be moody and not always the easiest person to get along with. Being close to Karl Lagerfeld, on top of my "independent" personality, meant that I could stand up for myself, the same way Anna was able to stand up for herself with Grace Mirabella. But I never did anything ugly or vulgar. I was never boldly disruptive.

Anna is not a woman of many words. She relied on editors, on the experts, for our opinions on dresses and collections. Perhaps she was not exactly secure in choosing clothes for the magazine. She's never been on a photo shoot since being at the top of *Vogue*. She always made the final decisions, and in fact she is incredibly brilliant at making quick decisions, but she was never really passionate about

clothes. Power was her passion, and even if Anna was silent, she was vital. She had power and she wielded it, brilliantly, to achieve a major career.

At a certain point Anna stopped putting me on shoots. She probably thought I didn't have the visual expertise or grace, or maybe she wanted a woman's point of view. The female editors, Grace Coddington and Carlyne Cerf, were the important editors; this much was obvious. Although I didn't feel competition with them, the New York office now carried an aura of overwhelming pressure.

After the success of Galliano's São Schlumberger show, it started becoming clear I'd hit a glass ceiling at *Vogue*. It was Anna Wintour who had officially "saved" John Galliano, but I was the one on the ground, keeping the seams straight, so to speak. I had done this great job but wasn't being treated properly or recognized for my efforts. And I put up with that, until I did not.

Anna Wintour, in all her imperial hauteur and froideur, had put me in a box and apparently decided there was no bigger job in the works for me. I couldn't, for example, be a consultant to the Costume Institute at the Met, when other talented editors became curators for shows. Anna Wintour didn't see me in the role of curator. That hurt. After all, I had learned from the best teacher, Diana Vreeland.

There was no big falling-out with Anna, no big blowup. I just walked into her office in New York one day, and when I walked out I slammed the door and left. There was no back-and-forth, no argument. Anna Wintour doesn't argue. I don't remember the specifics of what I said to her or what it was that pushed me to this point. I just remember that I was fed up.

When I got home, I booked a flight back to Paris and did not return any calls from *Vogue*. Karl Lagerfeld did his best to talk some sense into me. "You better get back in her good graces," he said.

I didn't want to hear it. I was done with New York, I was done with Paris, and I was done with the politics of fashion. All I knew for sure was that I needed to clear my head. My grandmother had

been dead five years and I hadn't had a chance to slow down and properly grieve since. I decided to move down to the furnished house I had bought for her in Durham and put some space between me and *Vogue*'s far reach.

A couple months went by in Durham, including Thanksgiving and Christmas. I was in my house alone, surrounded by my grand-mother's belongings. To stem the loneliness, I ate. Both holidays I had catered by Dillard's BBQ, a local soul food restaurant, enough for a table full of people. A pan of mac and cheese, a pan of turkey with the dressing, stuffing, candied yams, and a basket of homemade biscuits. And for dessert, a lemon cake and a chocolate cake. No veg-etables, no fruit, and no guests were invited. In one night I ate al-most half of it, then I woke up the next day and ate the rest.

Rather than deal with what was going on in my life, I turned to food in an attempt to suppress my emotions. I equated food, particu-larly desserts, with the love I received from my grandmother. With her gone, and my living a solitary existence in Durham, my eating was out of control.

Then one snowy night in Durham I got a call, out of the blue, from Anna Wintour. She was in London and the connection was bad, but the tone of her voice and the fact that she had called me at all told me something was wrong. Her mother, Eleanor Trego Baker, had died.

The phone line went out soon after she told me. Then it rang again; this time it was her husband, David Shaffer. He was in New York with the children, and a wild blizzard had shut down the entire Northeast. S. I. Newhouse had offered to send him to London by private plane but it would not be able to take off in the storm.

"Anna shouldn't be alone right now, but the children and I can't get out of New York because of the blizzard. I thought since you're in North Carolina, perhaps you can get a flight farther south and get over to England?"

"I will do my best." The storm was not as strong by me, but it was snowing, and there were cancellations. I managed to manipulate

and navigate and get on a plane to Miami. We sat on the runway for hours, waiting for them to deice the plane, but eventually we took off, and I got on an overnight flight from Florida to England.

I arrived just in time to change and drive directly to the crematorium. Anna's father was there, as well as her brother and sister. From a pew in the back, I watched Anna give her eulogy. She was close to her mother, though she didn't talk about her that much. So it was a shock when, at the end of her eulogy, tears welled up in her eyes. Anna broke down, in front of everyone, and ran out. I instinctively got up and walked beside her, cradling her in my arms as we made an exit. It was perhaps the one time I really ever held Anna Wintour.

Love comes in many guises. Love must be kind, and it must be a two-way street. Loyalty between two persons in an alliance of true friendship is a noble human endeavor. In true friendship, a human being finds strength. Good times or bad; the highest peak or the lowest valley in one's life. While I was under her employ, Anna never shared any personal details of her life with me. Not her divorce, not her father's death, nothing. But in this moment, I was not her employee, I was her close friend. We officially made up and began spending time together socially.

For the next few years, I lived in Durham and commuted to New York and Paris when I had to, staying in a suite at the Royalton or the Ritz. Graydon Carter hired me as a style editor for *Vanity Fair,* and it was for Graydon that I accomplished some of my favorite photo shoots. Many were hyperbolic attempts at fashion satire, and just about all of my shoots ran, with all the expected pages. It was a breath of fresh air, doing a photo shoot and then actually seeing it run in the magazine!

One winter night in Paris, 1996, Karl and I were talking about the current wave of big hoop skirts on the couture runways, which had been started by Galliano but found its roots in the nineteenth

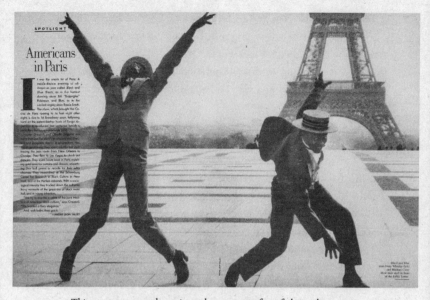

This spontaneous style conjures the memory of my father, who was a passionate amateur photographer, with his own darkroom and developing equipment. When he died, I put his favorite camera in his casket.
Photograph by André Leon Talley for Vanity Fair

century. The inspiration of Scarlett O'Hara was clearly being splayed across the Paris runways. Stories in *Vanity Fair* were supposed to relate to Hollywood or something iconic in the minds of artists and cultural critics, and I started to think about using *Gone with the Wind* as a possible reference point. It is an entertaining film but not one of my favorites. For obvious reasons.

Back in my first museum show, volunteering with Mrs. Vreeland, the exhibit had showcased Scarlett's curtain dress, along with several of Scarlett's other gowns and dressing gowns. I've seen the movie many times and can appreciate the scope and scale of the costumes, the grandeur, the rich, saturated colors. But seriously, can anyone who is black and in their right frame of mind enjoy this film?

The answer is no. The one great thing about it is that Hattie McDaniel, in her brilliant supporting role, became the first African American to be nominated for and win an Oscar.

If I were going to draw inspiration from *Gone with the Wind,* it would have to be in a way I'd be comfortable with. And then it hit me:

"Let's do an updated *Gone with the Wind* and have Naomi as Scarlett. 'Scarlett in the Hood!'"

Karl loved it, and we immediately began to plan out our shoots, using his appropriately grandiose interior décor. We would cast fashion's heavyweights to play the servants: Galliano, the star of couture, was cast as a house servant, mopping floors. Manolo Blahnik, the Bernini of shoes, as a gardener, and barefoot! Gianfranco Ferré, then running Christian Dior, would be Hattie McDaniel, in white shirt, custom-made piqué apron, and head scarf.

Naomi Campbell was posed, running up and down staircases, having dinner parties, in haute couture by Dior and Givenchy, an enormous vintage articulated diamond Cartier snake necklace, and the most expensive evening gown Karl Lagerfeld had ever designed for Chanel, costing over $200,000. Naomi played the role with such ease and joy, it almost made you forget the reality. If we were being historically accurate, a black woman would never have been able to play a grandiose grande dame of the nineteenth century. Lost in fantasy, that's what it's all about. I wanted people to think: *What if?*

Those images mean something totally different today than they did back in 1996 when they were shot. Fashion shows were exceedingly blond at the time. Designers would say they couldn't find anyone of color who looked right for their show, which was just hard to believe. Pushing back in such a subversive way felt bold and daring. Again, it was a quiet form of activism. My way of approaching diversity in the world of fashion was to communicate with the power of suggestion. I would not go up to Karl Lagerfeld and say, "Where are the black models on your runway?" Instead, if I didn't see a mo-

I
f anyone was
the first supermodel, it was
Scarlett O'Hara.

At Karl Lagerfeld's elegant hôtel particulier in Paris. Naomi Campbell as
Scarlett O'Hara saunters down the grand staircase in strapless haute couture,
spring 1996 Givenchy, from John Galliano's first ever couture collection in Paris.
Graydon Carter dared to trust me and let us create the story for *Vanity Fair*
on our own. *Photograph by Karl Lagerfeld*

ment of diversity, I would sit next to him and recommend girls who were missing. "What about Naomi Campbell, wouldn't she look great in that suit?" I never demanded representation and diversity of models; I finessed.

Most of the European designers whom I was close to rarely if ever needed finessing. The Battle of Versailles took place before I came to Paris, and black American models like Bethann Hardison and gorgeous Indian models like Kirat Young had had no trouble booking work in Paris since then. Karl, Yves, and Givenchy had always had beautiful models of color, ever since I'd known them. But trends would ebb and flow, and some years there would be plenty of black girls on the runway and some years there were very few. "Scarlett in the Hood" was powerful for that moment in time because in the midnineties there were very few. Does that photo shoot mean anything to the world all these years later? What is the legacy of a fashion photo shoot in *Vanity Fair*? In 2001, Alice Randall published the critically acclaimed novelette *The Wind Done Gone*. Perhaps she was inspired by this photographic satire. Fashion is not an industry that lives in the past, but rather carries its past along, like a shadow, wherever it goes.

In stark contrast, my knowledge and my past are what carried me through my career. My mind was constantly volleying the words of my grandmother and Diana Vreeland. One day in Durham, I went to my computer and sat there from seven in the morning until three in the afternoon, writing down my memories of them both. I knew it was in me, and I knew what I had written was important and powerful.

I called John Fairchild, still of *WWD* and *W,* and asked to see him for lunch. He invited me to Le Bernardin, a five-star restaurant. Mr. Fairchild dissected me as I glided to his table. Over lunch, I pulled out the pages from my Hermès attaché case and asked him if he would read them. I wondered if he would destroy me or praise me after he had reviewed them. I had no idea. But I knew he wouldn't simply dismiss what I had written, like other former employers

would have. He promised to seriously consider my pages, and a few days later, he called to say he would happily publish what I'd written, prominently, in *W*. Which he did, alongside photos of Diana Vreeland and my grandmother, the two women who expressed unconditional love to me.

Anna Wintour called me, *furious,* when it ran. How could I give my work to *W,* which was not a Condé Nast entity at that point? I told her exactly why: "I had to take it to Mr. Fairchild because I knew he would read it seriously and publish it respectfully."

She had nothing to say to that. But I could almost feel her disapproving gaze bearing down on me through the phone. The nuance of silence. I knew she wouldn't have taken the time to read the thirty pages that I had written. Mr. Fairchild, on the other hand, had always nurtured my writing.

My first memoir, *A.L.T.,* was a product of those pages. That book is something I'm immensely proud of, and if you read that book you'll truly get a sense of what shaped my personality and my aesthetic eye early on. But I still had to bite my tongue about certain people, for fear of reprisal.

When the book was written and close to publication, Anna wanted an advance galley of *A.L.T.* immediately. She wanted to be the first to read it. We were in Paris and I handed it to her in the car, on the way to a dinner. She read it overnight and the next morning said, "This is wonderful." To celebrate she threw a black-tie dinner in my honor on a Monday evening at the Metropolitan Museum of Art. A dozen close friends were invited: Oscar and Annette de la Renta, Ahmet and Mica Ertegun, Alexis Thomas (my friend from church), Lord and Lady Black, Diane von Fürstenberg. That is how Anna Wintour embraces a book—not by reading early drafts or giving notes, but by giving a party with the most prominent social denizens of New York. This was a supreme moment in the chiffon trenches.

. . .

In the fall of 1996, the entire Council of Fashion Designers of America went en masse to Washington, D.C., to honor the Nina Hyde Center for Breast Cancer Research. A White House visit and a gala at the Smithsonian Institution were arranged for the occasion, to be held in honor of Kay Graham, of *The Washington Post*. Anna Wintour loved Kay and considered her a friend and mentor. Anna invited me to come to D.C. with her, to the White House and to the black-tie gala.

Ms. Graham also hosted a luncheon at her Georgetown home, in her legendary Billy Baldwin–decorated dining room. The luncheon was in honor of Diana, Princess of Wales. To my surprise, I was seated to the right of Diana. This was indeed an honor. I was the only black man in the room.

Princess Diana wore a lavender Gianni Versace suit with a slim pencil skirt. I remember her asking me: "Lettuce? Lettuce?"

I didn't get it. I said, "Ma'am, lettuce?"

"Lettuce and Diet Coke?" she continued.

"I'm sure they'll bring you a Diet Coke, if that's what you want!"

"No, no. I suppose that's all they eat, lettuce and Diet Coke?"

A pregnant pause in the conversation followed, and me with a blank stare.

"The supermodels! I suppose they only eat lettuce and drink Diet Coke?"

It finally made sense to me. "Contrary to that general myth about supermodels, I can assure you that in my experience many of them have the appetite of linebackers! Literally!"

(If you wonder which models have linebacker appetites, I am not going to say. I will, however, say that once between two shows, back-to-back at Oscar de la Renta, a group of models, who will not be named here, requested that I send out for a bucket of KFC. The bucket of fried chicken arrived backstage, and in seconds, there was nothing but the empty container. It was as if a school of piranhas had attacked it. Before people became obsessed with kale salads and almond milk, top models ate steak, french fries, and, yes, lettuce . . .

on their hamburgers. Lettuce and Diet Coke are not in my memories about Naomi, Linda, Christy, Stephanie, or Cindy.)

As the luncheon continued, I made a colossal blunder. My elbow knocked Princess Diana's red wine glass straight into her lap. There was an audible gasp at the table. I said to myself, inside my head, *Oh, well, this is it, you'll never be asked anywhere ever again. You are sunk.*

With grace and total ease, Diana dipped the edge of her linen napkin in her water glass and looked at me with a beautiful smile as she blotted her dress. "Oh, it's nothing," she said.

The whole table relaxed their shoulders. Thank God! I thought I was going to be ostracized forever from the social elite!

Almost two years had gone by since I'd left *Vogue* in 1995, and yet my heart was still with the magazine. I told Karl I was thinking of going back.

"You better convince *her* to take you, and you better stay there this time," he said.

We didn't need to sit down and hash anything out; that's not Anna. When the time was right, I told her I wanted to come back, and she said fine. She did not make me grovel, nor beg, but simply agreed to take me back and went over what my new role would entail. Being creative director was no longer an option; Grace Coddington had already been named to that position several months after I'd left. I would now be an editor at large.

I moved back to New York from Durham and got back into a full-time work routine. I continued to escort Anna and share her chauffeured Mercedes-Benz sedan in Paris, to the twice-yearly ready-to-wear collections and often to the haute couture in January and July.

I also shared the car with her in Milan for the ready-to-wear collections, the lifeline to the commercial success of *Vogue*. My dapper and dandy appearance was paramount, though my position on the masthead had been lowered.

Although my new role was technically a freelance position, I was given a small office on the *Vogue* floor. I had my monthly "Life with André" column to do, and reported to a new editor, Alexandra Kotur, who had quickly become one of the great foundation personalities at *Vogue*. She never lost her sangfroid. I covered the collections and continued to serve as an ambassador for the *Vogue* brand, going to social events and networking, which was a large part of the job. But my schedule was set around Anna Wintour's fittings, as all her clothes are fitted and altered for her. I would observe and offer my keen eye for fittings of dresses from Chanel, or discuss fabric swatches from Prada, hers exclusively. Milan fittings for coats by Fendi, supervised by the late Carla Fendi, were some of Anna's most important appointments.

No one else was ever allowed to attend these luxurious fittings. As I recall, Grace Coddington once said, "André is the only person who has been allowed to see Anna Wintour in her underwear." That's not exactly the truth; Anna always displayed complete and correct modesty when fitting her countless couture frocks. Fittings usually took about thirty minutes. No hemming and hawing, no conversation. Anna puts on the dress, you say your opinion, change this, change that, and it's on to the next one. If you were ten minutes late, you'd miss most everything. Sometimes, we both arrived before the team from Paris. They'd rush in shortly after, out of breath, and measure and alter the toile in silence.

The worst fittings were when we had to go to Alexander McQueen. I'd always try to wiggle my way out of it, feigning an illness and announcing I was heading back to the hotel.

"Oh no you're not, you're coming with me," Anna would say. Maybe she was scared to be alone with him. I know I was. He didn't talk. He had so many demons and he didn't trust people. Not even a fellow Brit like Anna. I would extol and be enthusiastic and positive about the clothes, but he was always very withdrawn, and quite frankly his shows were not my favorites. Even though he was considered a genius, it came from a dark place.

Everywhere Anna Wintour went I followed, in my official *Vogue* capacity. On Mondays she had a brief staff meeting in her office. One week I showed up a bit late, wearing a jumpsuit, perhaps not the thing I should have worn. I walked into the room and she looked at me, observed me, but made no comment.

Shortly thereafter she called me at my desk and said, "You've got to go to the gym."

I wasn't offended, and it wasn't out of nowhere. Fashion at the time was obsessed with thinness. I'd gained weight in Durham and brought my binge-eating habits back to New York with me. My clothes fittings made clear to me exactly how big I was getting, and Anna Wintour's concerned glances did not go unnoticed. I was still wearing beautiful suits but it was becoming quite obvious that I was gaining weight.

If Anna Wintour wanted me to go to the gym, I'd go to the gym. Plus she offered to pay for it, so I had to take it seriously. The gym, located close to the *Vogue* offices, was a very expensive, tony setup. I had a private trainer, but I didn't practice the right eating habits at home, so I wasn't losing any weight. A friend suggested I try the cabbage diet, which I did for a little while. It's very easy; you just cook cabbage and eat it. People do it when they prepare for heart surgery. It worked, and I lost a lot of weight quickly, right in time for Milan Fashion Week.

In Milan, I would wake up early each morning and go for a walk, then spend some time at the hotel gym. I paid attention to what I was eating during the busy day of shows. I felt more in control of my weight.

Giorgio Armani's show was in the early evening, and I felt great wearing a gray cashmere turtleneck sweater and a Prada alligator balmacaan coat. I was standing in the waiting queue for entrance to the show, where a seat on the front row was reserved for me. On an upper level, there was a small VIP room, from which Lee Radziwill emerged and slowly came down the stairs.

At that time, we were not frequently on each other's radar. Lee

worked for Giorgio Armani, as an adviser, high-level ambassador, and events specialist, based in Milan. And it must have been that the last time she saw me, I was showing a little pillow of a stomach. Lee gently sidled up to me and gave me the most sensual rub across my stomach. And then she whispered to me for my ears only, "Ohhhhhh, André, you've lost weight. I am so proud."

I will always remember the way she made me feel in that moment. For a year, I went to the gym consistently, three times a week, but I couldn't keep up with the dieting. I'd buy all the right foods but they'd sit untouched in my refrigerator while I ordered takeout from the local deli. My weight continued to climb, and I developed asthma, something I'd briefly experienced in childhood but had long since grown out of. My breathing became labored, which was visibly distracting to Anna, especially when we had to walk up the many stairs outside the Met.

While I do think at a certain point my weight got in the way of my career, Anna didn't mention it again. And as my body grew and I no longer wanted to be harnessed into a suit—button-front, suspenders on the pants—I transitioned into a more extreme, original fashion point of view, in the tradition of Anna Piaggi and Isabella Blow. It wasn't just about the weight, however; it was the confidence *Vogue* gave me to be who I am. All the clothes I wore, my evolution of fashion, became a personalized reflection of my cultural knowledge of fashion, the history of fashion, as well as the history of fashion through paintings and literature. I began to dress based on research, in the highest-quality creations I could afford.

Anna depended on my views about the success or failure of a fashion collection and leaned on me for advice about how a couture dress looked on her, as did her daughter, Katherine, who went by "Bee." She was aware of the social ladies in my life, so many of them, who would take me to lunch, then to their fittings of important dresses: Anne Bass, Deeda Blair, Nan Kempner, São Schlumberger,

Lee Radziwill, and Lynn Wyatt. Women love to have friends who are not a sexual threat. Someone who listens.

The experience of having clothes made in Paris is unique. I'd learned it early on from Mrs. Vreeland, who was passionately devoted to her clothes from Paris couturiers.

When I first met her, Anna was wearing those cone heels by Maud Frizon. Manolo Blahnik was back then the rising superstar of shoes. Now, I can say with all authority, Anna's had a lifetime of Manolo Blahnik custom-ordered footwear given to her by our mutual friends, Manolo Blahnik and George Malkemus III. George was the owner, with his husband, Anthony Yurgaitis, of the Manolo Blahnik label in the United States until 2019, when the relationship folded. It was upon my recommendation that George had landed the lucrative empire three decades ago. They had made millions, if not several accumulated billions, from Manolo's genius mind for women's shoes.

Manolo Blahnik holds back nothing for Anna Wintour. In turn, Anna Wintour has not worn any other shoe but Manolo Blahnik—except for little Chanel ballerinas on the weekends—since 1989. I would meet Manolo and tell him what colors and styles Anna wanted, then he would create eight or nine versions for her to choose from.

What an incredible perk, to receive a lifetime of shoes, expensive, luxurious shoes. A signature cross sandal (not unlike the slingback sandal the late Queen Mother Elizabeth and Princess Margaret of England frequently wore) was her favorite for years. This uniform cross sandal would be ordered by the dozen, and after a season of wear and tear, tossed out, then reordered. All those shoes were stepped into after climbing into a Chanel couture, or rare Prada, or John Galliano, evening gown.

During much of my time at *Vogue,* the company would provide a town car to and from work. Those were the days of generous expense accounts; if a fashion editor wanted to go to Austria to photograph the new fur collections for ten days, there was no concern

about cost. Hotels, flights, food, the expenditures of the models, tips, etc.—it was all paid for, very few questions asked.

There were expense accounts for everything: lunch, dinner, custom dry cleaning; every single thing Anna Wintour wore was sent to the dry cleaner except her personal lingerie. I am not privy to how that is handled. Her two assistants, including the one who wrote *The Devil Wears Prada,* must take a sedan to her home every workday to deliver the big book (a mock-up of the current issue of *Vogue*), flowers, gifts, and huge piles of plastic-covered, fresh custom dry cleaning.

Sometimes I would piggyback and send my suits or formal white dinner shirts to Ernest Winzer or Madame Paulette by throwing them in the pile of Anna's daily dry cleaning. She has always been addicted to dry cleaning. When she was a young beauty in London, she would spend every morning before work dropping off the last night's clothes at the dry cleaner.

Nothing is left out of order in Anna's office or her homes. She is an advocate for cleanliness; you could literally eat off the floors in her home. Her kitchen was always spotless, which is directly related to the fact that I've never seen her cook anything. I *have* experienced her going into her small kitchen to make an espresso, when I might have been there for a late-afternoon fitting, just before a big event.

XI

When in a good mood, Karl could be the most generous man in the world, showering his friends with countless gifts of diamonds and precious stones, a sports car and expensive watches for his personal bodyguard, even providing black American Express cards for unlimited travel to and from Paris to his closest friends.

Karl invited me to stay the entire month of August 2000 in Biarritz, in his incredible villa. I hadn't taken a real vacation since coming back to New York. I told him I'd love to go, of course, but there was also a ball of dread in my chest. How was I to impress Karl Lagerfeld? It would require a minimum twice-daily wardrobe change. I had to quickly scramble for some clever idea.

Didn't Julius Caesar wear something akin to skirts, togas, and robes? Why did religious men in Bhutan wear robes that flow over their bodies? I researched indigenous dressing in North Africa, courtly dressing, theatrical dressing, and capes. This sense of sartorial style was my inspiration to assemble a wardrobe of caftans. Caftans are a simple way of being, easy to maintain, and bold. The loose fabric is dramatic and suited my height as well as my increasing girth. I told Karl and he loved the idea.

Yes! It seemed so right: comfortable, floor-length, cool shirts in the hot August summer. It is so much better than being trussed up in a pair of trousers and a chiseled, bespoke jacket.

Barbès, an African neighborhood in Paris, had numerous stores that sold beautiful, yet inexpensive, African woodprints in brilliant colors. I went on an exploratory trip, filled with the smells of live chickens and exotic vegetables. I found a store in a dark, unlit hole in a wall, sandwiched between a barbershop and a live poultry supplier. Three men sat at sewing machines, with piles of fabric behind them. The main tailor was Nigerien, Monsieur Sy. He told me where to go to find the highest-quality fabrics and said to bring them back to him. By the end of the afternoon, I had ordered seven caftans that would be ready in a week.

I called Karl and told him I could not wait to see him in Biarritz but I was concerned my current luggage wasn't on par with my new wardrobe. "I simply *need* a Louis Vuitton oversized trunk to travel with!"

Karl said to go ahead and pick it out, along with whatever else I wanted. I didn't ever ask Karl for money, nor did we ever talk about money. But I was always taken care of. It was all part of the performance and exactly the kind of thing Karl enjoyed being generous about. He then had his chauffeur-driven, customized Jeep drive me down from Paris to Biarritz in the south of France, with a new Louis Vuitton trunk and my new wardrobe. Karl followed by plane, as he finished up his collection for fall.

The massive Biarritz villa had an Olympic-size pool where you could hear music underwater. I never saw Karl in it, but he claimed he swam alone at night. A bit like King Ludwig II of Bavaria, floating through the grottoes in his swan boat, listening to Wagner.

Karl received several other visitors while we were there, and each was greeted with the utmost luxurious hospitality: beautiful linens, flowers, newspapers, and elegant Diptyque candles burning in every corner.

Élie and Liliane de Rothschild came for four days (Karl sent a

private plane to whisk them and other wealthy friends in and out of Biarritz). The grande dame Liliane and I bonded immediately—she loved my caftans—and Élie asked me to take his wife to Barbès, to buy fabric, which I did, later that year.

While my weight had been creeping up, this was the last time I was thin enough to sit by the pool before and after lunch, with the baron and his wife, where we discussed Marie Antoinette (Liliane was a royalist; Marie Antoinette was from her native land, Austria). Liliane would wear a full-corset one-piece *maillot de bain,* while Baron Élie would emerge from the musical pool completely nude. I never saw such long-hanging fruits as his.

I was about to depart after nearly three and a half weeks when Ingrid Sischy and her wife, Sandra Brant, arrived to take over my grand guest suite. Ingrid dismissed me most of the time and had no problem interrupting a conversation, thereby occupying and orbiting around Karl. No one else could get in a word after Ingrid arrived.

One morning, Ingrid woke up with a tick bite or spider bite, whatever, and insisted Karl take her immediately to the emergency room. She lowered her sweatpants to show Karl the big pink splotch, in front of his luncheon guests, including Bruno Pavlovsky, the CEO of Chanel in Paris.

It was time to go back to New York. I couldn't be there with those people. Karl hadn't said a word about my caftans, but he never really complimented the way others looked. Instead, you always had to compliment him. I suppose the fact that he didn't dismiss me completely was compliment enough.

I offered to tip the household staff and chauffeur, but instead, Karl had 12,500 French francs sent to my room, for me to hand out to everyone, from maids to cooks to the ladies who ironed the luxurious linens for all the beds in the house.

After so much generosity, I had to come up with an appropriate gift for Karl, something suitable to his grandiosity, but within reason. He loved four-leaf clovers as symbols of good luck, so I thought

it was particularly good luck when a jewelry dealer showed me an antique eighteen-karat-gold stickpin with a four-leaf-clover diamond embellishment.

It was, for me, a very expensive gift, even on a solid salary. I bought it and was proud to give it to Karl. At last, as a gesture of friendship, I could offer him a gift *worthy* of his vast collection of jeweled stickpins.

How hurtful it was when I found out soon after that he had re-gifted it to Eric Wright. No one could ever give Karl anything. He controlled his court. Victoire de Castellane (who designed the amazing costume jewelry at Chanel from the time she was a teenager) had once given Karl a small, beautiful mirror, designed by Christian Bérard, as a birthday present. She gave it to him at work, in the Chanel studios. By the time he got home and unpacked his car, he had re-gifted the mirror to me. It was hopeless.

Most of the twice-yearly special couture photoshoots for *Vogue* were overseen by Grace Coddington. These prestigious assignments were like a special award and Grace was the go-to genius editor for them. Sometimes, Tonne Goodman was assigned. There were only two occasions when Anna Wintour trusted me to do a full couture shoot, for which I was honored. One was a collage of designer diaries and swatch books of inspirations for that season. And the other was with Renée Zellweger, who had just won her first Golden Globe for Best Actress in a Musical or Comedy, for *Nurse Betty*. Arthur Elgort was assigned to photograph the shoot.

Renée came to Paris and Anna Wintour gave her a big party at one of *Vogue*'s select favorite bistros, Chez George. Oscar de la Renta, who designed for Balmain at the time, came to the dinner. So did John Galliano. In walked Renée, fresh from Hollywood, with a vintage Hermès Kelly handbag, alligator in black. She had treated herself to this bag, purchased in Los Angeles, but she was not sure of

its authenticity. I assured her I would go with her to the grand Her-
mès shop to ascertain whether the bag was real or fake.

Over three days, Arthur Elgort and I escorted Renée all over
Paris. We had fourteen pages to fill and each photo had a different
location and setting, most of which were outside. It was a physically
challenging shoot, running around Paris with quick clothing
changes, especially since Renée was not a professional model, but
she was totally cooperative and full of energy, style, and class. Ar-
thur knows how to engage his subjects and make them comfortable
in order to ensure his work is a success, and he got along with Renée
like fireworks.

After the last shot was done, Renée and I headed to Hermès. I
had a personal salesman there at the time, Monsieur Tessier, who
sported a very rococo moustache, hand waxed and curled on the
ends. Eric de Rothschild had personally introduced me to him and
asked him to take care of me, which he did every time I went in, and
I went in a lot (to buy printed scarves to line my suit jackets and to
cover scatter cushions for my sofas in my home in North Carolina).

Monsieur Tessier inspected Renée's bag and disappeared with it
into another room. Minutes later, he came back and told us this bag
was indeed one of the finest examples of Hermès from the 1930s, in
tip-top shape. "The skins used for this bag are the best examples of
Louisiana alligator," he said. "We don't use these skins now. But it is
a great buy." Renée was thrilled.

That year for the holidays, Renée sent me a live Christmas wreath
of a scale so big I had to pay two men to climb a ladder and hang it
on the front exterior of my house. It looked like a wreath you might
see on a door of a Fifth Avenue store, like Bergdorf Goodman. A
truly impressive gift.

Of all the Hollywood film actors I ever met, Renée is the only
one who has the eye and mental agility necessary to be a serious fash-
ion editor. She adheres to the mantra of Diana Vreeland: "Elegance
is refusal." Or as Chanel once said, "Simplicity is the keynote of all

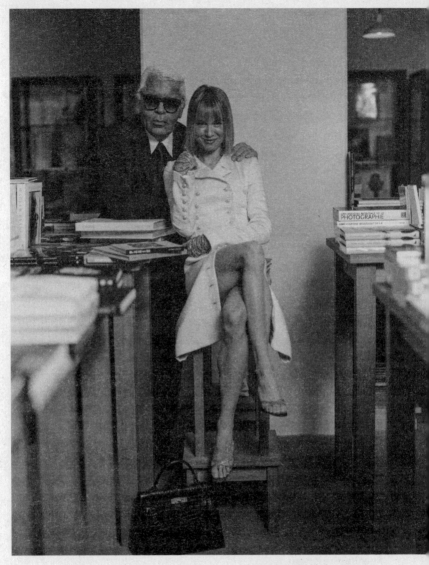

Renée Zellweger in a Chanel couture look by Karl Lagerfeld, for a *Vogue*
couture shoot styled by yours truly. The Hermès Kelly is her own
vintage; a present she bought upon receiving her first Golden Globe.
Shoes: Manolo Blahnik. Photographed at Lagerfeld's bookstore 7L,
on rue de Lille, Paris. *Photograph by Arthur Elgort*

true elegance." We speak the same language of style. She dresses with clean lines, strong fabrics, no excess. No bling bling, real or fake, on her neck or ears. Makeup made to look like she simply washed her face and put on a moisturizer. Heels are always high stilettos, bare legs. One simple gold bracelet on her left wrist.

Renée and I first met some years earlier on a shoot in California, when she was an emerging talent and I was with *Vanity Fair*. Two years after this couture shoot, Tonne Goodman and I again worked with Renée, on a *Vogue* cover shoot. Rarely do two editors go on a cover shoot, but Anna asked me to go because Renée and I had bonded. We remain friends to this day, regularly exchanging details of our lives by e-mail.

A nna Wintour liked to assign me house sittings. She knew I could charm the snakes from the trees, which is a good quality to have while traipsing through the dressing rooms of socialites.

Normally it would take four to five days to properly shoot a house to *Vogue*'s standards. You don't go in there and shoot a house layout in one day. Instead, you're there for several, from eight in the morning until five in the afternoon, shooting bathrooms, artwork, etc.

Back in the 1980s it took two editors, Anna Wintour and me, to photograph Paloma Picasso's apartment. Paloma was then married to Rafael López-Sanchez and had just bought a large duplex on Park Avenue and decorated it. It was a major coup for us to get that apartment in the pages of *Vogue*. Horst P. Horst was the photographer. Anna, then creative director, would go up and sit there one day and I'd go the next day. We were there for a week.

Ralph Lauren's Bedford house took three days to photograph. We had a great time and I was happy to get to know the iconic designer.

"I can see now, it's wrong, what people say about you," he said after the first day of shooting.

"What do they say?!"

"I thought you were pretentious!"

Everyone thought I was pretentious because I was running around Paris with Karl. But I wasn't, and I proved it to Ralph Lauren, whose approval I treasure.

One of my favorite house sittings was with Anne Bass, who had just left her husband and wanted to show off her new luxury Fifth Avenue home, decorated by Mark Hampton. There were *stacks* of telephone-book-sized divorce briefs strewn throughout her sitting room. It was a fabulous apartment, replete with incredible art— William Turner, Balthus, Picasso, and the Degas sculpture of the ballerina. Seeing her vast collection brought to mind my time with Andy Warhol, whom Anne had commissioned to paint over a half-dozen portraits of herself.

Vogue's former senior fashion news editor Kathleen Madden had gone down to Texas to interview Anne in her Dallas home, and when she came back she said, "All Anne Bass offered us was a glass of water." Anne was not the warmest person, which I already knew and was prepared for. As I had shown time and time again, once people get to know me, they get comfortable with me. I was confident it would be the same with Anne's shoot.

We shot a range of interiors: Anne's closets; her big puffy Ungaro dresses; one closet full of Scaasi evening dresses; her private exercise room, where she had a ballerina barre; her living room, featuring a Helen Frankenthaler; her library with the Picassos; her dining room with the Monets; the Degas in her bedroom, on the mantle in front of her Mark Hampton four-poster bed.

It was the biggest house sitting I'd ever done. At the end of the final day, we asked the butler if he could order us takeout. Anne walked in and found the photography team sitting on the floor in the kitchen, gobbling down greasy slices of pizza. She was quite startled. "What are you all doing in here?" she said.

"We're just wrapping up and didn't dare bring a pizza box to your dining room table! It would be so rude!"

Anne laughed.

After the piece ran in *Vogue,* Anne invited me to Florence with her and her daughter. I said yes, I'd love to go!

I got back to *Vogue* and Gabé Doppelt was circling around my office door. This was never a good sign. Gabé had worked at *Vogue* a long time and had a tendency to make herself important by telling news about other people that could be detrimental to them. You know, *that* kind of person. Jealous.

Gabé was well-known to stalk the lone fax machine all day, and apparently she had seen a fax from Anne Bass about Florence and told Anna about it. If I had been able to ask Anna Wintour, "May I go to Florence with Anne Bass?" there would have been no problem. But Gabé had taken the fax to Anna Wintour and must have presented it to her in a negative light and as a done deal. Without saying so, Gabé let me know that Anna Wintour was not going to let me go to Florence. The trip was kiboshed.

Anne Bass and I became good friends regardless. We would often meet in Paris and have supper, just the two of us. Underneath it all I found her to be a woman of sincere empathy, with a passion for the arts and a love of beautiful things. When she came to Paris to buy couture, I would go with her to YSL, Dior sometimes, and sometimes Lacroix. Then she discovered Chanel and often ordered from Valentino. The clothes were always off the charts, and she loved them. She was practically addicted to clothes.

Now she has turned her high-fashion attention to Prada, and custom-made Zac Posen day skirts and jackets. She has evolved with her new partner, a wonderful English painter, Julian Lethbridge, whom she met at a dinner at Anna Wintour's townhouse. We remain good friends to this day.

Karl Lagerfeld did things for *Vogue* he would not do for anyone else.

Four times a year, all of *Vogue* descended on Paris: in January for

the couture, March for the ready-to-wear, July for the couture, and October for the ready-to-wear. Each time, Karl would give a special dinner for the entire staff, at his house, surrounded by his eighteenth-century decor and his porcelains and silverware. If we had visiting writers, they would come as well. Even Oscar de la Renta and Tom Ford were each invited once, the only designers to ever receive such an invitation from Karl.

Karl had a knack for social networking with the editors. Having been born into a wealthy family, he knew the value of sending special handwritten notes and gifts. Distinctive gifts. He would send books and oftentimes Diptyque candles. He was the biggest client at Diptyque.

When a collection came, he would send grand flower arrangements to every important editor. Something like two hundred bouquets of flowers were sent out, from the best, most expensive florist in Paris. Each one with a handwritten note. When he went to Chanel, the arrangements, paid for by the company, only became bigger.

Somehow Karl knew how to keep strong relationships with people who were important to him. But he did have one spat with Anna Wintour, when she approached him about doing a Chanel retrospective at the Met.

Karl never got into the museum thing the way I did, ever since my time volunteering for Mrs. Vreeland. He was dismissive of curatorial exhibitions of fashion. He did not like seeing old, dusty clothes in museums, and he loathed coming to the Met. He came to the Met Gala for many years out of respect for Anna Wintour, but then one year he didn't come, and he never came back. Amanda Harlech curated an exhibit of his work in Berlin once, and he never even went. To his own exhibit, curated by one of his closest friends!

So when Anna Wintour asked Karl about doing a Chanel retrospective at the Met, she was asking a loaded question. The show was on, but then it was off. Somehow Ingrid Sischy of *Interview* got her two cents in and turned Karl against the show. In his mind, Karl was still at the height of his career, and a retrospective was for a designer

on his way out. Ingrid made Karl think it was not the proper thing. You know how people stir the pot. She wanted to show her power, impress.

Like any courtesan or courtier, Anna still went to Karl's shows and acted as though everything was status quo. In the world of Anna Wintour at *Vogue,* there are no arguments. Nothing was ever discussed. But Karl was not picking up the phone to talk about this museum show anymore.

One day, Anna asked me to get Karl on the phone.

"He's not coming to the phone, he doesn't want to talk about this."

"Come to my office and get him on the phone."

And I did. Then she threw me out and closed the door. I don't know what they said, but the idea of a Chanel show gradually fizzled.

About five years later, Anna once again came to me asking if Karl might finally be interested in a retrospective show.

I encouraged her to bring it up with him once more. He said yes, and the Chanel Met show happened, in 2005. With Anna Wintour, you know the drill: Things get done her way, even if it takes a few years.

XII

Stephanie Winston Wolkoff, publicity director at *Vogue,* came to my desk and said, "Ange, here's a letter you should read."

On elegant stationery, a formal invitation from SCAD, the Savannah College of Art and Design, had been penned by their original founder and visionary, Paula Wallace. She invited me to receive the Fashion Icon Award and hold master classes.

As reluctant as I was to leave New York and head down to Savannah, I was so charmed by this enchanting letter, and honored to be considered, that I agreed to go. My freelance position as editor at large at *Vogue* allowed me time away from the office and the ability to take on other projects.

I was greeted at the Savannah airport by Danny Filson, SCAD's best ambassador. He drove me by some of the interesting downtown architecture and sites. We stopped in for a bite at the Gryphon tearoom, a former local drugstore, where a whiff of the ancient Orient prevailed, with a Chinese sandalwood pavilion containing books arranged in groups by color, and the antique pharmacy drawers with ivory knobs remained intact, part of the charm and warm décor.

All the highlights of the school that seemed unique and exceptional, I was informed at this lunch, had been envisioned by Paula

Wallace, who founded SCAD in 1978. Paula nurtured her dream of a forward-thinking university for the arts in the South, with the highest standards.

A week after I received the Fashion Icon Award and returned to Manhattan, President Wallace sent me another elegant letter, suggesting that I present the André Leon Talley Lifetime Achievement Award each year, at the annual Senior Fashion Show, to anyone who I thought should be so honored. Nothing like this had ever been offered to me in New York or Paris; I gladly accepted.

The first recipient of the award was my friend Oscar de la Renta, who took a commercial plane down from Connecticut on a Saturday morning to receive the prize later that evening. Danny and I picked him up at the airport and went straight to President Wallace's residence. After a delicious Southern lunch, Oscar went to a hotel room, rested, and put on his navy bespoke suit to receive the award. A reception for the students followed, and a light supper, known as a repast in Southern jargon.

That night, I secretly whisked Oscar off to the last show, at midnight, at Savannah's gay disco, Club One. The Lady Chablis, known for her breakout role as herself in the book and film *Midnight in the Garden of Good and Evil,* came to Savannah every other weekend to perform. Everyone had the Lady Chablis on their radar.

We reserved front-row seats and had to sit through an hour-long display of funky drag queens lip-synching to current hits. Then the Lady Chablis swanned onto center stage, in a midnight-blue spangled Bob Mackie–esque gown. Her drag show was raw, raunchy, and completely off the rails; she stalked the audience, enraptured and fueled by generous alcoholic drinks.

The Lady Chablis called out members of the paying audience for her sexual rants, with the floodlights beaming directly in their faces. "By the way, ma'am, blue is definitely not your color," she deadpanned to one unsuspecting attendee. "Two tears in a bucket! Motherf★ck it!" I was terrified her swamp-vile jokes were going to

be too absolutely outrageous for the elegant Oscar, in his best navy lounge suit.

"Oscar, what do you think of her?" I asked as he sat with his arms folded neatly across his chest. His neutral face showed no emotion whatsoever. I thought, *Have I made a huge mistake, bringing Oscar de la Renta to this late-night den of drag?*

He then said, with great seriousness, "*Elle est très raffinée.*"

I was so relieved. After the floor show ended, we went backstage to the Lady Chablis's matchbox of a dressing room, cramped with knockoff evening gowns. She was honored to meet Oscar and full of grace.

That was the first ALT Lifetime Achievement Award. The second one went to Karl Lagerfeld, who, due to his busy work schedule, what with now covering Fendi, Chanel couture, and his own collection, didn't come to Savannah. President Wallace and SCAD sent me to Paris to present Karl with the award in person.

I called up my good friend Elizabeth Hummer, a videographer who had worked closely with me on special interviews for *Full Frontal Fashion,* a cable weekly fashion show.

"Elizabeth," I said, "do you want to go to Paris and film Karl Lagerfeld being presented with an award? We will be staying at the Ritz."

How could she possibly say no?

We were only in the City of Lights for a scant seventy-two hours. I presented Karl with the crystal orb, right at his atelier desk in the studio for his Karl Lagerfeld label. In return he donated a series of huge photographs for an exhibit at SCAD's Red Gallery. They were all of pale peony-pink evening dresses that had been shown in his former couture collection. Afterward, Karl donated the entire collection of images to SCAD.

Departing for the airport to return to New York, I spotted Elizabeth, coming down the main staircase in the Ritz lobby, carrying all her luggage and camera.

In my usual barking loud voice, I exclaimed, "Elizabeth, this is the Ritz! No one comes downstairs carrying their own bags! It's just not done!" Annette de la Renta would never be caught carrying anything upon checking out but her handbag. This was Paris!

The next year, Miuccia Prada received the award, but I almost didn't survive to give it to her. Days before she was due to arrive, I was in Greenville, Mississippi, attending the wedding of my great friend and one of *Vogue*'s best political writers, Julia Reed. At six forty-five in the morning, I was en route to the airport to return Anna Wintour's rental car after the wedding when I fell asleep behind the wheel, crossed two lanes of opposing traffic, and turned over three times. When it was all over I was upside down, in a cotton field, suspended in midair.

Luckily I had my seat belt on and didn't end up a mangled corpse. A man reached in, unbuckled my seat belt, and pulled me gingerly through the front passenger side.

"Is my luggage okay?" I asked him.

"Your car is totaled," he said.

"The car's a rental, my luggage is Louis Vuitton!"

He helped me open the trunk and, thankfully, my suitcases were undamaged. My guardian angel knitted his brow and I felt silly that I cared so much about the luggage when I had almost just died, but that was my honest reaction to the shock of it all. Then when my adrenaline returned to normal, I started to process what had actually just happened and how close I had come to a tragic end. A tow truck was called and I rode up front with the driver, who told me many a driver had been found dead in that field. I was silent and thanked God.

In Washington, D.C., Deeda Blair was expecting me for a lunch hosted in my honor at her home. I called to tell her I'd missed my flight and would be on the next available plane. I didn't say anything about the accident; I didn't want Julia Reed to find out while she was on her honeymoon!

For the next eight hours, I sat in the airport, Mississippi mud caked on my gray matte crocodile flat man bag and matching hat. The gray matching Prada balmacaan coat thankfully lay packed away in a suitcase, untouched by any mud.

After a quick stop in D.C. for Deeda Blair's lunch, I immediately returned to New York and quietly checked myself into White Plains Hospital, near my home. They kept me for three days, thinking I might have whiplash. I was traumatized but said nothing. On the third day, I left the hospital and flew back down to SCAD to greet Miuccia Prada and hand her the Lifetime Achievement Award. For one week, I spoke to no one of this accident, except Anna Wintour; she of course had to be told. It was her rental car, after all.

Over the next ten years, I presented the ALT Lifetime Achievement Award to the greatest talents in fashion: Tom Ford, Vera Wang, Marc Jacobs, John Galliano, Isabel and Ruben Toledo, Diane von Fürstenberg, Manolo Blahnik, Ralph Rucci, Francisco Costa, Stephen Burrows, and Vivienne Westwood. Zac Posen was awarded the New Look Award.

Just about every one of them came down to Savannah to be honored and appear in person, which truly made me proud. Galliano did cancel at the last minute. It was frustrating, as we had spent two years planning around his schedule to make it happen. But Galliano canceled on Queen Elizabeth II for a state dinner at Buckingham Palace, so it was hard to take it personally.

I suggested Paula Wallace invite Whoopi Goldberg down for a commencement address one year. Whoopi, the most sensitive, intelligent, articulate black woman on television, navigates steadily through the icebergs of being a black woman in the entertainment industry. She is otherness as she refuses all norms of fashion, and she creates her own style with her quirky collection of footwear (high translucent heels containing fake goldfish!) and her refusal to wear a typical evening gown to the Oscars (she selects frigates of crinoline and chintz brocade that have the scale of a Scarlett O'Hara dress).

She spoke inspirationally to the students at SCAD, with no notes, and got a standing ovation. Later, she donated an antique Steinway baby grand to the school.

So many firsts happened for me at SCAD, firsts I never could have achieved or been recognized for in New York. I sometimes felt as if people in the world of *Vogue* and fashion in general had put me in a preassigned, limited zone. Anna Wintour didn't see me in the role of curator. She failed to see how my knowledge gained under the tutelage of Diana Vreeland fueled me. I learned everything from Vreeland. Literally, she taught me how to analyze the power of fashion, its beauty, its technique, its historical relevancy, its worthiness to be viewed in an exhibit. Fashion can be an emotional experience.

Meanwhile, back in New York, one morning as I walked into *Vogue,* I was met by Patrick O'Connell, public relations director. He said we had to go to the conference room downstairs.

Whenever you had to take the trek to the third floor, it was grave.

"Am I being fired?" I asked.

"Just come," he said. I followed him back to the elevator. Dead man walking.

By the time we got to the third-floor conference room, I had pulled myself together enough to put on a brave face. As long as I didn't cry, I could deal with this. I opened the door, and there was my pastor, Dr. Calvin O. Butts III, of Abyssinian Baptist Church. Seated next to him: Oscar and Annette de la Renta, two of my closest, dearest friends. And then, standing stoically, there was Anna Wintour, with her new boyfriend, Shelby Bryan, seated next to her.

At first I thought, *How fabulous! I must be winning an award!* But the somber faces made clear there was no such award coming. "What happened?" I said.

Anna instructed me to sit down and Shelby filled me in. I was not being fired; I had just walked into an intervention. It was explained that my weight was out of control and I was being sent off to reha-

bilitation at the Duke Diet and Fitness Center in my hometown of Durham, North Carolina. A first-class plane ticket had already been purchased for that same day.

I didn't know what to say. Quietly I listened as Anna and Oscar explained their concerns. It was pretty clear most of the concern was coming from Anna and the rest of them had been pulled into this. None had had the forethought to warn me, though. *Maintain your dignity,* I thought. *Just keep it together until you can get out of here.*

After they were done speaking, Shelby asked if I'd be taking the flight. "I've got to think about it," I said, and walked out of the room.

I never got on the plane that day. And for a year after I pretended it never happened, instead trying to fix my dietary problems myself. I only got bigger. I sent a note to Anna, telling her I was ready to go to Duke and get help. She arranged for me to attend and *Vogue* paid for the entire program. The first week, I lost twenty-four pounds. The second week I lost twenty pounds. I sent Anna Wintour weekly e-mail messages about my progress. Each week I lost more weight and I was happy to be in an environment that cared for me and educated me, medically and emotionally, on obesity.

I stayed at Duke for three months, until spring, and in that time I learned the value of calories, diet, exercise, and, the hardest part, mental wellness. I never wanted to go to the therapy sessions because I knew I would never be able to discuss my childhood trauma, the root of my emotional weight issues.

When I got back to New York, I'd lost fifty-five pounds. There was a startling change in me at first. I could once again don my pale gray suit for a TV interview in the *Vogue* art department. And I went on to wear my navy blue suit in a special on the Oscars. For a while, dieting worked. I bought a rowing machine; I walked early in the morning before the day began. Anna even encouraged me to play tennis before dawn. I did this for a while . . . then I just fell off the wagon. It was hard to keep up the skills I'd learned and remain disciplined in my eating. I eventually gained all the weight back. Since

then, I've returned to Duke three times. It's been a yo-yo battle I long ago realized I will never win.

Overwhelmed by my increasing weight, I turned to gastric Lap-Band surgery, under an assumed name: Dolly Longstocking. My dear friend Alexis Thomas came to the hospital predawn and prayed with me (and my Russian anesthesiologist). She is the chair of the trustee board of our church in Harlem, Abyssinian Baptist Church. Our bond is fashion, but more than fashion, our bond is our faith. She guides me through the rains and the storms. Later that day, she came back and spent the entire night in a reclining armchair in my room. I spent the first week of recovery at her home in Brooklyn, where I drove her mad with my requests for crushed ice and ginger ale.

For Christmas, I gave Alexis Joan Crawford's perfect vintage mink coat, bought at auction at Doyle Galleries. She earned it with her unconditional love, but she seldom wears it; she chooses to wear her own mink, bought with her own hard-earned money. Such is a proud woman!

The Lap-Band didn't work for me. It's supposed to make you feel like you're gagging if you eat too much, but that never happened for me. Once again, I failed to keep the weight off.

Karl Lagerfeld, on the other hand, lost all his weight and kept it off for the rest of his life. At one point, Karl was as big as I was. He used to come home at the end of a day's work at Chanel and consume several frankfurters cold, right out of the refrigerator, like a rabbit nibbling on a carrot. In fact, during his open-fan fat-shielding phase, Karl loved nothing more than a steady diet of late-night cold, raw frankfurters, with several glasses of Coke Light in fine Baccarat crystal and huge slices of Emmental cheese.

When he decided to lose the weight, Karl leaned into it with his enormous wealth, relying on doctors and others to come up with the best possible diet. We would go to elegant lunches, with beautifully set tables and flowers, and Karl would order steamed fish and vegetables, and maybe a hot soup. And then, while everyone else at the table ordered dessert, Karl would have his man split open a space-

age package of chocolate powder, which Karl poured into a fine porcelain bowl of hot water and stirred to a creamy, almost mudlike consistency.

Gradually Karl was getting thinner, and his wardrobe reflected his new physique. People asked how he lost the weight but he kept his regime a secret. I don't know exactly what the regime was, but I know for sure it did not include exercise. He did have one craving that he found difficult to give up—bread. It is my own personal downfall as well. On trips, he would pack one small Goyard suitcase with his favorite bread. He would chew the bread, savoring every bite, and then spit it out into a napkin. That seemed like a lot of trouble, but it worked for him, apparently, as he eventually lost one hundred pounds.

Once Karl was skinny again, he would comment on my eating choices. If I had a glass of wine, he would say, "Are you supposed to really have wine? It has sugar in it." Although he chided me for my dietary habits, Karl still accepted me no matter my size. A fat man is always a fat man on the inside, no matter how skinny he becomes on the outside.

Lee Radziwill also had very serious concerns about my increasing weight.

One day, Lee summoned me to her apartment on East Seventy-second Street in Manhattan. She wanted to see me most urgently. I arrived, and she motioned for me to sit right next to her on her fine custom-made sofa; it was the scale of a boxcar, so deep and cushioned. "André, I love you. I want you to go and see my doctor, I want you to talk to him and he will help you with your weight problem." Lee made me feel like a child whose best friend wanted him to get well. She stroked my hands and was gentle with me. She intervened with the fragility of someone who was not afraid to recognize her own frailness and demons. Lee was special.

I took her doctor's name and went to go see him, but only once. He was a psychotherapist, and it cost me five hundred dollars for forty-five minutes. I thought to myself, *I don't have the time, nor the*

money, to put toward this. Coming from a Southern black culture and upbringing, I was taught to just get on with it. We don't have time for therapy and self-reflection. I regret not pursuing Lee's suggestion more; it would have been a much-needed investment in wellness.

The last of the three times I went to Duke Diet and Fitness Center (Anna got S. I. Newhouse to foot the bill each time), Maureen Dowd profiled me in *The New York Times*. She opened her text by busting me: She caught me eating biscuits at the Siena Hotel, where I lived during my months-long journey at DFC. I spent Christmas and New Year's there that year. It was bleak. Very bleak. On holidays, I cave in to the memory of love, and associate desserts and eating with the love I experienced at my grandmother's table. She was a great cook, and sweets crowded the side console cabinet during Thanksgiving and Christmas.

I have no answer as to how to overcome this. I will try until I die, every day. Just keep trying to be well. Enough said.

I intend to leave in my will that I am to be cremated in a caftan.

After gaining back the weight following my third and final visit to Duke, I came to terms with the fact that I would never again be skinny enough to wear traditional clothes; no more bespoke English suits. Somehow everyone seemed pleased with me in caftans, so I simply continued to collect them, wearing them from morning to night.

There are still times when I need a traditional suit, for a wedding or a funeral, and I go to Ralph Lauren for custom-made suits, including one of my favorites, a banker's gray three-piece suit he made for me for my cameo appearance in the first *Sex and the City* movie: I had no speaking role, but I am still recognized on the street from that brief appearance on film.

Caftans are my wellness retreat in terms of my daily, individual style. Do they hide the worst human flaws? Yes! Are they elegant? Yes!

As I slowly embraced the comfort and ease, my designer friends began asking if they could make caftans for me. Diane von Fürstenberg made me numerous caftans using the original silkscreen fabrics from her own collection, like one in black with pink surreal lips, which I loved.

After that, I met Ralph Rucci, who, in one fell swoop, cut me seventeen couture caftans, from swatches of very expensive silks. These are the foundation of my caftan life.

I have had brilliant black silk moire from Taroni fabrics by Ralph Rucci (two of them) and my samurai warrior trapunto caftans, inspired by a great exhibit at the Metropolitan Museum of Art in 2009: *Art of the Samurai: Japanese Arms and Armor, 1156 to 1868*. From that moment on, I decided to wear nothing but caftans, as a man could be dressed in something like a tunic, or floor-length dress, and be appropriately dressed.

I love my caftans and the evolution of them, including my cotton seasonless shirts in red and black, which are ordered from Au Fil d'Or, the large souk in Marrakech, and made by an ancestor of Monsieur Boujima, who had first made all the passementerie for Yves Saint Laurent's collections in the 1980s. My court capes and ceremonial coats, by Tom Ford, are some of the most brilliant looks I am privileged to wear. My favorite one is an embroidered blue court coat. I wore it for a portrait by Jonathan Becker on my favorite bridge, Pont Alexandre III, in Paris. The portrait accompanied a definitive feature article in Graydon Carter's *Vanity Fair*.

My personal style evolved over decades, and it is fundamentally the awareness that a man can dress with splendor, in full-blown over-the-topness, and be admired for it.

I am proud of my knowledge of historical style, how men dressed at the French court, with powder and curls in their wigs, fully adorned in ruffles, jabots, satins, and jackets that swung as they walked, like great skirts. Men wore heels; just look at the portraits of Louis XIV by Hyacinthe Rigaud—he wears not only heels, but red heels and white stockings on his shapely legs.

My clothes are like ceremonial seventeenth-century Italian armor. They are like *traje de luces,* bright pink capes lined in yellow, worn by matadors as they enter the bullrings in Mexico and Spain, or like the tight-fitting boleros and trousers of the great flamenco dancers. Capes and caftans suggest ceremony, a sense of formality. I may not be in a three-piece or two-piece business suit, but as much thought goes into my caftans as is required of my bespoke tailors from London, Richard Anderson and Huntsman.

Yes: I was using the caftans to shadow the rise and fall of my adipose crisis. I was bloated by weight, bingeing on sweets, whether it be marble madeleines and hot chocolate in Paris or the rich dishes offered at New York's finest restaurants. I was never insecure about who I was, how I looked. I never thought I was ugly. I never thought about my looks to begin with; I only thought about my clothes. In the cruel and sometimes fickle world of high fashion, I know I was quietly judged. Despite sometimes feeling like a manatee, I kept my pride intact. My confidence remained high at all times. To me, caftans were the culmination of historical inspiration and collaboration with great designers like Valentino, Ralph Rucci, Tom Ford, and an unknown man, quietly sewing in a crowded hole in the Barbès section of Paris.

In 2008, Valentino designed for me two incredible caftans to wear to his three-day celebration in Rome. Carlos Souza coordinated the fabrics, and when I arrived in Rome as a guest, I ran to his couture house for fittings. I had a canvas toile made for the shape; two vintage couture fabrics from the Valentino archives had been selected for me: a green cotton with huge black jaguars, and a brilliant Chinese dragon motif, edged in neon green and red. Both caftans were worn over custom-made Charvet of Paris cotton shirts and white dinner shirts.

Valentino's three-day party was extravagant, including a first-night dinner held in the famous Roman Forum. I was housed in the luxurious Hotel de Russie. Upon checking in, I had a handwritten note. It was from an Italian artist, Riccardo Ajossa.

tions with an insouciant remark. She had the best Irish qualities—loyalty, down-to-earth when it mattered, a sense of self, and confidence.

She was best at presiding over her tables of sketches and designs for accessories at Yves Saint Laurent. She admitted when she first joined the inner sanctum, including Anne-Marie Muñoz, she simply stood around and suggested colors. No matter how hard she loved to party, she took work and life seriously. One of her last projects, she curated the definitive Rive Gauche exhibit, at the Pierre Bergé–YSL Foundation in Paris, last year, which captured the essence of that groundbreaking moment when fashion broke away from couture and afforded women, and men, the ability to walk into a Rive Gauche boutique and find everything from Belle de Jour velvet dresses to plaid shirts with kilts. In my last conversation with her, she wanted me to be sure to attend the opening night. I went to the exhibit and called her, to leave a message that it was extraordinary.

Betty has kept all her original Yves Saint Laurent couture and Rive Gauche clothes, nearly three hundred items. Her husband, interior designer François Catroux, designed a private mini-museum at their home for the looks. The Fondation Pierre Bergé–Yves Saint Laurent will soon mount an exhibit solely consisting of Betty Catroux's personal archives.

There is a haiku poem by the seventeenth-century Japanese poet Bashō that sums up how I feel about Betty:

I sit here.
Making the Coolness,
My dwelling place.

During my time at *Vogue,* I had been involved in cover discussions featuring some of the most powerful and influential women of their time, including leading actresses, singers, models (of course), and even First Ladies.

Upon the election of President Barack Obama, Anna Wintour

arranged a meeting with Valerie Jarrett, to discuss Michelle Obama's first *Vogue* cover.

I had met the soon-to-be first African American First Lady of the United States before, at Oprah Winfrey's house. Oprah was having an all-girls lunch at the time of the Legends Ball and invited me along to Santa Barbara. She took Tina Turner and me on a golf cart tour of her estate, and afterward she sat me next to Michelle Obama for dinner.

I said to Mrs. Obama, "I know who you are because I saw you standing in the aisles of the convention while your husband spoke."

She said, "Well, I certainly know who you are." That was all she said, but I liked her instantly. Anna and I hosted a fund-raiser with her, early in that historic run for the presidency, and I would go on to attend all of Anna's private fund-raiser dinners for candidate and then president Obama.

For the *Vogue* cover meeting with Valerie Jarrett, Anna was more than prepared. Over a delicate luncheon, she presented her idea to Valerie, to have Mrs. Obama's first *Vogue* cover in March, after her husband's inauguration. March is *Vogue*'s "Power Issue."

Anna pulled out huge ring-binder notebooks with all the previous First Ladies' *Vogue* appearances. Eleanor Roosevelt, Mamie Eisenhower, Betty Ford, Hillary Clinton—*Vogue* had acknowledged all of them.

Valerie was impressed. Anna said, "We want to do this story in a very meaningful way. Annie Leibovitz will photograph and our talented editor Tonne Goodman will be on hand to style. And André will come down and do the interview."

That was an extraordinary moment for me. Anna could have picked anyone else, any of her favorite writers, but she chose me. She knew the historical significance of sending me, and I appreciated that.

The weekend of the inauguration, Obama had a ceremonial train depart from Philadelphia and ride into Washington, D.C., the same way President Lincoln had. I took a car from my house down to

Philadelphia, just in time to load up all my luggage and make my way to a holding room before boarding.

The train was to be divided into sections for the media and the Obama family. The press were all seated together, waiting to be called onto the train. I sat down among them.

"Oh, I know you," a woman approached me and said. "I'm Yvonne, a friend of Michelle's. When you get on the train, just follow me or you'll be stuck with CNN and all those people."

As the train started to board, I indeed followed Yvonne to the family-and-friends car, one car ahead of the Obamas and their two daughters, as well as the Bidens and their security and staff. The woman charged with Mrs. Obama's scheduling saw me enter and came behind me to let me know I did not belong on that car.

Yvonne said, "Leave him alone, he's with me."

That's the power of *Vogue*.

During the train ride, Joe Biden came to say hello, and then Michelle and Barack. There was also a birthday cake for one of the Obama daughters. Just before we pulled into Union Station in D.C., Mrs. Obama came in and said, "You know you all got to clean up this mess!" She didn't want the Amtrak cleaning staff to be burdened with picking up our refuse from the ride.

The January morning of the 2009 inauguration in Washington, D.C., was icy cold. Diane von Fürstenberg, with whom I would be sitting, met me at my hotel and together we walked to the Capitol.

As we made our way through the frigid air, we reminisced about how much the world had changed. "You were my first black friend, but now I have so many," she said. I have known DVF since 1975; I used to sit on her bed in the Hôtel Plaza Athénée, me in a navy sailor cap and turtleneck, while she talked long-distance to her wealthy boyfriend, now her husband, Barry Diller.

"Remember when we walked down the avenue Montaigne?" she asked.

"Yes, and people used to say, 'Look, it's Princess Diane von Fürstenberg with her friend the African king.'"

"You dressed the part," she said.

"I was young and handsome then."

In Diane von Fürstenberg's suite at the Hôtel Plaza
Athénée, Paris, France, circa 1978. She took this
photo of me wearing a navy sailor cap, seated
on her bed, where I used to sit while she spoke on
the phone long-distance to her boyfriend,
now husband, Barry Diller.

We took our seats, in a VIP section just behind Yo-Yo Ma. Diane's good friend Congresswoman Nancy Pelosi arranged them for us. The Obamas had not yet emerged center stage, but a crowd stretching as far as the naked eye could see stood behind us.

Diane turned to me and said, "Call your mother. Call her right now on your cell phone and tell her where you are."

I couldn't do that. I hadn't talked to my mother in years. We had barely spoken at all since my grandmother's funeral.

"You are her only child. You have to call her. I am a mother and I know what I am talking about. It is important to her."

Reluctantly, I rang the Carver nursing home in Durham, North Carolina. I reached the switchboard and asked for Mrs. Alma Talley.

The operator asked: "Who is calling for Mrs. Talley?"

"Her son."

There was a brief pause. The operator came back and said, "Your mother does not wish to be disturbed by anyone."

I hung up and told Diane they were unable to reach my mother. She took my hand and didn't say anything else about it. She's always been a patient and tolerant friend.

Today, we can proudly say we've had our first African American president and First Lady. Yes, Obama embodies the audacity of hope. Yes, there has been great progress and we all are proud to recognize this. But in the end, due to the sustained role of the status quo, from films, to politics, to the arts, a black man must still be smarter than any white person to ascend to the top of his field. He must also be smart enough to navigate through all the storms, the tornados, the earthquakes. The struggle for black equality is a constant challenge; it takes daily individual skirmishes to survive by hope and faith, to conquer all the inbred race problems through the power of love. President Barack Obama and brilliant Michelle Obama gave me a renewed optimism, faith, and a determination to continue to survive with the usual force and fanfare and aplomb I have sustained throughout my life.

I wish my grandmother had lived to see that. To feel that.

XIII

Two nights before Anna Wintour was to receive the Légion d'honneur, she asked me to pick a dress for her to wear.

It was the summer of 2011 and we were in Paris for the Chanel show, staying at the Ritz, as we always did, Anna on the first floor and I on another. We went to Chanel together and she tried some things on. I told her I wanted to wait to see the show the following morning before making up my mind about what she should wear.

The next day, as I watched the clothes on the runway, I made mental notes. What would be the perfect dress for such a prestigious honor as the Légion d'honneur? I selected a short blue sequined handmade trompe l'oeil couture Chanel dress. She liked it; I oversaw the fitting and had it sent back to the Ritz. The event was the next day.

At quarter to five in the afternoon, I met Anna in the lobby to make sure she got into her car. "Come with me," she said.

Mr. Newhouse, chairman of Condé Nast, was in town for the ceremony; why would she want to go with me and not the big boss? I wasn't expecting to ride with her but gladly jumped into the back of her waiting car.

We got to the Élysée Palace and were driven into the courtyard

and to the palace steps. Anna had a small, soft evening handbag, a *pochette,* that she thrust at me and said, "Here, hold my handbag."

I can't think of a single designer who wasn't there. Everyone from Milan, Paris, New York. Karl was there, Donatella Versace, Alber Elbaz—anyone who was worth their weight in gold. There was some champagne passed around by butlers, and we all waited until President Nicolas Sarkozy began his speech and gave out awards. I sat in a chair along the wall, holding Anna's bag and reveling in her unabashed joy as the highest accolade France can bestow was pinned to her handmade Chanel. Anna was immensely proud; it was one of the pinnacles of her career, without question.

Afterward, there was a cocktail party at the American embassy. At this point I was due to leave; I had a dinner to attend at Valentino's house. I said good-bye to Anna and handed her the *pochette.* She looked in her bag and said, "My cell phone, what did you do with my cell phone?"

"Anna, you never gave me your cell phone." She had only given me the bag, which was too small to hold a phone.

"What did you do with my cell phone, you've misplaced my cell phone, what did you *do*?"

"You never had a cell phone in the car, you never used it! It was never in the car, I never saw you on a cell phone, not once."

I went out to search the car anyway, though I knew it was not in there. I called the front desk at the Ritz and asked the manager to please go to Anna Wintour's suite and see if there was a cell phone on her desk. He called me back two minutes later and said yes, it was right on the desk, where I said it would be.

I told Anna her cell phone was in her room where she left it. Silence. Then, "Oh, okay," and she kept going through the party. I made my exit for my previous engagement.

That night, Anna penned me a loving thank-you on the back of a large, used Ritz envelope. On it, she wrote by hand: "*Thank You André for helping me.*" It was the last sincere handwritten note, a true gesture of appreciation, I ever received from Anna.

I kept the note and sent it to a local framer in White Plains. Thinking it was trash, he misplaced or lost it. I verbally assassinated that framer for weeks, months, until he retired.

Karl started dating Baptiste Giabiconi, a model signed with DNA in New York. He was not a dandy like Jacques, and I don't think Karl loved him like he did Jacques, yet he piled attention upon him. Baptiste became one of the top Paris-based male models.

Expensive gifts were lavished on Baptiste, who reminded Karl of himself when he was young. Top-of-the-line Rolex watches were one of the young man's obsessions. Karl rented an apartment for him and provided a full-time butler to take care of his needs. He was Karl's only official boyfriend.

Karl's taste in houses changed during that period. In an attempt to be more hip, he started renting villas on the Riviera, in gated communities. Very modern, very nondecorated, no period pieces, just things covered in white spreads and linens, all for this Baptiste and his group of friends.

The one time I visited Karl in the Riviera, in a rented villa, Baptiste was there, as well as his mother, on a visit. Baptiste pranked me by hiding in a closet and howling like a German shepherd, as though some guard dog were lurking in the vast series of rooms.

Karl was generous with material luxury, but more than that, he was a good friend. I could tell him anything, ask him anything.

While Karl Lagerfeld could be extremely generous, he could also be dreadful—like a bloodsucking vampire, absolutely "wicked," as Anna Wintour so aptly and diplomatically put it. The most important woman in Karl's early years, the woman who served as his muse and alter ego, was the Italian fashion journalist and editor Anna Piaggi. It was Anna who served as the official chatelaine of all of Karl's houses. She arranged suppers, dressed up to amuse him, and because of her intelligence and her incredible collection of vintage clothing, Karl supported her for nearly twenty years.

Then one day, out of the blue, Anna Piaggi was exiled from Karl's kingdom.

Perhaps Karl grew tired of her complaining. Sometimes, Karl just got tired of people. When Karl excised you, the luxury stopped. Anna Piaggi had lived in comfort due to Karl for over two decades, and now, recently widowed (her husband and her lover died one right after the other), she was left to pick up the pieces of her life, suddenly all by herself. If Karl saw her socially, he would be polite, but he would no longer have dinners with her.

I'm happy to say that before her death, Anna Piaggi was back in Karl's good graces and privileged to be back on Karl's list at the Chanel shop on rue Cambon. Anna Piaggi is remembered as one of the legendary and iconic fashion muses, along with the Marchesa Casati and Nancy Cunard. Her memorial took place in Milan during Fashion Week in 2012. Karl was in town but did not attend. Once again, he couldn't stand the idea of going to someone's funeral. He avoided anything to do with death.

The following year, Chanel hosted their twice-annual Métiers d'Art show in Dallas, Texas, showcasing the work of the specialized craftsmen whose expertise makes Chanel possible. Past Métiers d'Art show locations included Venice, Tokyo, and Manhattan. Chanel paid for first-class travel, hotels, and cars for all the big editors. Even though I was no longer at *Vogue* on a daily basis, I loved the privilege and honor of being on Karl's VIP list, as a friend. I was still important to him, it seemed.

Anna Wintour's flight to Dallas was delayed due to bad weather. She e-mailed me she might not make it in time for the show. "I am sure you will make it but I will let Karl know you are delayed," I responded. Then, soon after, I wrote back: "I have spoken to Karl and he insists he will not start the show until you are present."

Finally, Anna arrived around five P.M. She dashed into her fabulous handmade bouclé blanket tweed redingote, from the couture, and made it to Dallas's Fair Park, causing only a minimal delay.

The evening began with the premiere of a Karl Lagerfeld–directed short film, *The Return*. Karl created an open-air movie theater with vintage convertible cars lined up in front of a jumbo screen, like a drive-in. Very American.

The Return was a narrative of Coco Chanel's 1950s comeback, which depended on her own trip to Texas, to firm up the support of Stanley Marcus, president of Neiman Marcus. Geraldine Chaplin, daughter of Charlie Chaplin, starred as the great Mademoiselle Chanel. Amanda Harlech made an appearance as well, as a journalist friend of Coco's. It was all very period, and shot in Paris, which probably cost a fortune. I didn't understand the plot development, but that didn't matter. I was seated in the most important viewing car, a roadster once owned by Rita Hayworth. I sat in the front, beside Geraldine Chaplin. Karl and Anna were seated in the back.

After the film, we moved across the hangar-sized exposition hall to a makeshift Western bar. Anna and I exchanged glances as we slowly walked past a mechanical bull. The runway was like a rodeo, there was sawdust on the floor, and models walked out in themes of American Indians and cowgirls. Karl's godson Hudson Kroenig, a young boy of five or six, walked out in his little Western look, holding the hand of a model. In the other hand he held a small gun, which he pulled from a holster belt made just for his size. Nothing was missed. All details were impeccably turned out. The Chanel handbags had a Western theme and were later sold in Chanel stores across the world.

Anna left Dallas early the next morning but I stayed behind. There was something I had to talk to Karl about. The photographer Deborah Turbeville had just passed away from lung cancer, and I needed his help to fund a retrospective. Looking back on it now, knowing Karl never liked to discuss anything to do with death, my afternoon was doomed to failure.

Deborah Turbeville was one of the great visionary photographers. Her book *Unseen Versailles* was published by Jackie Onassis.

Karl had commissioned Turbeville for a special photographic essay of Chanel's couture archives, the oldest dresses dating to 1927, in Gabrielle Chanel's apartments, which remain intact above the 31 rue Cambon couture house. It's the apartment where Chanel sat on a huge boxcar taupe suede sofa, and where rare gilt and morocco-bound volumes were displayed on plain wooden shelves above the sofa. The eclectic mix was the forerunner of the modern interior décor, often seen in swanky, affluent houses in New York, designed by Henri Samuel, François Catroux, or Jacques Grange.

Karl paid me thirty thousand dollars to be the editor of the shoot and installed me in my favorite suite at the Ritz. (I stayed for three extra weeks after, and the whole thirty thousand dollars went to paying my bill.) This Chanel assignment to photograph the archives was Karl's idea and he gave me the great gift, the great honor, of working with Turbeville. He appreciated her and never interfered on the set during those three days. She presented the photographs about four weeks after she completed the session.

Turbeville and I remained in contact throughout the years, but I was surprised, shocked really, to receive a call from her agent telling me she was on her deathbed and one of her dying requests was for me to curate a retrospective of her life's work.

I was so moved by this. I went to her private funeral service and met with her agent, Marek. We tried to get an exhibit going in Saint Petersburg but it fell through. I went to the Museum of the City of New York; they told me it could be done but would cost over a quarter of a million dollars.

I met with Maureen Chiquet, then president of Chanel, and asked for money to support the exhibit. I showed her Deborah Turbeville's custom prints in a beautiful black box. She understood. "Convince Karl and if he says it's a yes, you will have the money."

This same box of photos came with me to Dallas. It made so much sense at the time; the Dallas show was a celebration of Chanel's history, as were Turbeville's photographs. Surely grandiose

generosity would be afforded to Turbeville now, in honor of her life? It was up to me to convince Karl.

To get to Karl, one now had to go through Sébastien Jondeau, his driver and personal security man. Karl had hired him from a moving van service; Sébastien had driven a delivery truck from Paris to Frankfurt, Germany, when Karl furnished a house.

The day after the show, I arranged with Sébastien to meet Karl for a late lunch in the Rosewood Mansion on Turtle Creek, where more than one hundred rooms had been reserved by Chanel. At the table were Eric Pfrunder, director of all Karl's photography at Chanel; Sébastien, the aide-de-camp; and Brad, an über male model, who had two sons. The eldest, Daniel, was Karl's godson and was treated like the grand dauphin. (Karl also bought a house in Maine and signed the deed over to Brad. Karl never saw the house in person.)

I sat at the end of the table, and Karl sat next to me. I presented the idea, showing him the beautiful, haunting, and respectable poetic images of Deborah Turbeville. He raised his dark glasses, peering with curious owl-like eyes, as I leafed through the entire collection of about thirty images.

Karl went radio silent and then said, "Let me think about it."

I knew that moment by the look on his face, and his body language as he moved away from me toward other people at the table, that Karl was not going to do one thing to honor Deborah Turbeville.

Maybe I should have had the foresight to suggest an exhibit that would include the work of Deborah Turbeville and Karl Lagerfeld. Why didn't I say, "Karl, wouldn't it be great to have a dual exhibit of Deborah's photographs of Chanel's early creations and your first collection from January 1983?" Or *something* that would give Karl the attention he so loved. Karl's ego would not allow him to support another artist in the realm of photography, as he was also a photographer who had shot nearly two decades of Chanel ad campaigns,

for both couture and ready-to-wear. He may have loved Turbeville's work, but she was now dead.

The mood at the table remained cold. On top of my colossal blunder, I had brought this all up in front of Karl's new clique. Several of them were extremely jealous that I had been seated at the show in the Rita Hayworth convertible next to Geraldine Chaplin and with Anna and Karl. That must have put the final nail in my coffin. I was riling up his new favorites, and now I dared ask him for money to support another artist? The guillotine dropped. After decades of friendship, I had finally made the list of erased, deleted personal and professional friends who were no longer of any value to Karl. The only people he never had a fight with were people of great power, like Princess Caroline of Monaco.

Karl Lagerfeld never reached out to me again. Chanel removed me from the guest list for their runway shows and removed me from their Christmas gift list.

Did I miss Karl Lagerfeld? Yes.

Did I miss the strict protocol required to be his friend? Yes!

Kate Novack, the director of my 2017 documentary, *The Gospel According to André,* sent multiple queries to Chanel, asking to interview Karl. She was ready to fly to Paris to talk to him. There was never an answer.

Finally, Amanda Harlech called me and said by telephone, "Karl told me to tell you to tell Kate to stop asking for an interview for the film. He said he doesn't like talking about the past."

I accepted his response, hung up the phone, called Kate, and told her. There would be no interview in Paris with Karl Lagerfeld. I was already just another ghost from his past.

XIV

My heart, formerly committed to *Vogue,* now belonged to SCAD, which had become a destination where I could create important fashion exhibits. Being an editor at large gave me a lot of freedom to do what I wanted, and SCAD offered me the possibility and creative freedom—and a stress-free, staff-supported environment—to create magic. I began spending more time there and asked friends in New York to donate haute couture for the SCAD museum collection.

It began with Anna Wintour's large donation of haute couture pieces. She went through her racks of suits and dresses from Chanel, Dior, and Valentino couture and brought them to the office. She allowed me to select certain pieces, which went off to SCAD.

Cornelia Guest donated the entire couture wardrobe of her late mother, C. Z. Guest. She shipped down everything, including one of the earliest Oscar de la Renta little black dresses, from when he designed for Jane Derby, in the 1960s, as well as her Mainbocher evening coat in framboise silk, to the floor; a full-blown broadtail fur dinner dress, from Max Mara; her lamé Chanel suits; and cashmere sweaters, mink lined, by Adolfo. Just to be complete with the

official donation, there were scores of C. Z.'s Kmart housecoats and matching nightgowns.

Deeda Blair donated Chanel tweeds and Ralph Rucci ball dresses, with matte alligator bibs attached to huge, sweeping silk faille skirts.

Pat Altschul sent her entire Yves Saint Laurent couture collection of trouser suits, with matching silk blouses with huge bows, and her major Balmain couture pieces, which she loved to wear. She sent one of my favorite dresses of all time, São Schlumberger's Chanel summer black cotton organza and lace strapless dress, inspired by Winterhalter, as well as a long amethyst silk faille opera coat that she ordered one season but never wore. Her Balmain at-home chiffon caftans, edged in ostrich, couture of course, and right out of the Joan Rivers fashion DNA, were also donated.

One day, I went to the museum and asked to see the growing costume collection. All the closets were open and I sat there, quietly scanning the collection. The idea for an exhibit was born: *The Little Black Dress*.

To me, this first venture as sole curator of a fashion exhibit was a masterwork in my legacy. It felt like one of my greatest moments.

The exhibit included an amazing Saint Laurent couture dress (1990)—inspired by a photo of Marilyn Monroe, taken by Avedon—owned by Anne Bass. She lent it for the exhibit. There was Diane von Fürstenberg's black Valentino couture slip dress (1991), inspired by Elizabeth Taylor in *Butterfield 8;* Norma Kamali's latex rubber one-piece cutout dress (2012); Balenciaga's baby-doll lace (1957); the most exquisite Fortuny Delphos dress of black fine-pleated silk (1907), from C. Z. Guest's estate; Gloria von Thurn und Taxis's wool and white braid coatdress, from Chanel (1990); Deeda Blair's amazing Saint Laurent haute couture lace dinner dress (1999); and Zac Posen's homage to Charles James in a nylon crinoline and horsehair construction (2013). Anna Wintour's black wool Chanel couture dress (2006), as simple as a T-shirt, ended up as the cover for the *Little Black Dress* book, published by Rizzoli and edited entirely by

me with the help of SCAD. Paula Wallace approved every single aspect of the exhibit; she also wrote a foreword to the book.

Diana Vreeland always had the unexpected element of shock and awe in her shows. Marc Jacobs's black embroidered lace shirtdress (2012) from Comme des Garçons was my breakout surprise for *The Little Black Dress.* Jacobs had worn the lace dress to the Met Gala that same year, totally transparent, yet buttoned to the top of his neck, with pristine Ben Franklin–style Pilgrim-buckle shoes he designed for himself. He was nude underneath, except for the most impeccable custom-made white cotton boxer shorts.

The other element of surprise: Mica Ertegun's sapphire-blue silk taffeta shirtwaist, tucked into her gorgeous flamenco-red silk taffeta long ruffled skirt (2001), from Oscar de la Renta. Why did I select this? Mica, another great style icon, ordered the dress for her fortieth wedding anniversary dinner and ball, held on the roof of the St. Regis that year. She said to me, over lunch at the Frank Gehry cafeteria at *Vogue,* "Everyone will be in their best black dresses from Paris or something so fantastic from their closets. I want to stand out and I am going to Oscar for something that goes with my ruby bib necklace by JAR."

I considered including a little black maid's dress in the exhibit. A new black maid's uniform to celebrate all the African American maids who had worked in the segregated South. I couldn't find the right uniform and ended up not including it. In hindsight, I wish I had. The maid's uniform was the little black dress for the suppressed, repressed, and oppressed. Its inclusion would have been a symbol for all the maids who wore the uniform, fed families, and saved and scrimped and put children through fine Southern schools of higher education. And for all the maids who overcame what that little black dress symbolized. Failing to include it is one of my greatest regrets.

. . .

Diane von Fürstenberg kept saying to me for years, "You must reconcile with your mother. If she dies and you have not reconciled, you will never be able to live with yourself."

Since my mother had moved into an assisted living home, she would not take phone calls. I offered to put a private phone line in her room, but she didn't want it. She told me she wanted nothing but to rest. She was fine not receiving people, except for close cousins from her church family, and taking occasional communion served by the deaconesses. She, like Mrs. Vreeland, just took to her bed and waited to leave the world, with her own sense of the world internalized.

The only way I was going to see her was to go unannounced, which I did three times. The last time I saw her, she smiled and was happy to see me. All was forgiven. I gently brushed her hair and asked if there was anything I could do for her. She only wanted me to bring her a bag of Lay's potato chips, a simple request for something she craved. I rushed out and bought several large bags. "I am just going to rest for a while now," she said upon my return. "I am fine." Life for my mother, Alma Ruth Davis Talley, "ain't been no crystal stair," as Langston Hughes wrote. When I was eleven, she divorced my father, William Carroll Talley, and in those days, black women rarely divorced a man unless he really behaved in some egregious manner. My father had not.

After her divorce, she always seemed a displaced person, as if she could not be moored to an arc of security or safe haven. She was never attached to anything sentimental: furniture, framed photographs, books, record albums, old clothes, linens. With my grandmother to look after me, my mother was not tied down emotionally to anything.

In the middle of the 2015 fall/winter collections at New York Fashion Week, my cousin Georgia Purefoy called to tell me my mother had died. I was stunned and unsure how to respond. I blindly went to the next fashion show on my schedule. Oscar de la Renta, on West Forty-second Street. Throughout the show I was quiet but

polite. I didn't tell a single person that my mother had just died. But I made sure I was seated near the bank of elevators, so I could be the first person to leave.

Oscar's show ended, to thunderous applause. I was out the door and into the small elevator. We were about eleven people, including a pregnant editor. As we made our way down, the elevator stopped abruptly and then shut down.

For the first ten minutes or so, we all remained calm. After that, for over forty minutes, I was given the task of barking and knocking the loudest. We were sardines packed in that elevator. All the while I kept thinking, *My mother is dead. My mother is dead and here I am stuck in an elevator with strangers*.

The New York City Fire Department finally axed its way through the ceiling and got the elevator back to normal operation. The doors opened and we were released. Whence came my strength to not break down, I do not know.

Alex Bolen, Oscar's stepson-in-law and head of the family firm, was waiting on the ground floor. He asked if I was okay. I told him I was fine, I just wanted to get out on the dark street and breathe some air before the hour-long car ride to my home in White Plains.

In the car, Oscar called me, personally asking after my welfare following the elevator incident. The next day, he sent a vase of simple white flowers. I still didn't tell him about my mother's death. I couldn't speak about it.

Before I took the flight from New York to Durham for the funeral, I went to Bergdorf Goodman and bought a long peignoir and matching long silk charmeuse gown, with long sleeves. It was the only one I liked, but I could see that someone had previously tried on the gown and lipstick was smeared, ever so lightly, on the hem. I asked the salesperson if she could check inventory for another gown, one that wasn't stained, but she said it was the only one. I had no choice but to go with my chosen selection. It was to be FedExed to the funeral home.

Two days later, I journeyed to Durham, and Danny Filson, who

had become a good friend from our time working together at SCAD, met me at the airport. He went with me to arrange the funeral and select a very expensive burial vault and a full mahogany casket, the finest one in the catalog. My mother had to be buried in the best that was offered to me. It was my duty as her only child to give her as beautiful a funeral as I could, as I had done for my grandmother. The same attention had been given to my father, although he was a Mason and they had taken over his funeral arrangements.

I went to Floral Dimensions and ordered a blanket of dense white roses. I never asked the price. They were instructed to take the orders from New York and Paris florists by phone, and to select only white flowers.

The vault was copper lined. I left nothing to chance. I selected the music: "God Will Take Care of You," sung by Mahalia Jackson; "Blessed Assurance," sung by Reverend Shirley Caesar; "Jesus Promised Me a Home Over There," sung by Jennifer Hudson.

Reverend Butts flew down from Harlem to eulogize my mother; he did not hesitate when I asked him, despite never having met her. My extended family from SCAD, Paula Wallace and her husband, Glenn, came up from Savannah for the service. Paula wore a beautiful black hat with a veil covering her face. They sat in my grandmother's favorite pew, right of center. Anna Wintour did not attend but she sent a beautiful black bench, and a plaque, to memorialize my mother.

Pallbearers took the solid-mahogany casket to the hearse, which had to be backed up to the front door of the church. They said it was the heaviest casket they had ever carried.

All these preparations had helped me with my grief, so by the day of the funeral I was fine. I had no overwhelming emotional response, except a feeling of finality. We walked to the family cemetery behind the slow-moving hearse, on foot. On the walk, I asked the undertaker's wife, did she remove the lipstick stain from the brand-new gown? I didn't want my mother to be buried with a very slight stain at the hem of the slip.

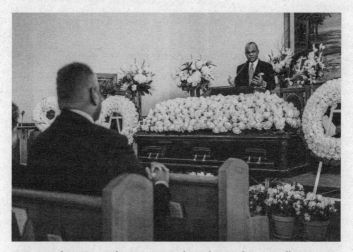

Reverend Dr. Butts eulogizing my mother, Alma Ruth Davis Talley, at my family church, Mt. Sinai Baptist, in Durham, North Carolina. October 2015.
Photograph by Colin Douglas Gray

Who would ever see? It was, after all, going underneath the peignoir coat. And it was not an open casket for viewing. But I saw it in my mind. I wanted her to assure me she had removed it with some delicate stain remover. Or just cut the entire hem off. She promised me she had removed the stain.

As we waited, I took a brief tour of my family cemetery with Reverend Butts. There was my aunt Dorothy Bee, killed in a car crash just a short distance from our church. And there, my grandmother, who had requested she be buried next to her lost daughter. And all of my grandmother's North Carolina sisters, as well as her mother, my great-grandmother, China Robertson.

I do not fear death, as it was always present in my Baptist upbringing: Prepare yourself for death. We all have to die one day.

At the head of my grandmother's grave, I had commissioned a gray Georgia granite obelisk, the exact same measurements as my height, six feet six inches. As I spoke to Dr. Butts, Paula Wallace quietly went up to this obelisk, rose up on her fine Prada heels, raised

her veil, and kissed it. It was a moving tribute to my grandmother, and to me.

My mother's black stone marker is carved to resemble an open book. I had done everything I could to make her home-going service dignified and elegant.

My mother never quite got me. I never understood what she wanted from me either. She never explained and I never asked. I suppose we could have had a better relationship had we talked through a counselor or third party. Some professional help was certainly needed in her anger management. When she died, everyone in my family came full circle and we mourned the happier days. We all felt my mother did the best she could, under the circumstances.

I wrote in the program for my mother's funeral: "In the kitchen, her specialty was macaroni and cheese. She loved making this dish on Easter, Thanksgiving and Christmas. She also loved chitlins and would practically have a tug of war over a bowl with my grandmother. My mother loved church life, and I am proud to learn she was a deaconess of this family church, in the latter years of her life."

Oscar de la Renta died the same year as my mother. In his honor, I presented an exhibit of his work at SCAD; Annette de la Renta, with her daughter Eliza Bolen, flew down to Savannah with Anna Wintour to attend the opening. It was a cold winter day, and Annette was still in mourning, wearing her black bouclé wool coat. She wore that coat all that year.

As they toured the exhibit, Annette was pleased to see the collection included Oprah Winfrey's blue taffeta dress (2010) as well as the original velvet dress Hillary Clinton wore on the cover of *Vogue* for Christmas (1998) and Eliza's simple Balmain wedding dress (1998). She loved how I arranged the lifeless mannequins' feet in a system of grosgrain ribbons deftly taped to them, to suggest sandals and elegant shoes. Vintage veils and immaculate white kidskin leather

gloves had been ordered from Neiman Marcus to accompany Oscar's grand evening dresses.

Weeks later, Alex Bolen, head of the Oscar de la Renta firm, called me in New York and asked me to curate the first full retrospective of Oscar de la Renta. Annette had sincerely thought my SCAD exhibit was wonderful and wanted me to continue my work on a larger scale.

There began my career for three years, curating Oscar de la Renta exhibits at the de Young Museum in San Francisco; at the Museum of Fine Arts in Houston, Texas; and finally, my finest work, in my view, at the Mint Museum in Charlotte, North Carolina.

My initial SCAD de la Renta exhibit was small and I relied on my friends to secure the clothes. But now I had clothes from the de la Renta archives. I remembered dresses Annette and Eliza had previously worn and requested they send me my favorite selections.

The success of the show led to the publication of a corresponding book, featuring the full catalog. Published by Charles Mier at Rizzoli, *Oscar de la Renta: His Legendary World of Style* was edited by me, with an introduction called "Thread of Memory," which encompassed my thirty-nine years of friendship, comradeship, and kinship with Oscar.

The book almost killed me, literally. I lost so much of my health and my work-life balance in trying to beat the clock and be the first to have a full exhibit of my friend's work, work I knew like the back of my hand, as well as produce the book. From the time Oscar died, in October, until the following spring, I was hunkered down at SCAD, working nonstop. And I was eating nonstop. For years now, I'd binged on all the wrong things, ignoring the value of exercise and proper caloric intake, with sweets being my greatest downfall. Chocolate anything: ice cream, cake, banana pudding, coconut layer cake, Kit Kat bars, Mounds, New York silver-dollar-size mints!

Now I sealed myself into the carriage house at SCAD and would wake every morning, attack the corkboard wall layout, and write the

book while having huge breakfasts: bacon with biscuits and butter, and grits with molasses. These would be followed by lunches and dinners with all my favorite comfort foods. Everything I ate as a child. Everything I associated with love and comfort and a safe, secure home.

I thought these wonderful Southern meals gave me the fuel needed to speed-race through the editing of both the exhibit and the book. Mea culpa: While the heaping portions made me feel loved, my health spiraled right down the drain. My left leg became hard as granite, and I made constant visits to Memorial Health hospital in Savannah to deal with multiple ailments, including asthma.

I am just a sinner when it comes to food. I will never stop eating. This food addiction started from patterns in my childhood and the secret flowerless garden of abuse, where the trees did not dance as the breezes passed between them.

The Oscar de la Renta exhibit traveled to Paris and was shown in the Mona Bismarck Center, for three months. Anna Wintour and Bee came early one morning during the haute couture. Maureen Dowd flew to Paris to see it. And Suzy Menkes wrote a wonderful review of my efforts. Another milestone in my chiffon-trenches life.

Anna Wintour is a year younger than me, and our birthdays are only a few weeks apart. For years we exchanged gifts: I'd send huge, expensive bouquets from her favorite florist. She would send me flowers, sometimes accompanied by a handwritten note.

At Christmas, gifts were also exchanged. One year, she gave me a ten-volume hardbound set of all the known African American paintings and sculptures that exist in the Western Hemisphere. This was a *very* thoughtful gift, and one I truly loved.

Another year, she partnered with Annette and Oscar de la Renta and gave me a beautiful African low-throne, a bleached stool, from some tribe, that had been found at an East Side antiques store in New

York. I still have it in my living room, piled with books, in front of Truman Capote's sofa, which I bought at auction.

I remember getting generous gift cards to my favorite horti-culturist, Rosedale Nurseries, in Hawthorne, New York. Anna Wintour—and Vera Wang—sent me so many gift cards to the nurs-ery that I was able to furnish my garden in White Plains with hy-drangea bushes, white cherry blossom trees, and huge rhododendrons.

In 2014, the Bunny Mellon estate sale went on for three days and made over fourteen million dollars at Sotheby's. I bid by phone on a New England pine breakfront cupboard and presented it to Anna Wintour for Christmas. It was my most important gift, a testament to our relationship in life and career. She had the claw-foot tub re-moved from her first-floor guest bath and installed the floor-to-ceiling cabinet in its place.

In 2016, I sent her a beautiful yellow Regency upholstered arm-chair, which I won at auction at Doyle Galleries in Manhattan. A thank-you note, handwritten, was sent to my home address. She's perfect in that old-fashioned way. But I have never seen it in her New York residence; I am sure it went to some guest room in her compound in Mastic, Long Island.

Extraordinary white nineteenth-century Wedgwood candle-sticks, a fine gift I found at Irish antiques dealer Niall Smith, are always on her dining tables for formal dinners, including the fund-raising dinners she held for Barack Obama.

My last gift to her was from her favorite shop, John Derian. It was an antique neoclassical column in wood.

A person's words and deeds can make an indelible impression upon the soul. You can make a person feel loved through the sim-plest things in life. It's not the extravagant gifts that count. It's the thought, the gesture behind it.

I used to present originally designed marzipan cakes, from Sant Ambroeus, to my special friends in New York at Thanksgiving and Christmas. Vanilla cakes with layers of marzipan frosting in pale

mint green and bright fuchsia, with beautiful red cardinals perched on marzipan twigs. A specialist would be flown in from Milan and spend the entire months of November and December filling preorders.

One year, I ordered Lee Radziwill a fuchsia frosted vanilla and buttercream layer cake, with a special design I knew Lee would love: a portrait of President Obama. She loved the Obamas; when Barack ran for president, the first term, we both showed up at the New York offices to hand-deliver our personal checks of $2,800.

The day before Christmas, I picked up the marzipan Obama cake from the store on Madison Avenue, and on the way out I ran into Lee's niece Caroline Kennedy Schlossberg.

She recognized me, flying down Madison, walking briskly, with this huge Sant Ambroeus box.

"What is that you have there?" she intoned.

"It's a special cake and I am actually taking it to your aunt's, for tomorrow's Christmas party!"

"Why didn't I get one?" she joked.

I had only met Caroline once, when I was introduced to her at St. Ignatius Loyola church, where I attended Christmas Eve midnight mass one year with Lee. Lee had worn a red wool A-line skirt, a black sweater, her favorite satin Prada belted coat with huge notched lapels, and low-heeled suede boots that were the height of elegance. Caroline walked up the main aisle and stopped to greet her aunt warmly, and we were introduced. Caroline's boots were also quite elegant.

Lee made such a presentation of the cake at Christmas lunch the next day. She said to all her guests around the table, "This is the most original Christmas gift I've ever received in my life. It's from André." It felt wonderful to be able to give such a well-received gift to a woman like Lee, who had such exquisite taste, with access to chefs and the best foods. I spent a great fortune on that cake, as well as on cakes for Annette de la Renta and Catie Marron.

Marc Jacobs, who was Lee's great friend, often spoiled her for her

birthdays, in gratitude for her friendship and their shared extraordinary taste. One year, Marc gave Lee an extravagant Giacometti sculpture for her anniversary.

I said to her, "What do you mean Marc gave you a Giacometti sculpture for your *anniversary*?"

"Of course it was not the seven-foot-tall Giacometti," she said.

It was coffee table size, yet it was original. Lee immediately went out in Paris, had it appraised, and probably sold it. I never saw it in any room of her New York or Paris apartment. She was so exacting in her taste!

XV

When Diana Vreeland, the great empress of taste and style, became a consultant to the Costume Institute, she invented costume exhibits as they exist today, from her first, 1973's *The World of Balenciaga,* to her last as directrice, *Dance*. She began holding the Costume Institute Gala at the Metropolitan and turned it into the most important social event on the fashion calendar. Eventually, it became known as the Met Gala.

My first Met Gala was the second one ever, in December 1974, when I volunteered for Mrs. Vreeland. The theme was *Romantic and Glamorous Hollywood Design*. I was not seated at the event, as I was working, but I still was able to attend the cocktail and post-party in the museum.

Escorting Mrs. Vreeland that night was her friend Jack Nicholson. She wore her beautiful black silk velvet Madame Grès *robe de style* and her Dal Co' of Rome red court shoes, with the extravagant Regency bows.

Cher made a splashy entrance down the escalator in her now-legendary Bob Mackie jumpsuit, an illusion of beads and bird-of-paradise plumes. (Years later, I managed to bus an entire choir from a Baptist church in Harlem to the Met Gala; when Cher walked in,

we both joined the front row and began beating tambourines with the choir.)

In December 1976, Diana Vreeland was escorted to the ball by the brilliant American designer Bill Blass. Spotting me in the Great Hall, Mrs. Vreeland summoned me to her basement office, where we three swigged down two shots of Dewar's scotch whiskey (she kept a bottle in her desk). After, Oscar de la Renta saw me standing on the sidelines during the pre-cocktail hour and simply had a chair pushed to his table and squeezed me into the dinner.

Under Anna Wintour's reign over the Met Gala you can be assured that would never happen. My invitation to the Met Gala under Anna's rule was as a staffer. I never got to pick my seat—well, only once, for the Charles James exhibit, when I asked to be seated with my friend George Malkemus. That was the year the Costume Institute became the Anna Wintour Costume Center.

Only three times in two decades was I allowed to escort a friend to the gala: Pat Altschul in 2005 (the exhibit was *The House of Chanel;* she purchased a vintage Chanel haute couture dress that once belonged to São Schlumberger), Naomi Campbell in 2006, and Whoopi Goldberg in 2010, when both she and I were dressed in custom looks by Ralph Rucci.

Tom Ford so graciously made most of my Met Gala looks for nearly seven years. For the *Poiret: King of Fashion* exhibit, he made a floor-length, fur-trimmed, gold embossed coat, inspired by a Poiret design. For the *Rei Kawakubo/Comme des Garçons* exhibit, I had a floor-length silk faille court coat made, with a thirty-foot-long train.

Prior to Tom Ford, Nicolas Ghesquière, of Balenciaga, made me incredible full-length court coats and cloque silk capes, inspired by capes the late master Cristóbal Balenciaga had designed for his female clientele.

For five years, I was assigned to the top of the Metropolitan Museum of Art steps, to chat up celebrities on live-stream video for *Vogue.* From my seated perch, I would wait as *Vogue* staffers worked in relays, on walkie-talkies, telling me who was arriving on the red

carpet and which personality was approaching the top of the stairs. They would arrive, and presto! We got crackin', as Mrs. Vreeland used to say!

These social greetings, fused with questions on matters of style and dress, received high praise. There was Jennifer Lopez, stunning in a Valentino couture dress, with her fiancé, Alex Rodriguez, the baseball star, a veritable walking volcano of hot handsome maleness. I also spoke to Caroline Kennedy Schlossberg, former ambassador to Japan and niece of my best friend, Lee Radziwill. P. Diddy actually stopped and kissed my hand. Serena Williams twirled in her emerald-green Donatella Versace dress. Rihanna stopped and bent down to kiss me in her Comme des Garçons Alice in Wonderland velvet cake of a dress.

People responded to my warmth and kindness, my gentleness. Even people who didn't know me would quietly stand in line to come chat.

Anna loved the segments and praised me for them.

There were many remarkable moments during the Met Galas, but two stand out as the most exceptional.

The first was when Beyoncé showed up, unexpectedly, in 2012.

Beyoncé usually comes up the steps at the Met flanked by publicists who don't grant you access even if you represent *Vogue*. Even if you're standing on the steps, doing interviews for *Vogue,* there's no chance to talk to her.

I was sitting on ground level, in my beautiful hand-embroidered silk Tom Ford coat, and *Vogue*'s Jill Demling told me Beyoncé had, at the last minute, decided to come.

"Who told you this?" I said.

"We're talking to her people. She's fitted a dress and she likes it and decided she wants to come."

"Is Jay-Z coming?" I asked.

"We're not even sure yet if she'll show!"

As the crowd started to work its way inside, there was no Beyoncé. The young *Vogue* assistants gave me blow-by-blow accounts:

when Beyoncé was leaving her residence, how soon she was to arrive. It was not guaranteed that I was receiving the proper information! But I waited. I didn't want her to pull up and not have anyone to attend to her. And just around eight-thirty, as the dinner bell was ringing inside, a huge black Mercedes van rolled up to the curb.

Beyoncé was escorted by a small army of style-squad assistants, and—amazingly—only one publicist. The dress was Givenchy couture, by Riccardo Tisci, a nude illusion embroidered black dress with gloves attached at the shoulders. Beyoncé must have looked at that dress and decided she needed to be seen wearing it in front of the adoring press. It looked like she was covered in a spray of floral sprigs, with a lot of bareness in the strategic optical zones.

All the other VIPs had already walked up the red carpet. I said hello and told Beyoncé I'd escort her up the steps. With thanks and grace, she accepted. She seemed happy that I had waited for her. Slowly we walked up the many steps, and I gently encouraged her to stop and speak to various reporters. She did stop, and then struck a pose for the photographers. Her formation on the red carpet was without parallel. To the left, to the right. When we got to the top of the steps, she glided, like a beautiful swan, into the dimly lit main hall of the museum and was escorted off to dinner.

In those moments, I felt truly alive. There went the American dream at its very best. My heart was full of pride.

The other exceptional moment? Well! I had a full emotional meltdown the year Rihanna unfurled herself at the Met Gala.

The theme for 2015 was *China: Through the Looking Glass,* a masterpiece of a show, curated by Andrew Bolton. It was one of my best performances of red carpet interviews. I spoke with Nicole Kidman, stunning in a gossamer Alexander McQueen spangled chiffon dress with a floor-length cape by Sarah Burton. And I interviewed Lupita Nyong'o, with her beautiful African-inspired coiffure.

But the truly outstanding moment: Rihanna in a magnificent Guo Pei cape, mandarin yellow and edged completely in luxurious

fox fur, also dyed mandarin yellow! Underneath, she wore Manolo Blahnik heels and a simple bustier top with a brief skirt.

Rihanna arrived exactly on time and slowly did her RiRi formation, giving the paparazzi what they wanted. As she climbed and posed, eight tuxedo-clad trainbearers carefully arranged the coat in a dramatic pool of fabric, spangles, and fur. The coat expanded, like a wingspan, across the entire width of the carpeted steps.

Rihanna is forever in the annals of the Met. A real-life dream. The power of a woman of color, ascending to her deserved moment in the sun. She outshined every single star that night. It was glorious to behold.

Tom Ford, the titan of style, is the American designer who most aligns himself to the great legendary talents, Halston and Yves Saint Laurent. His work explodes, like fireworks over the skies on the Fourth of July.

Nothing ambiguous, murky, or indecisive about Tom Ford. He is a virtuoso in terms of his professional efficacy. He became creative director for an almost bankrupt Gucci in 1994; by 1999, the brand capped off at an estimated four billion dollars in global sales. That year, Tom also began designing for Yves Saint Laurent, with the blessing of Pierre Bergé and Yves himself. Between the two power-house brands, Tom would be responsible for sixteen collections per year, men's and women's.

For his debut Yves Saint Laurent show, Betty Catroux sat in the front row, and Tom dedicated his collection to her. Tom blasted out Betty Catroux looks with ease, as well as his version of the romantic, feminine side of Yves Saint Laurent.

As Tom's star rose, Yves grew resentful. "The poor man, he does what he can," Yves said in the press. Tom told me over dinner at the Carlyle Hotel that he has terrible letters in his possession, handwritten to him by Yves. After one particular show, Yves wrote: "*In 13*

minutes you have managed to destroy 40 years of my work." Tom won't reveal any further contents but assures me they are the meanest and most vicious letters he has ever received in his lifetime.

When he left YSL to start his own brand, Tom continued to be inspired by Betty Catroux. I especially love his version of a smoking, circa 2018, with a structured jacket with broad notched lapels in contrast silk twill, and only one sleeve. Makes it sexier, more daring. Modern.

The built-in confidence Tom Ford possesses must have already existed when he was a young child growing up in Texas. He admits the first time he was with a man was his first night at Studio 54. If whatever he discovered at Studio 54 had anything to do with the man he is today, what a great awakening that must have been. Everything has come full circle now. He purchased Halston's Paul Rudolph–designed house, though he told me he does not plan to duplicate the Halston lifestyle. And he still has quite a few Warhol paintings, including a tiny white-on-white Rorschach, autographed by Andy, to Halston.

When being interviewed by *The New York Times,* Tom told Maureen Dowd that he planted a black garden at his London residence. Black tulips and calla lilies. He loves black. He loves black suits and hard, tight shoes, also black, and he drives around London in a sleek black custom-made car: Everything in the car is black on black. His hair gets help and is raven black. He compares it to the great empress of style, Diana Vreeland. He thinks about death constantly. He once planned on designing his own black sarcophagus but now has decided on quick cremation, to avoid the messiness of decay.

Nothing is by chance; he seems to be on jet engine energy, high acceleration 24/7. And he makes it all seem fun. People respond to his work. His clothes are youthful, sophisticated, and accessible. When First Lady Michelle Obama went to Buckingham Palace for an official state dinner, Tom custom-made a beautiful white evening dress. It was a completely brilliant choice.

After a hiatus of four years, Tom Ford made a comeback of sorts

in 2010, with a show that seemed like a brand-new dynamic. The show was "great fashion," as Cathy Horyn, *New York Times* fashion critic, said the day after, in her review. It took place in the small ground-floor salon of his just-opened flagship store on Madison Avenue in Manhattan. It seemed like the old days when fashion, especially high fashion, was shown in small salons, in Paris and New York.

Tom Ford wanted to make a splash, and he did. He took his address book and asked some of his celebrity friends and models to walk in his show; each would only have to wear one look. Two front rows were jammed against a small path as runway. As they walked, spectators, like Elizabeth Saltzman of *Vanity Fair* and Sally Singer of *Vogue,* who didn't grow up with salonlike fashion showings, sat on the front row and smiled.

I remember that show so well because I stood against the back wall. I didn't want to look like the giant on the front row, obstructing the view of Lilliputians next to me. And I also didn't want to be body-shamed by the grand presence of the *Vogue* phalanx of power.

From my vantage point in back I could see everything, from the shoes to the tip of the white fedora Lauren Hutton wore, with a white pantsuit right out of Saint Laurent's magic alchemy of trouser suits. Tom Ford himself, dressed in his uniform of white shirt, black tie, and black suit, narrated the whole show, which was the way fashion was in the old days in Paris.

The show included Farida Khelfa, a great model and muse of Azzedine Alaïa, and the iconic Marisa Berenson, movie star of the seventies and model. There were Tom's Hollywood friends: Rita Wilson; Julianne Moore; Lisa Eisner, who collaborated with him on jewelry; Rachel Feinstein, the New York–based artist.

Suddenly, the bombshell, breaking-news surprise: Beyoncé, not on the front row but on the catwalk! As she began her strut, she turned to Tom Ford and gave him a big wink and a smile. She wore a stunning long-sleeved short dress, all dark silver sequins, evoking smoke covering her ultra-voluptuous silhouette. Her hair was a full-

blown curly Afro. When she began her walk—and, by the way, she has never walked the fashion runways again, to my knowledge—the room roared.

Tom knows his duty is to be a commercial designer, but he also knows he is a leader among the pack. While these clothes looked absolutely great on models like Stella Tennant, he knew how to create fanfare by simply shifting back to old-school style yet bringing it into the cultural moment of celebrity. Each individual was appreciated for her own personality and body shape.

The small, intimate setting was exclusive; no more than about two hundred guests attended. Tom put a blockade on the photographers, which he now admits was a mistake. He was thinking exclusivity, the way the established houses used to handle things.

A great fashion show makes me feel good, like attending church on a Sunday morning. I felt privileged to be a part of it, a professional hallelujah. I may have been off the Karl Lagerfeld top ten friends list, but I still remained fiercely loyal to Tom Ford, who has continued to support me no matter my weight. After each of his shows in Milan, Paris, and New York, I have always rushed home to dispatch an e-mail with my immediate thoughts on his collections. Some e-mails are stream-of-consciousness and wildly romantic, and some are quiet. If I don't understand his message, I simply do not send one. That has happened only once in our many years of friendship.

XVI

Vogue started a podcast in 2016 and Anna announced me as the host.

The podcast started off with a big, successful roar and a roster of huge guests: Tom Ford, Kim Kardashian, Marc Jacobs, Alexander Wang. Anna quietly directed the whole thing from her office. She did not approve of many of the interviews I wanted to do, like Missy Elliott or Maya Rudolph. We instead stuck to insider fashion. Tonne Goodman would come down and talk about the next *Vogue* celebrity cover. Grace Coddington and Phyllis Posnick would come down, too. Even Anna came down and participated in conversations if she found my guest interesting enough.

Bill Cunningham, the great photographer, died in June 2016 from complications of a stroke, at the age of eighty-seven; I was one of the few invited to the private requiem mass at St. Thomas More, his regular church, which he attended every Sunday, when in town. On the day of this incredible mass, I couldn't attend. Michael Kors, the American billionaire fashion designer, was scheduled for a podcast interview with me at the same time the mass was being held. I kept my professional obligation to *Vogue*. While Anna attended Bill's

funeral, I was in the podcast room, talking to Michael Kors (who clearly was not invited to the requiem), doing my job.

And for peanuts in salary, really. I think I may have been paid five hundred dollars for each podcast. My car service bills cost that much and more for a round-trip from White Plains to One World Trade Center. I never complained; I just kept going and doing the best job I could for Anna and for *Vogue*.

Then, like a morning fog that suddenly lets up, the podcast no longer existed. No explanation or financial severance compensation. Just sphinxlike silence from Anna Wintour. She decimated me with this silent treatment so many times. That is just the way she resolves any issue. And I soldiered on, through the elite chiffon trenches. But, at the age of sixty-nine, I decided I was old enough, and it was time, to stand up for my dignity and take this silent treatment from the great Anna Wintour no more.

Graydon Carter's retirement from *Vanity Fair* was announced on the front page of *The New York Times* in September 2017, with a full detailed profile inside the broadsheet. Retiring saved his legacy: He was the last great editor of *Vanity Fair* magazine. His replacement supposedly was paid half of what Graydon made.

Recently, we compared notes on Anna Wintour, and there were some similarities. He said to me, "One day she treats me like a good friend and colleague, and the next day, she treats me as if she had just handed over her keys to an unknown parking valet."

I was a friend to Anna and I knew I mattered back in our earlier days together. Today, I would love for her to say something human and sincere to me. I have huge emotional and psychological scars from my relationship with this towering and influential woman, who can sit by the queen of England, on the front row of a fashion show, in her uniform of dark glasses and perfect Louise Brooks clipped coiffure framing her Mona Lisa mystery face. Who is she? Does she let down the proverbial dense curtain? She loves her two

children and I am sure she will be the best grandmother. But there are so many people who worked for her and have suffered huge emotional scarring. Women and men, designers, photographers, stylists; the list is endless. She has dashed so many on a frayed and tattered heap during her powerful rule.

In spring of 2018, I was in Charlotte, North Carolina, working on the Oscar de la Renta retrospective at the Mint Museum. At the same time, my documentary was making its New York debut at the Tribeca Film Festival. I was booked and busy.

Two weeks into the final organization of the show, I realized I hadn't received any e-mails from *Vogue* with details pertaining to my red carpet interviews for the upcoming Met Gala, to be held on the first Monday in May. Generally someone at *Vogue* called and formally requested my presence weeks beforehand. They paid me a small sum, but it wasn't about the pay. Rather, it was something I looked forward to all year.

The theme that year was *Heavenly Bodies*. I called up *Vogue* and asked what was happening. Why hadn't I heard from anyone yet?

"Oh, this is *beneath* you now, to do these interviews," I was told.

I took the call in stride, but really, it was a terrible way to find out my services were no longer desired. What truly perplexed me was that the previous year, for the *Rei Kawakubo/Comme des Garçons* gala, Anna had loved my interviews. She told me they were "great," which I distinctly remember because she rarely, rarely, complimented me.

This was clearly a stone-cold business decision. I had suddenly become too old, too overweight, and too uncool, I imagined, for Anna Wintour.

After decades of loyalty and friendship, and going through the peaks and valleys of the chiffon trenches together, Anna should have had the decency and kindness to call me or send me an e-mail saying, "André, I think we have had a wonderful run with your interviews, but we are going to try something new." I would have accepted that. It was absolutely fine to take another direction, younger, a blogger

or Instagram star with seventeen million followers. I understand; nothing lasts forever.

Simple human kindness. No, she is not capable. For years, Anna was the most important woman in my universe. I bottled up how hurt I was, as always, but our friendship and our professional alignment had just hit a huge iceberg. I later found out it had been *Vogue*'s digital staff that had decided to replace me, not Anna. I knew there was a change in the winds at *Vogue,* but I never thought I would simply be thrown to the curb.

My friends told me just to accept what had happened, move on, and take my assigned seat at that year's *Heavenly Bodies*–themed gala. And I did, in a resplendent bespoke Tom Ford black double-faced faille cape and cardinal-like coat with a black sash. But for the first time, I didn't go to Anna's hotel suite to see her final touches of hair, makeup, shoes, and jewels selection. I showed up to the Met, passed by the hall where I would normally do my chats, and took my seat, like any other guest, at a table with Vera Wang, Zac Posen, John Galliano, Rihanna, Cardi B, and Jeremy Scott. A fake smile stretched across my big black lips, and my hands clenched in silent disgust. I didn't want to create a scene, but I couldn't help but think, *This is beneath me, to sit here pretending I am okay with Generalissimo Wintour.*

Benny Medina, a major talent agent, interrupted my internal combusting: "Where were you earlier this evening? Why weren't you on the steps doing your thing? Jennifer [Lopez] was looking for you and when she didn't see you, she kept walking."

"I'm glad to know that," I said.

Annette de la Renta entered the room, in her black guipure lace, flounced Velázquez evening dress (it was Oscar's favorite dress he ever made for his wife, from his New York collection). On the way to her table, she gave me a warm hug and I felt the love. I realized then that in all my years of knowing Anna Wintour, we had never shared this feeling.

Annette moved on to her table and I felt suddenly, refreshingly, resolute. I stood up. Vera Wang asked where I was going; I told her

to the men's room, but instead, I swept and swirled my Tom Ford cape through the exhibit and down the back corridors of the Met to my waiting car.

On the way home, I swore to myself in that moment: *I will never attend another Anna Wintour Met Gala for the rest of my life.*

Throughout the rest of the summer, I did not hear from Anna. Then, in September, I received an e-mail from her assistant, asking if I would be attending Anna's Chanel couture fitting on October 17, one day after my birthday. I said yes, out of a sense of loyalty, not out of friendship.

Anna did not wish me a happy birthday that year, not even sending an e-mail wishing me many happy returns, as she usually did. Our friendship was officially, sadly, over. I attended the fitting, during which we exchanged no more than courteous pleasantries. Afterward, I sent her a glowing e-mail, remarking on how great she looked in her new black velvet draped skirt and top with an embroidered soft breastplate of armor done in intricate hand-sewn sequins. She responded almost immediately: "Thanks for making the time."

On her birthday, November 3, I sent her a celebratory e-mail. She did not respond.

I wonder, when she goes home alone at night, is she miserable? Does she feel alone? Perhaps she doesn't allow herself to feel these things, as she clearly is a person who does not dwell on the past.

In a broad sense, I do not see Anna, in her relationship to her editorial staff, or to me, working out of a higher sense of morality and spirituality. This is not to suggest she is altogether void of these human factors. She certainly is guided by them with her children and as a result is a great mother.

As Jackie Kennedy famously said: "If you bungle raising your children, I don't think whatever else you do well matters very much."

There is no doubt Anna Wintour is the best mother to her two

children, Charlie and Bee. She raised her children to be exceptional human beings. She has nurtured them from infancy to adulthood, and now they are both in happy marriages. Ultimately that's what matters most in life.

You might think I see myself as the victim in my alignment to Dame Anna Wintour. I do not. When we began our united trajectories at *Vogue,* she treated me with respect and with the concern of a friend, one who really cared. She gave me the opportunity to reach the pinnacle of the mastheads of *HG* and *Vogue.*

I've shared the great moments of her rise to becoming the most powerful woman in fashion. What drives Anna is a sense of her own ability to survive as a power broker, with sheer brute force, and to sustain an extraordinary level of success. Failure is not an option to her, in her life, in her career. She has held her position as *Vogue*'s editor longer than anyone in history, thirty years.

While I continued on as a freelancer my last few years at *Vogue,* I was never officially let go from the magazine by Anna Wintour or any other staffers. No one ever said, "You are fired, you should retire now." I remain on the masthead, even now, as a contributing editor, though I rarely go to the office. However, I continue to attend every single fitting of Anna Wintour's Met Gala dress, including hair rehearsals and jewel selections, right down to the Manolo Blahniks.

The Met Gala is the Super Bowl of fashion. Anna Wintour reinvented the party in 1999, eventually using her power to micromanage every single detail while simultaneously raising over two hundred million dollars. In 2014, the Met's Costume Institute was renamed in her honor: the Anna Wintour Costume Center. Michelle Obama, as First Lady, cut the ribbon at the official reopening. Anna deserved this honor, due to her great fundraising abilities; the Gala supports and finances the entire department. She is devoted to the museum and is a board trustee member.

Pivotal to her success is her laser focus on her Chanel (or Prada or

Galliano Dior) couture looks. She has leaned on my advice for the crucial process of two or three fittings per dress, and I've always considered it an honor to be asked to attend. Over the last nineteen years, I only ever missed one Met Gala fitting; it was at Dior, in Paris, 1999, when she selected a red fox sleeveless vest and amethyst tulle skirt from Galliano's great couture collection.

Sometimes these fittings begin in Paris, but most are in New York at the Lowell Hotel, or the Chanel headquarters on Fifty-seventh Street, or directly in Anna's home. Anna considers it her duty to be at her very best on the opening night of the Met Gala. Despite my wounded ego and insecurity, I continue to advise her out of sincere loyalty, no matter if she remains silent.

She will perhaps not like it that I revealed the process, but I finally take my fealty and flip it because I feel it's important to say, that I have helped her chisel out her optical moments for the most important night in the elite fashion world. If she asks me to attend her couture fittings after this book is published, I will be surprised.

I am not sure Anna ever really wanted me to become something larger than the role she perceived for me. She compartmentalized me as someone who served her as a trusted expert, religiously attending these key fittings for her wardrobe. She depended on my instinct for the deft nuance of her Chanel couture fittings. And for the last five years, I've gone without fail to her fittings, as a loyal friend, because it is expected of me. I have paid my own car bills from White Plains to Manhattan to attend these fittings. Never once did Anna offer or ask how I was getting home. She considers it a privilege, that I must be honored to attend these very private moments in her personal life and would do whatever is necessary to attend.

Anna is so powerful and so busy; she simply put me out of her existence. When I saw her socially, she used to come and sit next to me, and we would chat, superficially, but we had something to say in an even exchange. Now she treats me as a former employee, brief greetings, never anything more than perfunctory salutations. The only words exchanged are vapid demonstrations of politeness:

"Good morning, André," or "Thank you for coming." No superficial queries, nothing. Like any ruthless individual, she maintains her sangfroid at all times. She is always dashing in and out, and I do believe she is immune to anyone other than the powerful and famous people who populate the pages of *Vogue*. She has mercilessly made her best friends people who are the highest in their chosen fields. Serena Williams, Roger Federer, Mr. and Mrs. George Clooney, are, to her, friends. I am no longer of value to her.

The last true moment of grace I received from Anna was her interview for the documentary *The Gospel According to André*. Speaking to the director, Kate Novack, Anna Wintour told the truth. She verified my important role, or one aspect of it, in her life as editor in chief of *Vogue*. It was my knowledge of fashion that she found key to my ability to contribute. I was so pleased with her generous words in the film, which is now part of the National Film Registry at the U.S. Library of Congress.

The Empress Wintour, in her power, has disappointed me in her humanity. Our friendship has layered with thick rust, over the years. We went through thick and thin. I considered her part of my extended family. She moved on. No birthday e-mails, no gifts at Christmas, just polite and correct greetings and platitudes in public. Power through those platitudes Anna, but where is the *truth* to power, your human kindness? My hope is that she will find a way to apologize before I die, or if I linger on incapacitated before I pass, she will show up at my bedside, with an extended hand clasped into mine, and say, "I love you. You have no idea how much you have meant to me."

Not a day goes by when I do not think of Anna Wintour.

XVII

I introduced Lee Radziwill to Martin Grant, the cigarette-thin, blue-eyed Australian designer.

Martin would say, frequently, that watching Lee and me together was like watching "two battling princesses." Verbal sparring was our forte, especially on fashion, restaurants, and who was really well dressed in both Paris and New York. Lee actually thought few women could wear the title "best dressed."

When I first took Lee to Martin Grant's small Paris atelier, she was cautious, somewhat doubtful of his talents. She tried on her first custom order from this man and was sold. In fact, Lee loved Martin's designs; they were quality in fabric, simple in cut, and timeless. They also had an androgynous feel, which Lee favored. She rarely wore skirts or dresses in her last decade. She loved trousers and baseball-style or aviator jackets, made by Martin, upon request. I remember her ordering a white goatskin one, as well as a matte leather one in chalk white.

Martin somehow reflected Lee; he was nearly the same size and height as she was. She became his couture muse; he learned from her, and from the day they became friends, his clothes became fine investments, the kind of clothes *Vogue* editors might eschew for edi-

MARTIN GRANT

Years ago I was looking around Barneys with my friend André Leon Talley and fell upon a black leather jacket that I was mad about. I hadn't heard of the designer but naturally André knew immediately that it was now Martin Grant an Australian who lives and works in Paris. So do I! Atleast part of the year, so when I returned the first thing I did was to track him down. It wasn't easy but I was determined. Finally

I found his miniscule shop in the Marais but it was closed for lunch. I walked around & around until it was open & there he was! This young skinny, skinny super low key Australian who will always look like a boy & already had great success in his country.

For me his talent is exceptional especially for coats and leather jackets he is unbeatable. He is not trendy because he understands & respects line, proportion & simplicity.

How lucky we are that he came to Paris and doesn't need or want to show off.

Now his quarters are large & lovely & all these years we remain the closest friends.

Lee Radziwill's handwritten account of my introducing her to designer Martin Grant. They went on to become the best of friends.

torial pages but consider the go-to choice of an elegant individual. Candy Pratts Price and I were the only editors who went routinely to Martin's biannual presentations in Paris. As I recall, his clothes were never called in. Martin's own survival in the chiffon trenches is due to his self-taught skills of technique and appreciation of luxurious fabrics, and his antennae, raised at all times to a modern aesthetic.

Martin doesn't care for the faux fanfare of editorials in the glossy American *Vogue*. The Duchess of Sussex, Meghan Markle, the first biracial member of the English royal family, wears Martin Grant, and he was so proud when she appeared wearing his classic, simple lined trench coat or his beautiful soft striped pale gray shirtdress on a tour of Australia.

For the month of August, Lee would vacation in Corsica, at great expense. Martin and his partner, Mustapha Khaddar, would travel with her. She loved these holidays and so did Martin.

Lee took her matching Goyard luggage and piled it in a separate van on the way to a private plane for her four-week holidays in the sun, renting the house of Comtesse Jacqueline de Ribes, another Truman Capote "swan"—actually, one of the last ones living.

In the de Ribes holiday house, there was a maid named Jackie. Lee would screech, in her mellifluous voice, "Jackie, do this! Jackie, fetch this. Jackie, get me a glass of water."

It was a secret joke between Martin and Lee; she channeled all those years of walking in the shadow of her famous sister, the First Lady. Jackie the celebrity had stolen Ari Onassis from Lee. It was Lee who expected to marry him, yet she went to the nuptials of Jackie and Ari on Skorpios. In her public will, Jackie left provisions for Lee's children, Tina and Anthony, but she left nothing to Lee, "for whom I have great affection because I have already done so during my lifetime."

As Peter Beard, one of the great loves of her life, and a friend to the end, once said about Lee: "It's important in life to hold out for elegant miracles."

Lee was the elegant miracle in my life.

In 2016, when Lee had to have brain surgery, she called me and said, "André, I need a turban when I come from the hospital."

Norma Kamali sent me three jersey turbans, and I went to meet Lee at the hospital. I just missed her—she had just been discharged—but her apartment was only around the block, so I rushed over. Lee was in her car outside her home, waiting for a wheelchair. I gave her the turbans as her devoted caretaker Murelia helped her out of the car. Granting this little request was nothing, yet so appreciated by Lee.

In recent years, Lee sold her last Paris flat on avenue Montaigne and rarely left her New York apartment. I visited Lee often on early Sunday evenings at her home; her beautiful hair was combed out, and she wore pale gray cashmere sweats and her favorite peony-pink shade of cable-knit socks. No shoes. She had a cigarette in her hand and her black and white Japanese Chin, Lola, by her side. All Lola wanted was to have her stomach rubbed. I could oblige her, for hours!

I saw Lee last in January 2019, a few weeks before she died. I went up one Sunday evening wearing my big red Norma Kamali sleeping-bag coat and she said, "I have to go and get me a red coat like yours." She made you feel as if your choices were the best.

I noticed then, for the first time, that she had let all of her hair go pure white. I told her it was so elegant, like an eighteenth-century marquise or duchess. She loved that.

Everything was still impeccable and remarkable at her home. Her favorite pieces from Paris now populated her drawing room. She shared with me what a tough Christmas she had had. I told her mine was equally as tough and lonely, except for my intimate Christmas Eve dinner at Catie and Donald Marron's, with their children, William and Serena. I told her of Catie's Rothko and her Twombly, as well as her beautiful Christmas decorations, including a hall table displaying an entire Bavarian village in miniature. I also told her how I dared to ask for a take-away bin of the best Virginia ham and

dressing, since the Marrons were leaving the next morning for the Caribbean.

After two hours of talk, Lee got bored with me and told me it was time to leave. That was Lee. She was always so specific in her actions and reactions. Just before leaving I asked if I could take a photo of Lola, her seductive little lapdog. Lee picked Lola up; "Don't you want a photo of me?" she said. I took one of them both, and Lee looked so beautiful, at peace with all that remained: her friends; Tina, her daughter; Lola, her dog; and her memories.

She loved my last delivery of flowers, or so she said: two small orchids for her escritoire, and four small pots of pink cyclamens, just after Christmas. The last thing she said to me, upon my asking her availability: "It's not convenient today," and, in the most melodious voice, a personal Lee sonata: "Goooood-byyyyyyeee."

Lee saw the best in people she loved; she saw life's wonderful experiences of trust, laughter, and friendship through the eyes and sensitivity of a child collecting gleaming seashells from fresh ocean waves. In the words of her close friend Hamilton South, "Whatever time each of us had with her should be remembered as nothing less than a privilege."

I learned from Martin Grant, at five A.M. on a Saturday, that Lee Radziwill had passed the night before, Friday, February 15, at home. He called me from Paris; I was in Durham to screen my documentary. Friday night I had received the key to the city, given by the mayor. Onstage with me was my favorite high school teacher, Wanda Garrett.

Martin Grant said he had planned to see Lee in late January. She told him he could sleep in her guest room. He didn't make it, but he did fly overnight from Paris, with his partner, Mustapha, for the strictly private invitation funeral mass. Hamilton South had called him, to say the time and date of the service and that an invitation would follow.

"Hamilton has not called me. Do you think I am on the list?" I shrieked into the telephone at Martin as I sat in my small suite.

I didn't know if Lee had put me on the list of 250 chosen guests requested to be at the funeral. I was a nervous wreck! My good friend Georgia Donaldson brought me her fresh homemade Brunswick stew and sat with me every day as I waited for the phone to ring with my invitation. All I could think about was Lee transitioning from this universe to another. She was at peace, having fought against formidable odds.

After three days, finally, the call came. I texted Martin the news. He replied: "Praise the Lord. You can now relax, you battling princess." He asked if I would pick him and Mustapha up from the Mercer Hotel the day of the funeral. I said of course.

At 8:40 A.M., there was Martin on the sidewalk, in a midnight-blue and wool silk jacket, navy trousers, the most elegant and polished black shoes, and a pea jacket of his own design, of such simple and clean lines, it was akin to the simplicity of Yves Saint Laurent's famous pea jacket, in his early career.

It was couture. Of course. We had fifty minutes to get uptown from Mercer Street to the church of St. Thomas More on East Eighty-ninth Street. Lee's father's sister, Aunt Maud, had been a parishioner there. On the way, I remarked that Lee, were she here, would have taken that pea jacket right off Martin. "And I would have given it to her," he said, and lit a Marlboro Light cigarette. Mustapha was also dressed so elegantly in a single-breasted cashmere coat, trousers, and really wonderful black leather shoes. Both men looked the way you should look: classic, in quality fabrics with simple cuts, and really dashing.

We continued with our fond memories of Lee. I told them that when I gave her a beautiful black leather square handbag, with gold metal ornamental handles, for her birthday, I was sure Lee quickly handed it over to her maid. I never saw her carrying it and she never mentioned it again. The best things to give her, on any special occasion, were her favorite white orchids. I often sent up six beautiful white orchids in fresh terra-cotta pots, from Rosedale Nurseries in Hawthorne, New York. In Paris, I would go to Moulié-Savart,

tucked in the corner of the Place du Palais-Bourbon (just two doors down from American *Vogue*'s headquarters in Paris), and select fresh lemon trees, in huge terra-cotta pots, for Lee's living room. She could not easily recycle these plants as gifts.

In her final moment of creativity, Lee was laid to rest in a simple wicker coffin; the entire top was covered in her favorite sweet peas, white and pale pink.

Each moment of Lee Bouvier Radziwill's hour-and-ten-minute-long liturgy was carefully, exactingly, painstakingly created. Her funeral program was sixteen pages, printed on pale ivory stock. The first note: "PRELUDE, Excerpts from Puccini's 'Music Without Words.'" Lee's favorite bedtime music. Her surviving daughter, Christina, read E. E. Cummings's "Maggie and Milly and Molly and May." It must have been her favorite poem from childhood. Then Hamilton South gave the most heartfelt and sincere eulogy.

The recessional, to Brahms's "O Welt, ich muss dich lassen," moved me to articulate: "Good-bye, Lee, good-bye, Lee, I love you."

After the funeral, Martin, Mustapha, and I took the car back to the Mercer Hotel. It was so fitting that Martin and I would share the moment of Lee's death in such a close bond. We sat there quietly in a corner of the Mercer lobby and remembered how we had spent so many moments in our lives in this very same hotel, often seeing Karl Lagerfeld there, and how on his last trip, Martin saw Naomi Campbell. She still has the elegant red redingote coat she wore in his breakout runway show (and subsequently wore right out onto the street).

How did Lee take to Mustapha?

"Well, at first, she said to me, 'Martin, how appalling, you can't have a boyfriend called Mustapha.' She was having nothing to do with him. Then I told her everyone in Paris kept saying Mustapha looks so much like President Barack Obama. She quickly chimed back, with no explanation, 'When are we having lunch with him?' That's all she needed for approval."

On one of the last trips to Corsica, Lee fell, going down the steps

from her villa. She went home, called Martin the next day, and said she couldn't walk.

Martin taxied to her apartment; cradled her in his tiny, childlike, elflike arms; and took her downstairs to a waiting car. She wore only her nightgown and a sweater.

X-rays showed Lee had broken her hip. She was immediately operated on and had a hip replacement. When she saw the replacement X-rays, she said, "I have a beautiful Brancusi sculpture inside me." This was typical Lee, turning a serious and grave crisis into an amusing, whimsical anecdote.

In Lee's simplicity, she was magnificent. She tried so many careers: acting, film producing (*Grey Gardens*), interior decorating, editing (two great books, published by Assouline of Paris), writing for magazines, gardening, even designing. I said immediately after the funeral, inside the church, seated alone, to the *Daily Mail,* that the Bouvier *soeurs*—Jackie and Lee—were the closest thing America had to royalty.

Lee did not bow to the pressure of New York social life, where air kissing and backstabbing is the norm. She cared little about what was the last word in fashion or being accepted by a clique of society crows just to get out of the house for lunch. She leaned heavily on her close-knit circle of good friends; she demanded so much of them, but so much was given in return.

We both loved church services: She went to my church, Abyssinian Baptist, and I went to hers, St. Ignatius Loyola, on Christmas Eve. Before she died, Lee went around her apartment selecting special gifts for friends; her executor later sent me a pillow in leopard print by Renzo Mongiardino, the Italian interior designer, which had traveled with her through all her lives in many homes. And a favorite framed photograph of Lee and I, in our white looks, she in Dior trouser suit and me in a white Prada alligator coat at a *Vanity Fair* party. At Christie's, I bid on many lots from her estate; I was happy to purchase her Bible she had kept with her since her mother had given it to her at the age of eight. It is spine cracked and

well worn. And the only pair of candlesticks, which she kept on her mantle: a pair of French ormolu.

Hamilton shared with me, five days after her funeral, that Lee had been cremated. Her ashes were to be scattered, partly in the Mediterranean Sea, partly in the Atlantic, and the remainder placed in a headstone next to her father, John Vernou Bouvier, in the Saint Philomena Cemetery, in East Hampton.

XVIII

In his final days, Karl pushed everyone away. Everyone, that is, aside from Choupette, his beloved white cat that he was devoted to and spoiled (the feline, who was known to wear rare diamond jewels, had her own maid, who accompanied her on trips, and a personal dentist).

The last time I saw Karl Lagerfeld was in late 2017, at a private party thrown in his honor by *V* magazine at the Boom Boom Room in New York. I was surprised to be invited; if Karl really didn't want to see me, I'm sure I would not have been on the list. I went with Gloria von Thurn und Taxis. Our table flanked Karl's big table.

Right away I walked up to Karl and his all-important, ego-addled table. It was his party, after all, and my grandmother raised me right. Through gritted teeth, I said, "Hello, Karl, how are you?" Then I swiftly made my way to my assigned seat for dinner.

Gloria made her round later on and spoke to Karl in full German for about four minutes. She came back and told me she was telling Karl about me. She said Karl seemed interested in my welfare and asked her how I was doing, and if I was okay. But then he got distracted by so many people. She knew it was time to get up from his table and just leave it alone.

Naomi Campbell was there. Virginie Viard was there, but I never saw her. Mariah Carey came, in a *clinging* Chanel evening dress, and sang in honor of Karl. When she saw me, she stepped off her elevated stage platform and gave me the biggest hug. After Mimi's performance, Gloria and I left, without saying good night to Karl. I wanted to get out with my dignity intact. Although I missed Karl, I would not play kiss-ass to him.

I was already mourning the loss of Lee Radziwill, who had died the weekend before, when I learned from CNN on February 19, 2019, that Karl Lagerfeld was dead, at eighty-five years of age. He had been rushed to the hospital, and a liter of fluid had been removed from his lungs. Then he simply went to sleep and never woke up. Only Sébastien, his aide-de-camp, was there with him in his final moments.

Anna Wintour called me from London. "I thought he would live forever," she quietly uttered, with that break in her voice she usually gets when she allows her emotions to well up into a mobile device. "We were trying to get through, Amanda and I, making plans to see him for dinner, when we got to Paris." We continued talking for a while, remembering our best moments together with Karl.

Sally Singer from *Vogue* e-mailed me and, with grace, asked me to contribute something. Within ninety minutes I'd written directly on my iPhone what would be my last piece in *Vogue* on Karl Lagerfeld. I wrote from the heart.

Naomi Campbell also called me, from some foreign city, on one of ten ubiquitous cell phones she keeps in a Hefty zip-lock bag (a cell phone for each country is thrown in her carry-on, as well as a fresh bottle of Tabasco sauce). Naomi wanted me to know she was thinking of me. It meant a lot.

Three days later, Karl was memorialized. I was not invited, though I would not have been able to make it on such short notice anyway. Anna Wintour and Princess Caroline of Monaco both spoke. Anna wore all the blue aquamarine stones, surrounded in diamonds, that Karl had given her. Two brooches and a big necklace. I

saw the photographs. According to my dear friend Amanda, the Lady Harlech, the service at the crematorium was dignified, though it lacked the touch of Karl. There were no foot tubs or buckets of full-blown roses, white ones, the way Karl would have loved. You would think someone as meticulous as Karl would have planned out exactly how he wanted his funeral to go, the way Lee Radziwill did. But as I have written, Karl did not like to deal with death.

In my Southern Baptist culture, people visit the graves of loved ones. One summer, I faxed Karl that I had been to the grave of my father, who is buried in Roxboro, North Carolina. Amanda Harlech told me later that Karl told her, "Apparently André's spending his time running around North Carolina, visiting graves of his relatives."

While he rarely spoke of death, Karl did mention that he did not want any funeral, and no one was to view his remains. Karl did not want to be seen in a state of death. He told me he had included in his will that when he died, he was not to be seen by anyone. His wishes were not followed. He was laid out in a black wooden coffin, in a black jacket and his favorite lean-legged black suede trousers, a wide necktie, and a high Edwardian white-collared shirt; the necktie was accessorized with some of his favorite diamond stickpins and precious rare vintage stones. Only a chosen few were invited to view his body. Karl would not have liked any of this. He would not have wanted it. But the service was not for him; it was for those mourning his loss, and for Chanel to have a sense of closure.

When Karl's mother died, we were in Paris at a party for Karl, and he received a private phone call. He came back and continued on as though nothing had happened, but I could tell he was perturbed.

"What happened?" I asked.

He hesitated. "My mother has passed."

I started to give my condolences but he stopped me and moved on to another topic. He never mentioned his mother's death to me again except once, to say he wanted his ashes mixed in an urn with hers in the château he had bought for her. The remaining ashes,

he wished to be mixed with those of his one true love, Jacques de Bascher.

Karl Lagerfeld refused to acknowledge the most basic fact of life: Death comes for us all. The only funeral I ever saw him attend was Gianni Versace's. Karl chartered a private jet for the day and we flew together from Paris to Milan. We sat in the third row, behind Princess Diana of Wales and Elton John. Gianni was one of the few designers Karl sincerely liked. Everyone liked Gianni; he came from a big family and he had a kind heart. They weren't intimate friends but they enjoyed each other. They really got on. Karl went to Gianni's funeral out of respect.

Perhaps Karl thought contemplating death was a waste of time. Truly, there was no one with a more robust schedule in all of fashion than Karl Lagerfeld. He ran three of the biggest fashion brands in the world simultaneously for decades: Chanel, Fendi, and his eponymous Lagerfeld label. And still he took on various anonymous freelance work. While other designers were driven to drink and madness and sometimes suicide by the pressures of one fashion house, Karl made it all seem so easy.

Karl was like a brother to me for forty years. And then five years before his death he cut me out of his life. I have gone over and over in my mind the deep loss of Karl in my life. With great happiness, I can focus on the good times with Karl, not the dark hours of the final years. I will always have the golden memory of walking in the forest at midnight, behind the château in Brittany, with Karl, Patrick Hourcade, and Jacques de Bascher, carrying huge torches of twigs and branches for light, as we glided along rough paths. It was like a fairy tale, complete with a castle.

In the halcyon days of my early years, Karl and I went by car through the Black Forest to a hotel, just the two of us, where he was launching a beauty product. The softly falling snow covered the highway. The forests were beautiful. Karl was happy, and it shows in a photo someone took of us, me in a beautiful long, black broadtail

coat he had designed for me, suede gloves, and a Tyrolean hat with a very beautiful badger's brush.

Every moment with Karl, I now realize since he has been gone, was an amazing tutorial. A face-to-face dialogue between the Socrates of high fashion and his best student. Since his death, I have come to the realization that our relationship was as lustrous, as smooth, and as rare as the Peregrina pearl. There was no other man in my life who gave me so much and who shared so much.

It was a wonderful relief to be told by Amanda Harlech and Anna Wintour that after he and I had stopped speaking, every time they saw Karl, he asked after me and how I was doing. Truly he could be as lethal as a black mamba snake. But I am sure now that he cared for me, even after our falling-out. I loved him, and he loved me right back.

XIX

The day Karl died, Naomi Campbell called me from some remote place in Africa. She knew how close I was to Karl and that I'd need a friend to lean on. Naomi is not in my life every day, she goes AWOL for weeks, months at a time. But she is there, just when you need a friend, with no personal agenda.

These days Naomi's life is all about Africa, crisscrossing the continent to support global awareness of the business potential of African fashion designers. When she called me that day, she asked me to come with her to Lagos, Nigeria, where she was due to attend Arise, the Nigerian Fashion Week. She suggested that I come with her and premiere my documentary there.

It is the wish and desire of every black human being to see Africa at some point before they die. But at seventy, highly overweight, and in poor health, it seemed a tall order for me. If only one person on God's green earth could pull it off, it would be Naomi Campbell. I said yes and she said she would be in touch soon to sort out the details.

Weeks later, I was seated at the closing day of Tina Brown's tenth annual Women in the World Summit at Lincoln Center, waiting to hear Tina in conversation with Anna Wintour (Anna and Tina were estranged for a while, but now they're friends again).

My phone rang. I knew those sitting around me would not appreciate my talking on my cell phone but it was Naomi, and one cannot just decline a call from Naomi Campbell.

"Are you coming with me to Africa?" she said.

"Yes, Naomi, but I have to hang up the phone, I am at a summit with Tina Brown. I am not supposed to be on this cell phone!" People were looking at me.

"Ring my agent and they'll arrange the details."

With that I hung up. By the end of the summit, I was listening to former secretary of state Hillary Clinton, and my phone rang again. Naomi.

"We are leaving Monday," she chimed.

"What, I can't possibly leave *Monday,* what about the visa?!"

"Don't worry," Naomi said, and hung up.

The next day, I had a final fitting appointment with Anna Wintour for her 2019 Met Gala dress. It was to be held in the vast fashion closet at *Vogue,* which meant I would be in the *Vogue* offices for the first time in three years. The directrice of Chanel's couture, Virginie Laubie, came all the way from Paris to supervise.

The 2019 Met Gala dress, designed by Karl Lagerfeld just before his death, was a masterpiece. A pale pink wool long strapless dress, embroidered with beautiful small flowers, simulating eighteenth-century porcelain.

The theme of the exhibit, curated by the Met's Andrew Bolton, was *Camp: Notes on Fashion.* Bolton was inspired by the essay "Notes on 'Camp'" by Susan Sontag.

Anna's dress had nothing at all to do with camp. It was elegant and expressed the highest standards of Chanel technique and refinement, as designed by Karl. The last of his mind's creations Anna will ever own. She also chose a Chanel pink feathered cape, which I was not a fan of to begin with. It was a riff on Armani Privé couture 2018 (which was included in the Met exhibit), imposed into a Chanel cape, as no one other than Anna Wintour could demand.

Anna does not have the deportment to make such an elegant cape

move with éclat. In pictures, she looks frozen, like a hieroglyphic image on a tomb wall.

There was polite talk about the devastating news that after three decades, George Malkemus and Manolo Blahnik (who had made the pale, pale pink glossy snakeskin sandals to match the dress) were dissolving their partnership. The jewels were brought out from the vault to try on with the evening dress. In my humble opinion, the nineteenth-century diamond necklace she chose to wear (and shipped from S. J. Phillips in London, on loan) was a bit too Marie Antoinette. That's all the commentary I gave. I was trying to be diplomatic and get across the point that her neck seemed to be strangled by this and, symbolically, it was wrong. She wanted it worn high on the neck and was asking if two of the stones could be extracted from the necklace to make it sit high on her throat.

The fitting was fast, and I have to admit, I wasn't entirely there mentally. I was thinking about Africa, the continent from which my ancestors made a passage in the hulls of ships, tortured, chained, beaten, lost, refound, and survived.

I've known and supported Naomi since she was discovered as a teenager in Covent Garden in London by a model scout. Quickly, by the time she was eighteen, Naomi pranced out of the paddock with great style, appearing on the cover of British *Elle* and skyrocketing to supermodel status. Yves Saint Laurent went to bat for her, threatening to remove all advertising from French *Vogue* if they did not put her on the cover. And so in August 1988, she became the first black woman to be featured on the cover of French *Vogue*. One year later, she again made history, as the first black woman to appear on the cover of American *Vogue*'s September issue. Over thirty years later, Naomi has appeared on endless covers of *Vogue,* as well as in endless moments of melodramatics.

I was front-row center in Paris in 1993, at the Vivienne Westwood show, when Naomi fell as she turned at the end of the runway.

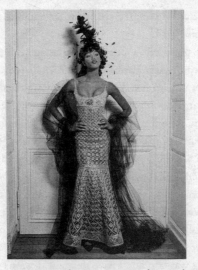

Naomi wears the most expensive dress Karl
Lagerfeld had designed since he became
designer for Chanel. She is posed as Scarlett
O'Hara, about to be taken down at
Melanie's birthday party, to which she was
forced to go by Rhett Butler. In the film,
Vivien Leigh wore a ruby dress in a cloud
of ruby tulle. Naomi wore gold and black.
The set was Lagerfeld's residence in the
landmark Hôtel Pozzo di Borgo in Paris.

She had on nine-inch lilac chopine lace-up ghillie oxfords. Like a colt,
she fell to the ground and simply bounced back up, resplendent in her
authenticity, and walked in those impossible towering shoes. I wit-
nessed this and it was a miracle to see her natural gifts at work. That
image went around the world; she was simply Naomi, in her power.

Early on Naomi realized that as a woman of color, she had to
work harder than her fellow supermodels to maintain her position at
the apex of high fashion. She has this something, this *je ne sais quoi*,
that allows her to maintain numerous and countless lives restored
and renewed. Her life has been a topsy-turvy ride, from rehabs for
cocaine and alcohol abuse to raising money for the Nelson Mandela

Children's Fund, as well as organizing benefits for the victims of Hurricane Katrina. Naomi goes out every day resplendent in the latest fashion. Being in her entourage is like being in a film; she's larger than life, like Elizabeth Taylor. And like Elizabeth Taylor, Naomi has managed to parlay her celebrity image into a world-class brand of goodwill.

Able to work miracles, Naomi arranged for me to make it to the motherland. I brought with me Chase Beck, my "homeboy" from Chapel Hill, North Carolina, who for this trip would be my assistant. All I had to do was show up with my bags packed.

Chase and I had a smooth flight to London. Our transfer was hell, largely due to a demonic golf cart ride across terminals, but I was pleasantly surprised at the gate to see Edward Enninful, or should I say Sir Edward, as he's been knighted by Queen Elizabeth II. He was on the same flight from London to Lagos, with his wonderful husband, Alec Maxwell.

First class was half empty, so Chase spent the last two hours of the flight with me. The flight attendant did not complain. I woke up from a nap and found him standing in the middle of the cabin, eating the complimentary chocolates left on a stand. Edward and I talked about Karl a little bit. He told me Karl had seen my documentary, which I was shocked to hear.

We landed in Lagos by the end of the day. The hustle-bustle of the terminal had none of the modern high-tech seduction of terminals all over the world. My wheelchair (now required for airport travel as my weight had affected my mobility) almost tumbled off a hydraulic lift that connected one level of the airport to the other. It was primitive to say the least. By the time our luggage came down the chute and our visas were arranged, it was getting dark.

It slowly dawned on me that we had been abandoned. Chase and I huddled with Edward and his husband. People were gazing at us, focused on our foreignness. Men surrounded us, offering currency exchange. I nervously yelled out, "Chase, do not get lost in the crowd."

Finally, we were deposited into taxi vans, and fortunately mine

was air-conditioned for the hour-and-a-half drive through the seventh circle of Dante's hell.

I prayed out loud for most of the ride. Chase sat calmly, balancing out my hysterical demonstrations of panic. The nighttime traffic was a mix of unmarked lanes, horns honking, and no streetlights. Old, rusted Volkswagen buses, which could literally have been the same ones that once carried hippies to Woodstock, were used as public transportation and packed like sardines. People on foot darted in and out of traffic, selling everything from fruit juice to lemons, beautifully arranged in towering pyramids, carried and balanced on top of individual heads.

I thought to myself, *I have come from New York to Africa to die in traffic. How ironic.*

We arrived at the Seattle Residences hotel, on embassy row in downtown Lagos, and I was shown to a massive three-bedroom suite, all Westernized to within an inch of any first-class hotel accommodations in Europe. The impeccable beds, adorned with plush white linens, were equal to those at the Ritz in Paris. Chase took the second bedroom, and the third was given over to my enormous wardrobe of Tom Ford caftans, bespoke Dapper Dan–Gucci–collaboration custom caftans in rich brocades, and Ralph Rucci taffeta and *gros de Londres* caftans, all unfurled from my army-navy surplus bag, to be ironed the next morning by an educated male butler, a native of Lagos, who spoke perfect English.

Around ten P.M., Naomi Campbell stopped by my suite to welcome me. She was resplendent in all her regality and her divaness. She was on her way out and invited me to join, but I was not up for an adventurous night on the town.

Attendees present at the Arise Fashion Week were well-heeled, educated, and highly Westernized Nigerians, usually in Louboutin stilettos and carrying authentic Gucci bags. Men were dressed in the last word in Prada sandals, slim jeans, and very original shirts, cut by two talented Nigerian designers, Joseph and Ola. Every person was polite and they loved, *adored,* Naomi. Nduka Obaigbena, the media-

mogul founder of Arise, had Naomi on the cover of *This Day* every day during her stay. Each and every time Naomi walked down a runway in Lagos, the entire room erupted in verbal awe and applause. She has never lost her cool on the runway. Never. Ever!

Naomi participated in a panel on the future of the fashion business, and I was asked to give a few words. I took the opportunity to thank Naomi and remarked how her activism and charity work had sustained her powerful legacy, surpassing her celebrity image. I also told a story of a time I had to babysit her in my suite at the Four Seasons in Los Angeles, where she fell asleep in a long Jean Paul Gaultier evening dress and heavy eyelashes. Naomi has always been a true and loyal friend. She was in tears after I spoke.

I always woke up thankful I had come to Nigeria, which was questionable to me at first. I couldn't let Naomi down. And she proved to me she was grateful, taking my hand when I stumbled and attending the panels she had me participate in.

If Naomi were music, she would be Saint-Saëns's "The Swan," from his suite *The Carnival of the Animals,* or she would be Scott Joplin's "Gladiolus Rag." She has majestic drama on a professional runway, and her personal life is itself reminiscent of "Triumphal March" from the second act of Verdi's *Aida.* If she were a poem, it would be "Correspondences" by Baudelaire.

The screening of the documentary was well received, and the corresponding Q & A was robust. Audience members lined up to meet me after. By the time I finished, I was happy to go back to my hotel room and watch Beyoncé's *Homecoming* on Netflix. I was in for the night. The humidity was overwhelming.

I arose on Easter Sunday morning to attend services with Naomi and Nduka Obaigbena, at the Cathedral Church of Christ, the largest Anglican church in Lagos.

We arrived late, Naomi wearing a pale blue Chloé dress of silk crêpe to her midcalf and Givenchy high heels. As the church doors opened, the choir was singing out, "*O death where is thy sting?*" from Handel's *Messiah.*

Nduka quietly turned to me and said, "This is your home." And with great discretion, he handed me a wad of the local currency to give during the offering.

Ladies of great refinement had pulled out all the stops for Easter services. It was akin to Easter services in my childhood. I sat there, respectful, as Naomi participated in a traditional dance, accompanied by an orchestra of percussion and voices. As the service came to an end, she was mobbed with requests for selfies. Nothing got out of hand as we recessed down the aisle to exit to waiting crowds of people outside.

That afternoon, Naomi took a spin on some Nigerian magnate's luxury yacht in the marina. My focus was to be on time for an eight A.M. departure the following morning. Naomi was taking us home in a private jet and if I missed the flight I would have to go back to the dreaded airport in Lagos. I woke up at six to be downstairs, not wanting to hold up the motorcade to the private jet, which seated six, along with a makeshift double bed for Naomi. Of course, Naomi overslept and forgot to pack, so we were rushed by police escort, horns honking, to the private airport and arrived by quarter to ten.

We waited on the sweltering tarmac as the plane was prepared. Like a movie star, Naomi got out of her big black SUV and took her time applying her lipstick, combing her hair, and smoking a cigarette, seemingly oblivious to the heat slowly melting us all.

It was so hot I was about to pass out. But I couldn't simply board, as it was her private plane. I'd need permission to board before she did.

"Do you mind if I climb aboard the plane? It's so hot," I said.

Naomi threw me a look that, if it were a poison dart, would have been a fatal blow. "Wait, I have to film my departure," she answered definitively.

As we waited on the hot, humid tarmac, I whispered to Chase, "Don't say hello to her. Don't speak until she speaks. Don't even look at her! We don't know what this mood might be."

Naomi got her footage, boarding the luxurious private plane, and Chase and I were finally allowed to board as well.

After we took off, Naomi mentioned that she had slipped and eaten gluten at the hotel. "Eating that croissant was like having a sleeping pill," she said. I shot a look at Chase, reminding him to keep quiet.

It was a ten-hour flight to Teterboro. Chase never once talked to Naomi. She appreciated this and was polite to him. Most of the time, she watched television on her computer.

Toward landing, we talked about the upcoming Met Gala, the first ever I was opting not to attend. I told Naomi this, and my reason why. That Anna had unceremoniously flung me out with the garbage. She said she thought my decision was right.

Outside, Naomi smoked a cigarette and waited until everyone was accounted for and in an SUV on their way home. I thanked her profusely for her generosity. I was transformed. It was, to me, better than any trip I had ever taken.

Naomi's elegance permeates in so many ways. Her spirit is fierce. It's her God-given gifts that astound one as she walks for the best talents of the world. Karl Lagerfeld selected her for the highlights in many of his couture collections, especially in the halcyon days at Chanel. She was a John Galliano favorite in his great moments at Dior and Givenchy and Galliano. CEOs of Gucci listen to her every recommendation. She has represented beautifully, and with elegance, Ralph Lauren in his campaign advertisements. Saint Laurent loved her. Gianni Versace never did a show without her, and Azzedine Alaïa treated her like a daughter. These designers considered her the proverbial muse, not only for her individual walk, but also for her distinct personality.

In those four days in Lagos, I saw Naomi talk to CEOs about offering scholarships to countries in Africa, and I saw her push for an African *Vogue*. She has always been for people of color and fights the good fight behind the scenes. As I screamed at her on one of our finest fashion shoots, "*Éclatante! Éclatante!*"

"What the hell are you saying?" she screamed back.

"Sparkle," I roughly translated.

Sparkle she did, and she continues to do so, illuminating the fashion galaxy.

Wearing a black agbada by
Patience Torlowei of Nigeria.
Photograph by Alessio Boni, 2019.
Photographed at the Paradise Club, in
the New York EDITION hotel.

XX

One of the most prophetic American designers, Marc Jacobs has always been a loyal friend and an inspiration. At his first show at the Plaza, he showed a white mink trench coat and black-watch plaid skirts, and I knew he was going to the top.

I will treasure forever the memory I have of Grace Coddington, Tonne Goodman, and me at a Louis Vuitton fashion show, fall/winter 2012. The show, always the last one in Paris Fashion Week, opened precisely at ten A.M. in a glass dome built in the courtyard of the Louvre.

As a double screen recessed, steam rolled across the seated audience and a custom-made French locomotive moved slowly to the end of the two-sided catwalk. I thought in that moment of John Galliano's fall 1998 couture fashion show, which had models coming off a train, but that fashion extravaganza had taken place *at* the Austerlitz train station. Marc Jacobs supposedly spent four million dollars building this train for this set in secret. Throughout the fourteen-minute show, models emerged from the train's cabin, each with a liveried porter carrying glamorous totes, hatboxes, hard boxes, and beauty cases. It wasn't just about fashion; Marc crossed into the realm of fashion performance as artistic installation. The

history of Vuitton, originally a house of luxury travel accessories, was in the forefront. I was proud to see an American of such talent create such a show.

After the show climaxed and the glass-domed hall emptied, Grace, Tonne, and I sat there in tears, joyful in our hearts and grateful we had witnessed such genius. The romanticism of the show was so overwhelming. This show defined Marc's extraordinary ability, as did so many moments at Vuitton, especially in the early days when he showed under the hot pyramid of the Parc André Citroën in Paris, in the middle of the afternoon.

Anna Wintour always adored Marc and helped him land his job at Louis Vuitton, where he soared. In a fifteen-year span, he took Vuitton from a prestige luggage house to the most influential fashion house in Paris. At the same time, he had the genius, and the fortitude, to maintain his place atop the Mount Everest of fashion. The eponymous Marc Jacobs fashion line always closes out New York Fashion Week with collections that become prophetic to the industry and are original, fierce, and unorthodox.

For fifteen years, Marc managed to uphold his rank as arguably the most anticipated fashion presentation of both the Paris and the New York fashion calendars. That is unprecedented. He maintained his standing, often with controversy, especially when some of his shows were two hours late. And then in a total reverse and about-face, his Marc Jacobs brand would show precisely on time, at eight P.M. If you were not in your seat on the front row two minutes before the show began, tough luck. You had to stand in the back.

Rich or poor, Marc has always kept close to his core friends: Rachel Feinstein and her husband, John Currin (both critically acclaimed artists); Lil' Kim; Kate Moss; Robert Duffy (his longtime business partner); Naomi Campbell; Debbie Harry; Christy Turlington; and Lee Radziwill, who spent months shopping for Marc's duplex apartment in Paris, just in view of the Eiffel Tower, purchasing the right Christofle silverware, Baccarat glassware, fine dinner plates, and luxurious sheets from Porthault.

I often picked up Lee on the way to see Marc's shows in Paris. She was a true friend to both of us. Unfortunately, she was no longer with us for Marc's wedding celebration, at the Four Seasons in Manhattan.

Marc Jacobs's wedding to longtime boyfriend Char Defrancesco represented a certain moment in time where the world had suddenly become more accepting and accessible to gay men. A sincere and legal celebration of their love, done their way. Embraced and respected, rather than career destroying. The year 2019 marked the fiftieth anniversary of Stonewall, and presidential candidate Pete Buttigieg's May 2019 *Time* cover was momentous, in both its existence and its seeming banality.

The morning of Marc and Char's April wedding, I meditated on not going. I had been hibernating in my house in White Plains for the past few winter months. Intuitively, something told me this wedding would be Marc's answer to Truman Capote's legendary 1966 Black and White Ball. It would be the key fashion wedding of the new era, akin to Paloma Picasso and Loulou de le Falaise's respective soirees. Plus I had never been to a formal gay wedding before. No matter the effort, it was my duty, after having RSVP'd yes, to get up out of the house and go.

I rolled up to the Four Seasons twenty minutes early, in my Tom Ford black taffeta caftan, and underneath it my Tom Ford blue silk satin shirt to the ground, tailored from fabric that artist Garrett Rittenberg bought me from Ethiopia. Parked outside, there was a sleek vintage silver and black Rolls-Royce. This had to be Marc's. He had clearly planned for this day to be the big one. Inside the party, I swiftly rushed past a pink carpet and a photo booth installment with cardboard three-dimensional French poodles and other breeds of dogs. Up the steps, Marc and Char greeted guests in their Huntsman suits, custom-made on Savile Row. The receiving line was massive, so I walked by them slowly and zoomed around the room looking for a banquette or chair, to find my seat and take it. This was a celebration that didn't have formal assigned seats. People roamed and

walked, talked and took selfies, looked at their phones or just chilled. I found a banquette just behind the big bar in the Grill Room and dashed to claim the corner. I never moved from that seat until I left, at 2:40 A.M. the next morning.

The only place to be that Saturday night was there. The guests included Justin Theroux, looking hot and casually dressed; Camille Miceli, Parisian fashion accessory designer at Dior; Delphine Arnault, the daughter of Bernard Arnault of France; Virgil Abloh, creative director of Louis Vuitton's menswear, as well as designer of the Milanese fashion house Off-White; Stefano Pilati, who flew in from Berlin (he designed the Saint Laurent ready-to-wear collections from 2004 to 2012); Bette Midler; Sandra Bernhard; accessories director at *Vogue* Candy Pratts Price and her husband, Chuck Price; English photographer Robert Fairer; creative director of *Allure* Paul Cavaco; Helena Christensen; and Grace Coddington, the high divinity of *Vogue*'s fashion editors, who honored Marc by wearing a pair of silk custom-made pajamas: a beautiful tailored soft shirt and loose, elegant trousers. Grace is still the same; she doesn't change. She was escorted by fashion genius Joe McKenna, who had worked closely with Azzedine Alaïa.

Anna Wintour came early, in a Marc Jacobs dress, and stood and talked to Marc and Char on the receiving line. She stayed forty-five minutes, a respectable amount of time, for her. I saw her from a distance, but she didn't see me. My seating situation was too valuable for me to risk getting up and losing it, so I stayed firmly installed on my cushiony banquette.

As I sat with my back to marvelous glass Austrian curtains, it felt like being back in the golden days of fashion. It was an extraordinary coming together of the fashion community, and everyone was there to celebrate love.

Carlyne Cerf de Dudzeele appeared and sniffed out a seat beside me on the banquette. She wore her Azzedine Alaïa fringed sweater. Black. Her Uniqlo jeans. Black. And her signature look, an armful

of swag: pavé diamond bracelets and a huge, gaudy vintage Rolex women's watch, with the face completely in pavé diamonds.

On her feet were gold leather Manolo Blahnik thongs, with a sensible heel. I asked her later how many pairs of these gold shoes she had. She showed me a photo on her phone of rows and rows of gold thongs.

In my career at *Vogue,* I worked with three amazingly talented and gifted editors: Carlyne Cerf, Grace Coddington, and Tonne Goodman, who is the only American out of the three. Each with her own unmistakable style helped to create *Vogue* through visionary and brilliant fashion editorials. I never touched them in their genius for the visual message of a fashion page. It takes a woman to translate the beauty and the pragmatism of a dress. I never could reach this troika of fashion luminaries.

Marc Jacobs's wedding was like a reunion of the best of the best of *Vogue.* Cerf and I sat the entire night, toasting Marc and greeting everyone from our perch on the black leather banquette. We fueled our happiness with chilled shots of vodka, sitting there watching the world go by.

DJs Fat Tony and Tremaine Emory shared the booth and created a soothing high-voltage old school–meets–new tech soundtrack. Everything seemed to blend, like a delicious fashion smoothie.

The party started with Kate Moss and Naomi Campbell (who wore a black Balmain couture cape, to the ground, with matching sparkled bra and trousers), who came along and posed for the hired photographers in a group series of photographs. Video artists were also roaming the plains, capturing this historic lovefest for Marc and Char.

Early in the evening, two huge Jumbotron video screens showed Marc and Char the day before, walking down a red corridor in their Frank Lloyd Wright–designed Rye residence, where they held their formal wedding. For the vows, they both said, "I will never float away from you."

Toward midnight, the giant wedding cake was cut and served to nearly seven hundred guests.

The whole event was so like the nights in the seventies when Nan Kempner would dance on the large speakers at Studio 54 in YSL couture, or Grace Jones would dance on the tabletops of Club Sept with no underwear. The music made the madness; it made the evening. I just sat there and enjoyed watching the fashionistas run up and down the stairs, including African model Alek Wek and black designer André Walker, a friend and an unsung genius.

Little napkins, white linen, made for the occasion, were embroidered with two lovebirds seated on the same branch, with the words "Never Float Away." I folded one in my hand, to take as a memento.

I never got the chance to speak to Marc and Char that evening, but they know I was there, as evidenced in photographs and videos. When it was time to leave, I asked André Walker if he would usher me down the stairs, as I had sat in one spot too long, slowing my circulation.

As I slowly rose, like an old elephant shocked by some unknown noise from his slumber, André walked backward before me, orchestrating my tired legs, assuming the stance of a Graham technique instructor. Quietly, he gestured and spoke in low tones, urging me down the steps in a *glissade* that would have been perfect had I been leaving a party in eighteenth-century Versailles.

Marc thinks of everything; on the way out, there was a gift bag for each guest with a sweatshirt with the emblem of two lovebirds on a branch. Each guest was given one or two, but I had failed to see them. I found out later and asked Marc if he could send me two sweatshirts. He first offered to make me a special sweatshirt like a huge caftan. I told him no, not necessary. He sent me a box with two of the sweatshirts. I will keep them in the box forever, the way I have kept in my fur closet his special gift of a Louis Vuitton mink blanket, monogrammed with the LV logo, like the luggage, full-length for a king-size bed. I also treasure a navy and black mink throw from his final collection at Vuitton in 2015, and in my home in North Caro-

lina is a special gift of four-piece, custom-made hard-box Vuitton luggage he designed in black, without the monograms.

Vanessa Friedman, fashion critic for *The New York Times,* called Anna Wintour "the magical manipulative Wizard of Oz" in an article on the 2019 Met Gala. She described Anna's Chanel haute couture pink ostrich-feather cape and exquisite column of a dress in pale, waffle-weave bouclé tweed and embroidered flowers on a nearly invisible green treillage as "a subtle impression of a pink flamingo." I disagreed with her on that description.

Since she took over as chairwoman of the event in December 1999, Anna Wintour has reinvented for herself the role of gatekeeper, and tsarina, of this worthy cultural institution. She has also raised close to two hundred million dollars.

This year, the headlines read like this one from the *Daily Mail:* "The year the Met Gala lost its sparkle: Critics blast guests' 'stupid' outfits while favorites Beyoncé, Rihanna and Bradley Cooper skip it and others say the 'self-indulgent' extravaganza has finally jumped the shark."

Mercifully, I opted out at the right time. Two thousand nineteen was indeed the ball of the emperor's new clothes, or, as one of my best friends said, "Halloween at the Met." It's now a ball where young YouTube influencers are suddenly skyrocketed to positions of credibility. And most often these so-called social media influencers are devoid of any knowledge of taste, fashion, or culture.

Jared Leto went with his severed head, fashioned after Alessandro Michele's Gucci autumn/winter 2018 show, where the models held versions of their own heads. Gucci, by the way, carried the whole weekend, in a series of incredible luncheons and events to launch its beauty line. They, along with Condé Nast, underwrote this year's magnificent nightmare.

Katy Perry came as a chandelier, in a short dress that actually lit up. Later, she changed into a giant hamburger, with pickles, ketchup,

and a bun. Her head poked out and people, from photographs I reviewed online, took nibbles at her during the party.

Billy Porter, the breakout star of the FX series *Pose,* came in on a royal couch, à la Cleopatra, suspended in air by six strong, half-dressed men in gold trousers. He arose from the couch and did an art deco version of some mythological man-insect right out of an Erté drawing.

Cher, who came with Marc Jacobs about three years ago, was now the dinner entertainment. She showed up ironically in blue jeans with holes at the knees and belted out tunes, with a bright fuchsia and black lace camisole under a big black jacket, and a huge frilly, fluffy Jean Harlow blond Afro wig.

Legendary photographer Annie Leibovitz was invited by Anna to sit at her table and lend some gravitas to the evening. Ms. Leibovitz had been the partner of the late Susan Sontag, author of "Notes on 'Camp.' " She showed up in elegant attire, a black smoking suit by Christy Rilling, which was beautiful from the photographs I saw online: flattering and worn with a soft, gentle white ruffled shirt. Annie brought her three daughters, all in long, flowing dresses, to the pre-dinner reception.

My replacement on the live-stream video was a young African American female, a YouTube star with some seventeen million followers. *Vogue* stands for excellence in everything, but I was told that on Monday evening, even the live-stream feed experienced technical difficulties until people chimed in from the Internet. Eventually the live stream cleared up.

What could this talented YouTuber offer? Surely she didn't know what a martingale back is to a Balenciaga one-seamed coat. Or did she know that Katie Holmes's Zac Posen dress, worn with great elegance, constructed with great technique, was an homage to the master architect Charles James, who was the subject of the 2014 Met exhibit *Charles James: Beyond Fashion*? Or that Cher's incredible Bob Mackie jumpsuit, worn to the gala in December 1974, was the fore-

runner to all the see-through evening dresses designed by Riccardo Tisci at Givenchy couture, now worn by Beyoncé and Kim Kardashian in this century?

Like an extinct dodo bird, my brain, rich and replete with knowledge, has been relegated to the history books.

In hindsight, the two best-dressed women, in my view, were Anna Wintour, in Chanel, and cape-clad Naomi Campbell in Valentino haute couture, by Pierpaolo Piccioli (who has given Valentino another life since he took over, resulting in the brand being a major influence in the fashion world). They dressed the way people should dress at this type of occasion. You've never seen Anna Wintour in an absurd thematic dress; she maintains deft control of her image. Chanel pink for the "think pink" theme of the exhibit and the party, awash with a pink carpet. And as Susan Sontag wrote in her essay, "Camp is a woman walking around in three million feathers." Anna selected the pink ostrich cape as an homage to the camp theme, but she also needed a cover-up for the beautiful Chanel dress with short cap sleeves.

On Monday evening of the Met Gala, I came home and planned on going to bed early to avoid the barrage of e-mails flying in with images from the pink carpet at the Met. I took a look at one or two before turning off the lights. Julia Reed wrote, "The real elegance took a train out of town a long time ago." Anne Bass sent me a photo of a man in feathers and a cape surrounded in ostrich trim. He looked like Liberace reincarnated as Dame Edna. "Would you want to know this person if you met him at a party?" Anne Bass inquired.

I responded with a simple "No," and went to bed.

Tonne Goodman's book, *Point of View,* was published in 2019. Now a *Vogue* contributing editor, Tonne reached the highest level of the *Vogue* masthead as fashion director and has, to date, been

the editor of almost two hundred American *Vogue* covers. Her sister, Wendy Goodman, is design editor of *New York* magazine and has also penned wonderful, beautiful books.

These sisters, Tonne and Wendy, are literally to the manor born. They grew up on Park Avenue, went to the best schools, and spent time in the living rooms of Diana Vreeland and Gloria Vanderbilt. Style is in their DNA. They have always been part of my extended family, mainly because they are both close to the Vreeland dynasty.

In a handwritten memo dated November 2, 1970, Diana Vreeland wrote to her *Vogue* staff, including Grace Mirabella and Baron de Gunzburg, the Russian expatriate, about Tonne Goodman: "Please do not fail this girl—though she is not pretty—she pulls together perfect bones and proportion in an aristocrative manner."

Vreeland invented her own word to describe Tonne (aristocrative!) and her tall, lean, elegant cool. In 1974, there was Tonne Goodman, one of the few other volunteers at the Costume Institute, working for Diana Vreeland. We were trained in her brilliance, and under her guidance we both soared, like American bald eagles.

As I read Tonne's book, I was blown away by its uniqueness, honesty, and original point of view about her fashion life. It is a lavish and authoritative book, tracing her autobiography through words and chosen photographs of her shoots, from her early career, beginning at the Vreeland exhibit *Romantic and Glamorous Hollywood Design,* and including her brief period as a high-fashion *Vogue* model photographed by Richard Avedon. Tonne decided modeling wasn't for her when the great photographer David Bailey told her to "look fuckable." She then transferred herself from in front of the lens to the back side of the camera, next to the photographer, as a super style editor.

I let Tonne know, as a friend, and someone I so admire, that I was disappointed to not get an invite to her book launch party. Tonne apologized and, in an attempt to make it up to me, asked me to be on an upcoming panel to talk about her book. I graciously accepted. On

the evening of June 19, Tonne, Eve MacSweeney (also a former editor of *Vogue*), and I did a special presentation at NeueHouse, in Manhattan, assembled in front of a standing-room-only crowd on the evening of Karl Lagerfeld's memorial in Paris (which I was not invited to and to which I would not have gone if I had been).

This night, I proudly wore, for the first time, my new white Swiss *broderie anglaise agbada* (a male garment inspired by the Yoruba tribes in Africa), opulently embroidered and flowing like a Baptist minister's summer garb. It was designed by my new friend Patience Torlowei, a Nigerian designer of luxury women's intimate apparel.

Grace Coddington was in the crowd. She sat next to Marianne Houtenbos, the agent/studio head for Arthur Elgort, a great American *Vogue* photographer and father of the current star Ansel Elgort. I also saw Tonne's sister, Wendy, and Mrs. Vreeland's two grandsons, Alexander and Nicholas Vreeland, a Tibetan Buddhist monk, in his deep-crimson robes.

Tonne and Eve (and Grace) are fiercely loyal to *Vogue*. I stated unequivocally that *Vogue* has not shown any fierce loyalty to us three in return.

After the talk, I stayed and took so many photographs. Nicky Vreeland posed for a photograph with me, for an Instagram post. I felt so honored that Nicky was there. Grace Coddington came up and gave me a big emotional hug.

"Grace, I thought you would surely be in Paris, at the memorial. I know how much Karl loved you and how much you cared for him," I said.

"I thought about going but I am sure it's going to be a corporate thing, so I decided not to."

"I am so glad you are here, Grace."

She then tossed her waterfall of flaming red Burne-Jones hair and we posed for photographs, clinging to each other, embracing our combined decades of dedication to *Vogue*.

I felt so charged after this evening, where we, as the now—

contributing editors of *Vogue,* spoke our passion and our truths to this rapt audience. I was so honored Tonne shared that moment with me.

The most important advocate for diversity in the fashion industry is Bethann Hardison. She was a top model in the 1970s who walked in the groundbreaking Versailles show in 1976. In the 1990s, as fashion became whiter, Bethann started hosting town hall group meetings about diversity. Now she sits on the board of the first-ever global initiative for diversity, at Gucci.

In May of 2019, Marco Bizzarri, the CEO of Gucci, hosted Gucci's first formal luncheon of influential African American people: Robin Givhan, Pulitzer Prize winner and critical fashion observer of *The Washington Post;* Symone Sanders, senior adviser to presidential hopeful Joe Biden; Steve Stoute; and Naomi Campbell, who of course arrived late, nearly at the end of the luncheon. It was a private lunch, with no press. There were maybe three hundred African American people in attendance, all of whom were aware of the importance of diversity and the power of black talent. It was a Gucci moment of respect and empowerment.

Creative director Alessandro Michele set the tone for this brand to make worthwhile initiatives for global awareness of black talent and individuals. It stemmed from the backlash to Gucci's golliwog, a black knit hooded hat, which seemed insensitive and racist to many people. Gucci did a preemptive strike with this global initiative and they deserve credit for it.

I had not seen Bethann, who is a dear friend, for nearly five months before the lunch. She showed up early, and we decided to share our table, along with Sir Edward Enninful. As the luncheon began with words from Dapper Dan, who is in a special partnership with Gucci, I began to tap my fingers on the surface of the table. Bethann took this slow, deliberate tapping of my fingers as a signal that I was impatient. Without any verbal demonstration, she gently

and quietly rubbed the back of my hand to end the finger tapping. An affectionate, quiet gesture, much like a mother would give a child. It was born out of genuine affection for me, and I loved her for this.

I think it's a nuanced thing, but there's still room for diversity in fashion. People forget to think about diversity, but they forget less when there are people in place who put them in the moment where they must really think about it. A moment of awareness of black culture. Gucci has established a committee of prominent black people who are paid to advise them and make them aware of products that could be insensitive or offensive to black culture. And not only does Gucci listen to the advisory board, they are giving back to the community in ways that have not been done before. Naomi Campbell made Gucci aware of the importance of black talent in Africa, and they began using their money for scholarships in Ghana, Senegal, Japan, and China, for students of fashion.

My great friend the scholar Dr. Janis A. Mayes said to me, "André, we are trained in whiteness. Whiteness can be fly, but we are trained in our formal education in whiteness."

She was speaking, quite literally, of our graduate program at Brown, a school named after slave owners. We were both students with full scholarships in French studies. My master's thesis: "North African Figures in Nineteenth Century French Painting and Prose." It included Flaubert, Delacroix, and the great Orientalist movement in literature and painting that reached its zenith in the nineteenth century. I also understood she was speaking of a larger, symptomatic truth as well. Blackness, such as in the form of Toni Morrison or the literary imagination of James Baldwin, is filtered through agents of whiteness. Why didn't James Baldwin, a great writer, receive the Nobel Prize? Why isn't Whoopi Goldberg starring in great movies? Why didn't Tamron Hall get a better deal from NBC, while Megyn Kelly had dismal ratings and a sixty-nine-million-dollar payout?

We've been educated to appreciate and evolve our paradigms through the telescopic world of white. Returning blackness to truth

must be done through the analytical excellence of the black intelligentsia.

When I was in Toronto doing press for my documentary, *The Gospel According to André,* a young black man in the lineup of reporters waiting to chat with me stood out. His name was Tre'vell Anderson, and he was the entertainment reporter for the *Los Angeles Times*.

Tre'vell came into the press conference location in a brilliant Ralph Lauren poncho as Native American Indian blanket, loose black Hammer leggings, and high stiletto boots. These boots were nothing compared to his long, long Chinese mandarin lacquered nails in bright gold. His hair was groomed into an extravagant Regency Afro pouf, with a giant ebony roll in the front that towered to the ceiling, and cut Vidal Sassoon scissor short in the back. This is a man who uses his personal style as a fashion warrior.

In Tre'vell, I saw my younger self. In that moment, I flashed back vividly to interviewing Karl Lagerfeld at the Plaza in 1975. Now here I was, being asked questions about the documentary and my journey. Tre'vell's intelligence and confidence in the delivery of his questions and the span of his fashion knowledge was breathtaking; it brought me to tears! My heart was full of pride and joy, as though I had just experienced the "Hallelujah" chorus on a Sunday morning, in any missionary Baptist church.

Tre'vell, only in his twenties, is already on the path to fame and recognition. While his stiletto wearing is remarkable, what's more remarkable is his substance.

I had come full circle.

I cite this talented young man because he created and crafted his career through the love and devotion of his grandmother, his education, and his solid confidence, clearly instilled at a young age. I can only imagine the confidence he had to have to get to the *Los Angeles Times,* in stilettos. I think even Andy Warhol would not have tolerated me in heels on a daily basis. In 2020, one makes one's own rules, as long as you have knowledge to watch your back. Dreams can come true for anyone who wants to *become.* Fear is no longer a barrier.

Upon the morning of Edward Enninful's taking over the helm of British *Vogue* from a white woman, I dashed off a simple e-mail to him with huge congratulations. He responded succinctly: "Thank you, André. You paved the way." I sat alone at my computer as tears rolled down my cheeks.

Symbolically I may have paved the way but Edward got there on his own talents. To any young black man, or any individual of any race or sexual identity, who thinks there is no place for them in the fashion world, follow Edward's shining example. Go to school, get your degree, and follow your inner core. Make no apology for who you are. Personal style is outstanding when it's backed up by knowledge and confidence. Be confident, be bold, and use your voice to express that personal style.

Rumors continue to fly that Condé Nast is not floating at the top of the list of powerful entities these days.

Vogue didn't used to have to worry about anything, because they had the advertisers. Now, with the rise of digital, *Vogue* is hemorrhaging losses, letting people go and leasing out office space to outsiders. Advertising isn't what it once was, and big stars no longer have to depend on magazines to present themselves to the world. *Vogue* needs to learn how to reinvent itself. How they will do that, I do not know. That is for Anna Wintour to figure out.

The move downtown to One World Trade Center was, in my view, the beginning of the end. The cutbacks and layoffs are known; Tonne Goodman and Grace Coddington are now employed as freelancers. Grace does a lot of work for Edward Enninful at British *Vogue,* and Tonne Goodman still shoots covers for *Vogue*. She is hired on a daily creative contract. She gets a day rate. Often *Vogue* will not even agree to pay a day rate for a much-needed fitting of clothes before the actual shoot occurs.

When I was there, we'd have twenty-two people going to Paris for the collections. Editors, advertisers, and maybe a photographer

or two. Now the only people who stay at the Ritz are Anna Wintour and *Vogue*'s chief business officer, Susan Plagemann. Key, core talents, like Tonne Goodman, Grace Coddington, and Phyllis Posnick, arrange their own airfares to Europe and attend the collections on a limited schedule. These are women of a certain age who were used to the perks of Condé Nast for most of their careers. So was I.

Grace Coddington used to stay at the Ritz, with a chauffeured town car. Now she must queue in long lines at airport taxi stands in Europe. In her seventies. It seems hardscrabble and undignified. Grace was never spoiled by the perks of *Vogue,* but certainly, if you're used to staying at the Ritz your whole career, it's going to be hard to transition down to a more economical option.

People of a certain caliber—not even myself, but people like Grace and Tonne, or even Eve MacSweeney—deserve those perks and should be rewarded for their loyalty. They are not. Grace and Tonne should have been given parachute packages, not slashed salaries and downgrades to "freelance status" as contributing editors (as was I).

When Polly Mellen, who had been at *Vogue* for thirty years, was forced to retire, they gave her a cocktail party in the basement of Barneys. I went, and remained utterly confused throughout the night. It didn't make sense; it was so undignified. They could have honored her with a seated dinner, with guests of her choice. Or a golden watch, a Bentley, a Rolls-Royce, *something*! She could decide to keep it or sell, but a little cocktail-hour bash in the Barneys basement? Ageism at its worst. They wanted to get rid of her at *Vogue* to make way for someone else. They booted her upstairs to *Allure,* and she retired soon after. That was not befitting of what Polly Mellen had contributed to *Vogue,* nor of the decades for which she worked there.

We are the dinosaurs of *Vogue,* an endangered species. We have been pushed out for younger people with smaller salaries. No health insurance, no perks at all.

I wonder, does Anna Wintour now offer her editors a ride to shows or just greet them in her usual ceremonial charade of unity on the front row?

I began paying my own expensive car bills in 2007, after the economic crisis, and when fifty thousand dollars was cut from my annual salary. But that to me was simply a sustained method of survival in the chiffon trenches, which have eroded over the last eight to ten years. Out of this erosion, I had dreamed and hoped for an enduring friendship with Anna. We have been through so much together.

I have had the most privileged role, alongside her on the front rows of international fashion shows. And I am sure she lobbied for me to win the Eugenia Sheppard Award for my first memoir. I've been at her personal moments of glory, for this philanthropist who raised millions of dollars for AIDS research and who raised hundreds of millions of dollars for the Costume Institute of the Metropolitan Museum of Art, now named the Anna Wintour Costume Center.

But still, Condé Nast is special in its ability to spit people out. From the highest to the low, you are dismissed without ceremony and without dignity, like in the court of the Sun King. When Diana Vreeland was fired, they changed the locks and painted her famous red walls beige. She was literally locked out. Grace Mirabella learned she was fired when it was announced on television. Condé Nast is special for that kind of thing. It is not a place of great empathy for humanity. When you're there, you're glorified to the highest, and then when they've decided you're done, you're just thrown out the door, like trash.

I lived through the golden age of fashion journalism. *Vogue* gave me a great life, a great memory of richness. I saw the best in people, along with the worst, when they feel you are no longer of value. There are bittersweet moments but I always gave back to *Vogue* whatever they wanted.

I think today Anna still feels a kinship to me or she wouldn't keep inviting me to her Chanel fittings. Her way of letting me in. And as

of the writing of this book, I remain on the *Vogue* masthead as a contributing editor, just like Tonne and Grace Coddington. *Vogue* people are always loyal to the brand and what *Vogue* stands for. In hindsight, I know that for all those turbulent and frequently *marvellous* (spelled with two L's, the way Diana Vreeland did in *Vogue*) years, Anna Wintour in her sphinxlike silence really cared about me and my wellness. Now, as I look back on that intervention, booking me into a ritzy private gym with an instructor, it's clear that she had my back (although it may not have felt that way at the time). Some invisible gossamer thread connects us, and at the crucial moments in her life she still desires my point of view, asking me almost inaudibly, "André?" As if to say, *Speak up,* and, *What is your final word?*

All the saints who are assembled here. I don't call you saints because you are perfect, I call you saints because you belong to God.

A saint is a sinner who fell down and got back up again. Across two hundred and eleven years, Abyssinians have kept the faith.

We are rational. We are historically minded. If you want to know where you are going, understand where you came from. We are the arc of safety. We are in the congregation, seeking salvation through Jesus Christ. We are straight and we are gay. I don't have to point out, nor do you have to demonstrate what your sexuality is. If there is a judgment it is between you, the individual, and your God.

> —Reverend Dr. Calvin O. Butts, Abyssinian Baptist Church,
> Harlem, New York

On a recent Sunday, the National Bar Association Judicial Council held a judicial memorial service during the morning services at Abyssinian Baptist Church, the oldest congregation of African Americans in the great state of New York. Some eighty members processed into the sanctuary, in their regal and classic judicial black robes, with great dignity and authority. I bowed to most of them as

they walked past my pew. Some of them smiled, especially the women, and some men.

How proud I was to have chosen to go to church on that Sunday morning, in one-hundred-degree heat, dressed in a traditional white cotton Swiss fabric, with a long train emblazoned with gold and navy ecclesiastical trimming.

As the service unfurled, Reverend Dr. Calvin O. Butts introduced the chairman of the council of black judges. You could see the glory and power of faith and family, and the struggle, in every face that assembled. You could see how we are as a strong black race, so full of greatness. A thread of us stood up and applauded.

At the end, as they recessed out onto the blistering sidewalk, one judge, with a ginger-colored short Afro, took my hand in hers and said, "Thank you for giving me the confidence, by your example, the strength to become and be who I am. To be free."

I thanked her with my open heart in my hand and my words. Reverend Butts's sermons most often remind me of the great oratorical sermons of the French cardinal Jacques-Bénigne Bossuet, tutor to the grand dauphin, the legitimate son of Louis XIV. He weaves together black history and cultural significance and just plain common sense, and speaks to the congregants in a universal, noble, yet simple manner. And always steeped in the significance of the black church in black lives.

I feel somewhat aligned with Reverend Butts, as he and I are the same age and both only children. In fact, Reverend Butts, who graduated from Morehouse College, is the embodiment of all the traditions I grew up with and that remain in me. Sunday-best clothes and Sunday-best manners. I have seen him at the Westbury polo matches, an annual summer event for the church, and his coordination of nuanced linen suits and hats inspires young black men. I try not to bother him, e-mailing him judiciously, as he has a demanding schedule. It must be a huge task to pen his oration every week, and to consult with his members.

In his example, and in his standards as a sinner saved by grace, I come home. I have the option to come home, any given Sunday morning, or even on a weekday at Bible study or a prayer meeting. I feel strong when I leave the sanctuary and I feel so much love, my spirit overflows.

Recently, I realized that in my seventies, my greatest joy is to wake up, say my prayers, and be kind. I try to be kind to everyone I encounter; sometimes I miss the beat. I must be kind to even the stranger who asks for a photo with me. I must be kind to someone older than I, by opening the door. I must let women go before me through the revolving door. I thank God for my grandmother's silent love and for Diana Vreeland's exuberant outbursts of love and affection.

When I am overwhelmed with feelings of emptiness and deep sadness, when the day begins and ebbs into dark blues, I have life-enhancing stratagems to make the day a better one. I begin each day in prayers for my friends and loved ones. I learned this from my grandmother, who would pray out loud seated on the edge of her bed. Then I ring up my friend Sandra Bernhard, who helps me sort out the ills and the cracks. This is a near daily dose of SB, who calls me the oak tree of her life. She is measured and doesn't know how much I depend on her for her sense of balance.

When I am really feeling helpless, I can call my friend Alexis Thomas, a deacon of the church, and she will stop whatever she is doing and pray with me by telephone. She might be at home or work, and she will stop and say an eloquent prayer, based on scripture, invoking my name and my needs. Tears well up in my eyes when she prays by the Bluetooth in her ear while driving. In a major crisis, Reverend Butts will get on the telephone and we pray together. My faith and my church life are paramount to my wellness.

In Victor Hugo's novel *The Hunchback of Notre Dame,* Quasimodo, the bell keeper, shouts out, "Sanctuary! Sanctuary!"

That resonates in my life, as I have always, to the very moment I pen this, been afraid of real life. Real life for so long has been one of selected darkness. But the sun eventually shines. I dreamed of the

life I have lived and I survived with dignity and grace. After all, my ancestors survived the original sin of this great country, slavery, the injustice of having to suffer racism and survive. If this country can survive all the injustices, what is my plight and my burden? I think it is a true wonder that I have come this far.

I have always feared life. I love living and I love looking to the endless skies. The world can't hurt me. No one can hurt me when I live in the circle of faith, love, and prayer.

It gives me unbridled joy to give love.

I always wanted love.

EPILOGUE

This book, now released in paperback, is the story of how I survived in the chiffon trenches of style and fashion, becoming the first African American to be named creative director of *Vogue* magazine. It was first published in May 2020 – the height of the pandemic due to COVID-19 and in the middle of the incredible global focus on the systemic racism that is pervasive in our culture. Black Lives Matter, in all aspects.

Somehow, my story in many ways aligned with this cultural shift. Upon publication, I received handwritten notes, phone calls, and e-mails, saying how important it was to tell my story. *The Chiffon Trenches* became a *New York Times* bestseller. I felt I had indeed, as the civil rights folk song says, "Overcome. We shall overcome, some day." I overcame all formidable woes and obstacles, and still I walk with my head held high, in dignity and in confidence of who I am, who I became: this unique person in the world of style and fashion.

Much has been written about Anna Wintour, the longest running editor in chief in *Vogue*'s history. I owe much to her. Yet, I owe much more to Diana Vreeland, who was the most important fashion editor and editor in chief of *Vogue*. Diana Vreeland is my spiritual light and that light endures.

In my narrative, Anna Wintour is credited with giving me a special platform. Yet, after my book published, she released a personal statement … to the world. She apologised for the "hurtful and intolerant" stories and images towards black people published by *Vogue*, and the lack of diversity under her reign at *Vogue* for which she took full personal responsibility.

As I said in a radio interview, Dame Anna Wintour is a colonial broad (she was knighted by Queen Elizabeth II); she has never allowed anything (or anyone!) to get in the way of her white privilege. When discussing a long list of ideas about my February column one year, she said to me, from behind her desk, "André, *Vogue* is not here to run a column about your ideas on Black History Month."

> *We're taught from grammar school up to accept segregation as a way of life. You lied to me, because you never intended that I should be free, and I lied to you because I pretended that was all right.*
> — James Baldwin

These words aptly describe my relationship to the white space I occupied at *Vogue* and in the chiffon trenches of Paris, London, Milan, and New York. I occupy white spaces, but I am a proud black man, who is proud of his ancestral past. My ancestral recall is my spiritual storehouse and my foundation. My grandmother, who is paramount in my life, was the role model that gave me structure, faith, and values that I still live by.

I hope reading this edition of my memoir will give you a "woke" moment, of what it is like to be of the white space, applauded by the whiteness of privilege, and yet be a black man, who overcame.

September 2020, White Plains, New York

BEST-DRESSED LIST

Based on my decades of observation and social interaction, including serving on the official International Best-Dressed List judges' committee, under the auspices of the late founder Eleanor Lambert (as well as current officers Reinaldo Herrera, Graydon Carter, and Amy Fine Collins), I offer my personal best-dressed lists for women and men. The main requirements for my lists are: sartorial uniqueness, consistent style, personal achievement, and a high moral code, which leads to high standards in dress. And so, I present, in no particular order:

WOMEN

ANNA WINTOUR: Only when she is dressed in Chanel haute couture. Due to her profession, and background, she sees dressing well as a moral duty. As a global vision of fashion, she is loyal to Chanel's venerable and timeless elegance.

ANNE BASS: She had the most elegant wardrobe of any woman I ever met: couture Valentinos, Chanel, Diors by John Galliano, and the ultimate Yves Saint Laurent. She was more than her couture choices; she was a great cultivated patron of the ballet and also a great grandmother, who decided to shelve her couture worth millions, in her numerous closets in numerous homes, and wear Prada!

ANNETTE DE LA RENTA: She has worn the best of Paris and has rows and rows of Saint Laurent couture in her closets, as well as her husband's couture. In her youth, she loved Madame Grès. Her favorite uniform: simple Chanel couture dresses, or an old Fendi shearling coat with suede trousers and above-the-knee Manolo Blahnik boots. She inspired Karl Lagerfeld.

BIANCA JAGGER: Decades of great style, from her YSL wedding suit, with a big soft floppy fedora, to crinolines and ball dresses. Christian Dior by Marc Bohan, Zandra Rhodes, Halston, Norma Kamali, Tom Ford, and Valentino, who designed an entire wardrobe for her to wear for a movie that was never released.

COMTESSE JACQUELINE DE RIBES: French style at its zenith. She has been muse to the great houses of couture and muse to herself for her own high fashion line sold in luxury retail stores. If she loved a St. Laurent couture dress of great design, she would order three: one in pale apricot and two in subtly different shades of pale, pale blue. She had her own exhibition at the Met in 2015, on view for three months.

DIANA VREELAND: She wore Balenciaga to work, then, in the youthquake sixties, switched to cool sheath dresses in summer, and pullover cashmere sweaters and wool trousers in winter, with red Mick Jagger rock boots in plastic snake, by Vivier. Her favorite jewels were fake Kenneth Jay Lane, except for a gift of a white enamel snake by Bulgari (actually a belt that she wrapped twice around her

throat as a necklace). Racine wool jersey triangle kerchiefs, cut by Madame Grès, were worn as uniforms by day at her throat and, like an Apache dancer, at her waist over her slacks.

RIHANNA: For taking her style and turning it into a global fashion empire, Fenty and Fenty Beauty. She has the attitude of modern Africa—think Princess Elizabeth of Togo. She inspires so many young girls with her fierce look, her personal line of lingerie, and her sportive heeled shoes for Puma. In 2019, she shattered the crystal ceiling with her Savage X Fenty show, featuring a diverse lineup of models and dancers. Savage X Fenty is everyone's "add to cart" necessity.

MICHELLE OBAMA: In the White House, she wore Versace metallic mesh, draping across her body like a Grecian goddess's toga. She wore rock-star, silvery-sequined stocking boots on a nail-thin heel by Balenciaga during her book tour for *Becoming*. She mixed high-low like no other fashion lady could.

DIANA ROSS: When she was on Ed Sullivan as a Supreme, she was inspirational as well as aspirational. And not only to African American women, with her flowing chiffon coats onstage, over sequins, and her mountains of Afro hair. She came to the Met Gala wearing real turkey feathers as a strapless ball dress during the Vreeland era. Tom Ford has dressed her, and gladly.

ALEXANDRA KOTUR: My dear friend and my column editor at *Vogue* for over fifteen years. She was creative director at *Town & Country,* and is now a mother of two wonderful young children: Digby and Roberta, for whom I am godfather. Alexandra wears clothes the beautiful Waspy way. Her day uniform: lean trousers, from spring to winter, summer, and fall. Very little jewelry, beautiful flats from Manolo Blahnik. For evening, the most beautiful couture shirts—very romantic—and huge sweeping skirts, all by Carolina Herrera. Very little makeup, by day or evening. She is a true lady.

BARBRA STREISAND: She has a breathtaking ability to wear outrageously elegant things, like white mink knickers and a mink newsboy's cap, in her black and white television specials. And she wore Scaasi's brilliant Peter Pan–collared top and jaunty bell-bottom trousers as she stumbled up to get her Oscar for *Funny Girl*. The illusion black chiffon was lined in subtle nude georgette, so on black and white television, she looked nude, but she wasn't. And surely, there has never been a better front-row spectator at Chanel than Barbra when she was in Paris being photographed for *Vogue,* wearing a matching leopard coat and fedora, and then swinging around Avedon's set in Madame Grès.

BETTY CATROUX: A former Chanel *cabine* couture model and muse to the great master Yves Saint Laurent. She's the only woman who has managed to pull off wearing black nearly every day of her adult life, nearly all of it from YSL. She is responsible for making the black trouser suit elegant. Black looks fresh on Catroux.

MICA ERTEGUN: She was one of the best and biggest clients of Madame Grès when she was young. Long before I came to New York, she was ordering extravagant black McFarlands from Adolfo for the legendary nine o'clock parties. She spent her money at Saint Laurent, Jean Paul Gaultier, John Galliano for Dior, and Givenchy haute couture. And yet, one year she found her Met Gala look at Norma Kamali: a black gypsy skirt, which weighed about fifteen pounds, paired with a black shirt. I thought it was Madame Grès, and Mica was so proud that she had made a couture look from the heavy gypsy skirt.

ISABEL TOLEDO: Her sense of elegance endures. This self-invented Cuban-born fashion designer wore looks that evoked refinement with sophisticated irony. Her best little black dresses were chosen because of historical references to couture and her Spanish roots. Of course, her Manolo Blahniks were chosen with an appreciation for dramatic and original details with every ensemble.

TAMRON HALL: The best-dressed woman on daytime television. Tamron cuts a major swath by wearing a white Roland Mouret jumpsuit—strapless—with a lightning bolt detail at ten o'clock A.M. Her look is always beautiful, like the powerful, illuminating African American film stars Diahann Carroll, Dorothy Dandridge, and Lena Horne. She loves edgy Chanel, Balenciaga, and Gucci by Alessandro Michele, yet she also wears emerging American design talents, like Denzel Parris, on her show. She will wear a stunning catsuit with a matching cape; she loves vintage and she wears the best stilettos with everything. She takes bold risks every day and they always work.

RENÉE ZELLWEGER: As a multi-Oscar winner, she has evolved over seasons of red carpet dressing into pure elegance. For example, the sleek, simple, Armani Privé she wore when she won Best Actress for her outstanding portrayal of Judy Garland in the biopic, *Judy*. For the 2020 Screen Actors Guild Awards red carpet, she wore a strapless midnight blue duchesse satin evening dress by John Galliano. With the eye of a great fashion editor, she selects dresses that are modern, minimal, eschewing all real or faux jewels on her neck and ears (no bells and whistles!), aiming for a pure Brancusi silhouette in slim sheath dresses, or robe fourreau, as it's known in couture.

CATIE MARRON: She wears American brands, and eschews fine French couture. Consistently, her wardrobe consists of the best Michael Kors and Oscar de la Renta, with a mix of accessories from Lanvin, and shoes always from Manolo Blahnik. To dinner, she once wore a Bill Blass vintage halter black cashmere sweater, with two satin bows. No other black cashmere sweater could ever top it!

TINA BROWN (LADY HAROLD EVANS): She does a perfect glissade across the stage on towering six-inch stiletto heels, introducing international speakers and panels at her Women in the World Summit, in a super-structured pencil skirt and a crisp white shirt, accessorized with one gold bracelet and hell-red lip rouge. The crisp,

rolled-up sleeve of her white cotton shirt, tucked into a pencil skirt that zips up the back with a gold zipper to the hem, shows a woman can be as cool as a modern-day Gibson Girl in the evolution of her sexual and intellectual power.

LIFETIME ACHIEVEMENT AWARD: CAROLINA HERRERA.

She gets her own category because when she still lived in Caracas, Venezuela, she would come to New York during the winter social season and turn heads, in Tan Giudicelli couture. When she dressed in Paris, at the couture, she had a cardinal rule: "I always selected the dress I knew no one else would think of buying." For nearly five decades, she has been the most elegant lady in New York. Karl Lagerfeld said so, and I agree.

MEN

MANOLO BLAHNIK: His Anderson & Sheppard suits are tailored in every hue, from lilac and lavender to peony for summer, and in elegant tweeds and overscale checks in winter. This man exudes elegance in every way, from his tone-on-tone socks to his incredible oxfords or slip-on moccasins, designed solely for him and by him. His big addiction: *poils de veau* or stenciled moccasins for day and evening.

DR. CORNEL WEST: Professor of public practice of philosophy at Harvard University, author, and scholar. He has always worn a black suit, white shirt, and black tie. His distinct look: the silver and ebony Afro and beard, perfectly groomed, with rimless eyeglasses. The black suit uniform has a black roll-neck ribbed collar, often worn with a black turtleneck under the white shirt. This man is a true inspiration of style, an eloquent as well as elegant man who speaks with expertise on everything from black jazz to black politics.

TOM FORD: He has made his personal style into an empire, encompassing everything from scent to fashion for women and men. He has dozens of simple black single-breasted suits and white shirts, and wears only elegant, elongated black shoes.

OSCAR DE LA RENTA: What style! His perfect single-breasted suits—beige in summer, caviar tweeds in winter—and the most elegant bare feet. He even looked impeccable wearing a polo shirt and khaki Bermuda shorts. He always looked elegant, standing or photographed next to his beloved wife, Annette de la Renta.

BARON ERIC DE ROTHSCHILD: He wears his fifty-year-old custom-made suits from Anderson & Sheppard, the best London tailors. For weekends at Château Lafite, he favors simple pale washed denim shirts and blue jeans; for dinner, he wears beautiful velvet dinner jackets, white pleated dinner shirts, and needlepoint or broadtail slippers by Louboutin. In Paris, his underground garage has polished concrete floors, and numerous Warhol Marilyns hang on the walls, just for the sheer luxury of having them in this unexpected place.

MARC JACOBS: He dares to wear his elegant suits with women's handbags by Chanel or Hermès envelopes. He once showed up at the Met Ball in a see-through lace shirt, buttoned to the top of his collar, by Comme des Garçons. He wore impeccable white sneakers by Balenciaga to his postwedding celebration and to Lee Radziwill's funeral. He carries a quilted Chanel *pochette* like a manbag from the seventies. Of course, he has fun, buying multicolored fur coats and fox scarves from his favorite Prada collections.

DR. CALVIN O. BUTTS III: Every Sunday from his pulpit, he represents the tradition of black male elegance, with sumptuous robes and shoes so polished you can see your reflection in them. Even his informal dress is nuanced, with well-chosen straw fedoras, linen shirts, and trousers. He is an icon of respectability and correctness.

THELONIOUS MONK: The only man to wear gaudy, outrageous rings and make it look cool as he sat at the piano, inventing and composing great modern jazz music. His silk shantung suits and white shirts with neckties coupled with his exotic headgear—Chinese silk skullcaps with tassels or kooky hats from his travels to places like Poland—and his plain slip-on shoes are the essence of every man's wardrobe. He wore great overcoats with fur shawl collars, double-breasted.

WILL SMITH: Swag: He has the same impact as Cary Grant did, old-school style, except he is today's black screen idol, who walks the walk with class. Always elegant, even in a T-shirt, cap, jeans, and white sneakers. And yet, he is Hollywood's best example of a man when he is in a black suit or black tie.

LIFETIME ACHIEVEMENT AWARD: RALPH LAUREN.

For the last half century, this designer has made a global impact on style, not only with his clothing line but with his own personal sartorial perfection. He switches from Cary Grant in cosmopolitan elegance to the Marlboro Man on the American plains. Whether in blue jeans with the perfect black smoking or dinner jacket, or wearing exquisite double-breasted banker stripes, or white tie and tails, he achieves his own version of "American style," at its most unique best.

ACKNOWLEDGMENTS

Thank you to my editor, Pamela Cannon, and everyone at Ballantine Books, including Jennifer Hershey, Kara Welsh, Kim Hovey, Lexi Batsides, Jennifer Garza, Michelle Jasmine, Debbie Aroff, Kathleen Quinlan, Richard Elman, Elizabeth Rendfleisch, Robert Siek, and Robbin Schiff, for all your assistance.

Thank you to my wonderful literary agent, David Vigliano, and his associate, Ruth Ondarza.

I must thank Thomas Flannery, for his tireless work in putting this book together. His brilliance and insight from the beginning of the project to the end made my journey in words happen in the best way possible.

Thank you to the artists, photographers, and estates who so kindly allowed use of their images: Jonathan Becker, Alessio Boni, Arthur Elgort, Bertrand Rindoff, Colin Douglas Gray, Robert Fairer, Diane von Fürstenberg, Garrett Rittenberg, Kimberly Cole Moore, the estate of Bill Cunningham, the estate of Diana Vreeland, especially her grandsons, Alexander and Nicholas Vreeland, the estate of Helmut Newton, the estate of Karl Lagerfeld, and the estate of Lee Radziwill.

Thank you to my great Armonk team of wonderful drivers and

managers: Raoul Joseph, Mark Maffia, Juan Lazona, Patrick Talty, and Rafael Ruiz, and finally, Lisa Bove, who will skate on thin ice to make sure my schedule is ready and cars are waiting at the curb.

Naomi Campbell is my ultra angel; she gives me so much love. Complete. Supreme. Love.

Thank you to Will.i.am for believing in me.

Thank you to Riccardo Ajossa, Jack Alexander, Patricia Altschul, Sara Arnell, Peter Eric Assue, Shelton Barrett, Anne Bass, Chase H. Beck, Richard Benefield, Lynn and Marc Benioff, Bonnie Berman, Sandra Bernhard, Eli Binstok, Manolo Blahnik, Deeda Blair, Mayor Michael Bloomberg, Linda Bell Blue, Alex and Eliza Reed Bolen, Tina Brown, Reverend Dr. Calvin O. Butts III, Mrs. Patricia Butts, John Camperlengo, Beatrice Caracciolo, Mariah Carey, Graydon Carter, Englebert de Castro, Tomas Cathecart, esq., Betty Catroux, Dolores de Celestino, Nancy Chilton, Grace Coddington, Partricia Colwell, Chad Cooper, Jared Cooper, esq., Yvonne Cormier, Joseph Corron, Laurie Dawoyt, Alex Denis, Georgia and Alec Donaldson, Andrea Donnelly, Maureen Dowd, Carlyne Cerf de Dudzeele, Edward Enninful, Mica Ertegun, Roz Evans, Laurie Ann Farell, Dr. Claudia Felberg, Silvia Venturini Fendi, Dany Filson, Dr. Michael Finkelstein, Evan Fishburn, Tom Ford, Susan Fox, Bruno Frisoni, John Galliano, Valentino Garavani, Wanda Garrett, Giancarlo Giammetti, Robyn Gibbons, Dr. Charles Glassman, Whoopi Goldberg, Tonne Goodman, Wendy Goodman, Martin Grant, Michael Guthrie, Tamron and Moses Hall, Bethann Hardison, Carolina Herrera, Spencer Hersh, Derron Hogg, Deborah Hughes, Iman, Bill Jacobs, Marc Jacobs, Kris Jenner, Jimmy, Chandra, Evie, and Lydia Johnson, Norma Kamali, Chaka Khan, Reverend Dr. Carolyn Ann Knight, Michael Kors, Alexandra Kotur, Jennifer Kumwenda, Dr. Marina Kurian, Hildy Kuryk, Ralph Lauren, Carl Louisville, Helene de Lundinghausen, Tiggy Maconochie, George Malkemus, Dr. Victor Marks, Catie and Donald Marron, Serena Marron, William Marron, Charles Masson, Manfred Mautsch, Janis Mayes, Ari Melber, Felix Montalvo, Michael Moore, Dr. Michael Morledege, Peggy Noonan,

Kate Novak, Patrick O'Connell, Jennifer Park, Barry and Willie Parker, Saundra Parks, Dr. Leon Popovitz, Miuccia Prada, Georgia Nunn Purefoy, Brian Raines, Julia Reed, Annette de la Renta, Sir John Richardson, Fiona Da Rin, Jane Rosenthal, Isabella Rossellini, Andrew Rossi, Eric de Rothschild, Ralph Rucci, Rosina Rucci, Joe and Mika Scarborough, Ivan Shaw, Ashley Shift, Sally Singer, Jada Pinkett Smith, Will Smith, Molly Sorkin, Hamilton South, Carlos de Souza, Theo Spilka, Sara Switzer, Paul Tadeushuk, Princess Gloria von Thurn und Taxis, Diane Taylor, Alexis Thomas, Teddy Tinson, Patience Torolowei, Reverend Dr. Eboni Marshall Turman, Rossi Turman, esq., Connie Uzzo, Diego Della Valle, André Walker, Darren Walker, Paula and Glenn Wallace, Sharon Wallberg, Vera Wang, Bruce and Beverly Weaver, Kanye West, Kim Kardashian West, Vivienne Westwood, Serena Williams, Venus Williams, Wendy Williams, Oprah Winfrey, Anna Wintour, Ron Worgul, Dr. Jeanette Yuen, Tony Yurigaitis, and Renée Zellweger.

PHOTO CREDITS

left) © Getty Images/Michael Loccisano, (bottom right) © Getty Images/Dimitrios Kambouris; page 7: (top left) © Getty Images/ DAVID X PRUTTING/Patrick McMullan, (top right) © Getty Images/Ron Galella, (bottom) © Getty Images/Stephen Lovekin; page 8: (top) © Getty Images/BILLY FARRELL/Patrick McMullan, (bottom) Courtesy of DVF Archives

ABOUT THE TYPE

This book was set in Bembo, a typeface based on an old-style Roman face that was used for Cardinal Pietro Bembo's tract *De Aetna* in 1495. Bembo was cut by Francesco Griffo (1450–1518) in the early sixteenth century for Italian Renaissance printer and publisher Aldus Manutius (1449–1515). The Lanston Monotype Company of Philadelphia brought the well-proportioned letterforms of Bembo to the United States in the 1930s.